Painting Ships, Shores and the Sea

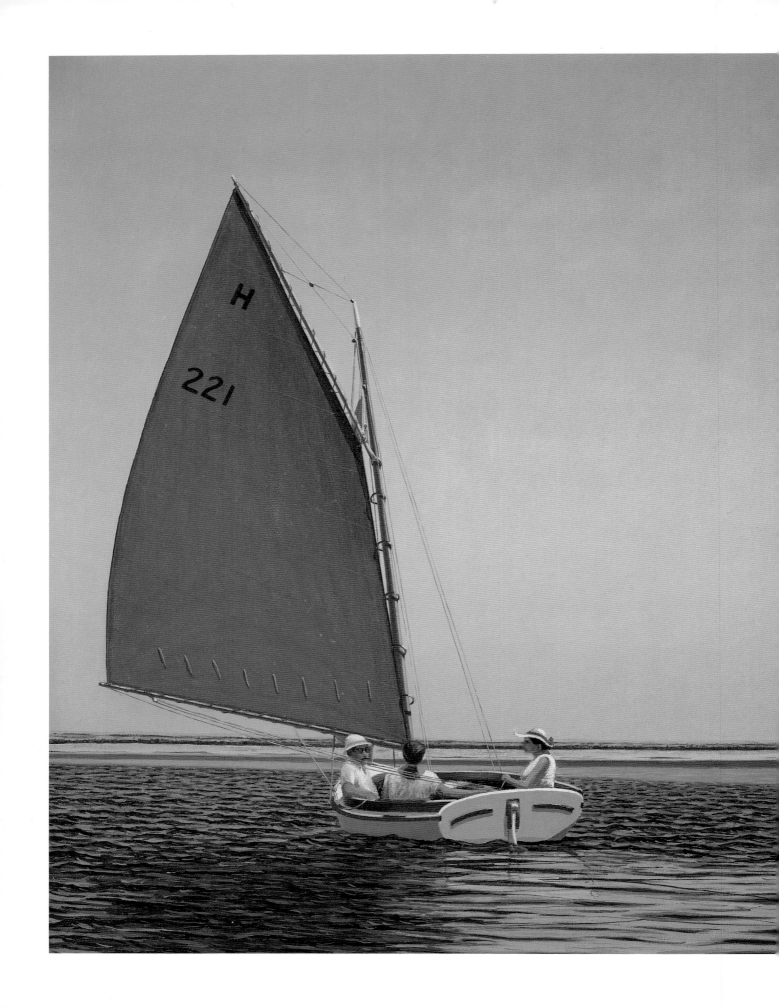

Painting Ships, Shores and the Sea

RACHEL RUBIN WOLF

ZEPHYR OFF EDGARTOWN LIGHT
Charles Raskob Robinson, Oil on Canvas

NORTH LIGHT BOOKS
CINCINNATI, OHIO

ABOUT THE AUTHOR

CREDIT: MICHAEL WOLF

Rachel Rubin Wolf is a freelance writer and editor. She acquires and edits books for North Light Books and has the privilege of working with many fine artists. Wolf is the project editor for the *Splash* series as well as *The Best of Wildlife Painting, The Best of Portrait Painting* and many of North Light's *Basic Techniques* series paperbacks. She is the author of *The Acrylic Painter's Book of Styles and Techniques*, and a contributing writer for "Wildlife Art News."

Wolf studied painting and drawing at the Philadelphia College of Art (now University of the Arts) and Kansas City Art Institute. She continues to paint in watercolor and oils as much as possible. She resides in Cincinnati, Ohio with her husband and three teenage children.

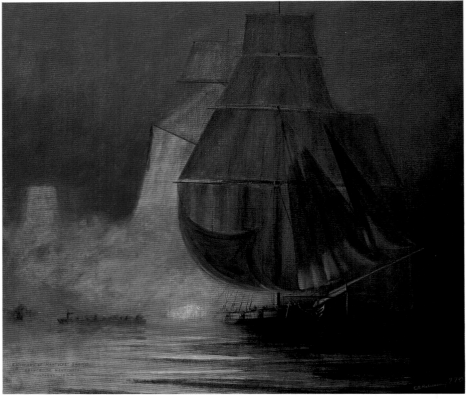

SO'TH'ARD OF NANTUCKET SHOALS
Charles Raskob Robinson, Oil on Canvas

Painting Ships, Shores & the Sea. Copyright © 1997 by Rachel Rubin Wolf. Manufactured in China. All rights reserved. No part of this book may be reproduced in any form or by any electronic or mechanical means including information storage and retrieval systems without permission in writing from the publisher, except by a reviewer, who may quote brief passages in a review. Published by North Light Books, an imprint of F&W Publications, Inc., 1507 Dana Avenue, Cincinnati, Ohio 45207. (800) 289-0963. First edition.

Other fine North Light Books are available from your local bookstore or direct from the publisher.

02 01 00 99 98 5 4 3 2 1

Library of Congress Cataloging-in-Publication Data

Wolf, Rachel.
 Painting ships, shores & the sea / Rachel Rubin Wolf.
 p. cm.
 Includes index.
 ISBN 0-89134-787-9 (alk. paper)
 1. Marine painting—Technique. I. Title. II. Title: Painting ships, shores and the sea
ND1370.W58 1997
758'.2—dc21 97-14318
 CIP

Edited by Joyce Dolan
Production Edited by Katie Carroll and Michelle Kramer
Interior designed by Sandy Kent
Cover designed by Brian Roeth

The permissions on pages 140-141 constitute an extension of this copyright page.

METRIC CONVERSION CHART		
TO CONVERT	**TO**	**MULTIPLY BY**
Inches	Centimeters	2.54
Centimeters	Inches	0.4
Feet	Centimeters	30.5
Centimeters	Feet	0.03
Yards	Meters	0.9
Meters	Yards	1.1
Sq. Inches	Sq. Centimeters	6.45
Sq. Centimeters	Sq. Inches	0.16
Sq. Feet	Sq. Meters	0.09
Sq. Meters	Sq. Feet	10.8
Sq. Yards	Sq. Meters	0.8
Sq. Meters	Sq. Yards	1.2
Pounds	Kilograms	0.45
Kilograms	Pounds	2.2
Ounces	Grams	28.4
Grams	Ounces	0.04

ACKNOWLEDGEMENTS

After working on scores of books for North Light in various capacities I had begun to think of myself as an "old hand." Well, this book was a new deal. Though I love the outdoors, spent a part of all my childhood summers at the ocean and even have an uncle who resides on the Chesapeake and builds boats, in taking on this project I had to admit that I knew little about the subject. Therefore, I had to rely on the expertise of others in great measure.

Thank you especially to Carolyn Mizerek, wife of artist Len Mizerek, and friend of the ASMA, who was indispensable at the beginning of this project. When I was at a loss as to where to start, she enthusiastically helped me compile names of potential contributing artists, talked up the book idea to her artist friends, raising interest and even excitement about the project, and sent me great packages of catalogs and other material to get me started. Thanks, Carolyn.

The artists themselves were my other panel of experts. Their suggestions about what to include were very helpful, and their patience with my poor vocabulary when it comes to sailing and boat terms was greatly appreciated. Thanks to artist Marc Castelli for helping to "spice up" the section titles. Thanks also to Rob Miller for his final "expert read" of the manuscript to catch any "landlubber" mistakes that I may have missed.

Thanks to Barb Richards, my faithful friend and keyboarder for decoding the handwritten captions we got from a few of the artists (no easy feat!), not to mention my own handwritten notes and edits, and for preparing the first draft of the manuscript to my specifications. I couldn't have met my deadline without you.

Thanks as always to all the staff at North Light who finished putting the pieces of the puzzle together to make a finished book: Joyce Dolan for her ruthless content editing and forgiving me for changing my first deadline, Katie Carroll and Michelle Kramer for all the undisclosed details of production editing, and Sandy Kent and Brian Roeth for the beautiful book and cover design.

A second and the biggest thanks to all of the contributing artists for your hard work. Despite all that I asked of you, you all responded with warmth and professionalism, and for the most part were very mindful of deadlines. (All that sea air must be good for the personality.) I heard some wonderful stories along the way and will not be able to rest until I visit Tilghman's Island. (Anybody give sailing lessons?) I truly hope you enjoy this book.

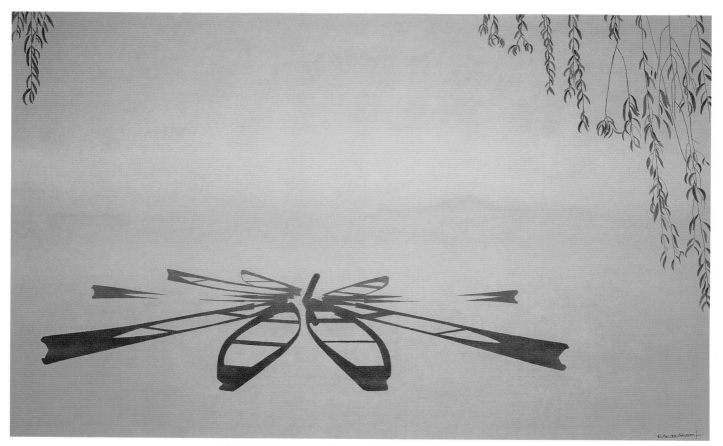

MORNING STAR, *Charles Raskob Robinson, Oil on Canvas*

INTRODUCTION

Sunlit seashores, quiet bays, rocky coasts, off-shore breezes blowing eggshell sails, the open seas and the ships that traverse them are all the special world of the marine artist. You may be an avid sailor, or simply an artist who loves the smells and sounds, the inspiring light effects, that are found near water. In either case, this book is for you.

The twelve wonderful artists who graciously contributed their talents to this project are each inspired by the sea and ships in a personal way and express that vision uniquely. They share their excitement with you, and pass on many techniques and tips that only an experienced pro could know.

Whether your affinity to the sea comes from a stroll on the beach, an off-shore sail, your live-lihood or the promise of great adventure, this book will help you create art that expresses your special fascination for the sea and for the vessels that wander its un-steady paths.

—*Rachel Wolf*

TABLE OF CONTENTS

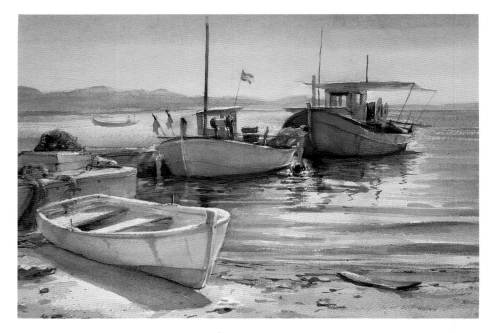

PART 1

HANDLING THE LINES
Tips on Drawing Boats and Water

PART 2

FITTING OUT YOUR PAINTING
Painting Techniques for Marine Subjects

PART 3

LIGHTING EFFECTS
Use Light to Best Advantage

PART 4

BUILDING A SEAWORTHY PAINTING
Eleven Step-by-Step Demonstrations

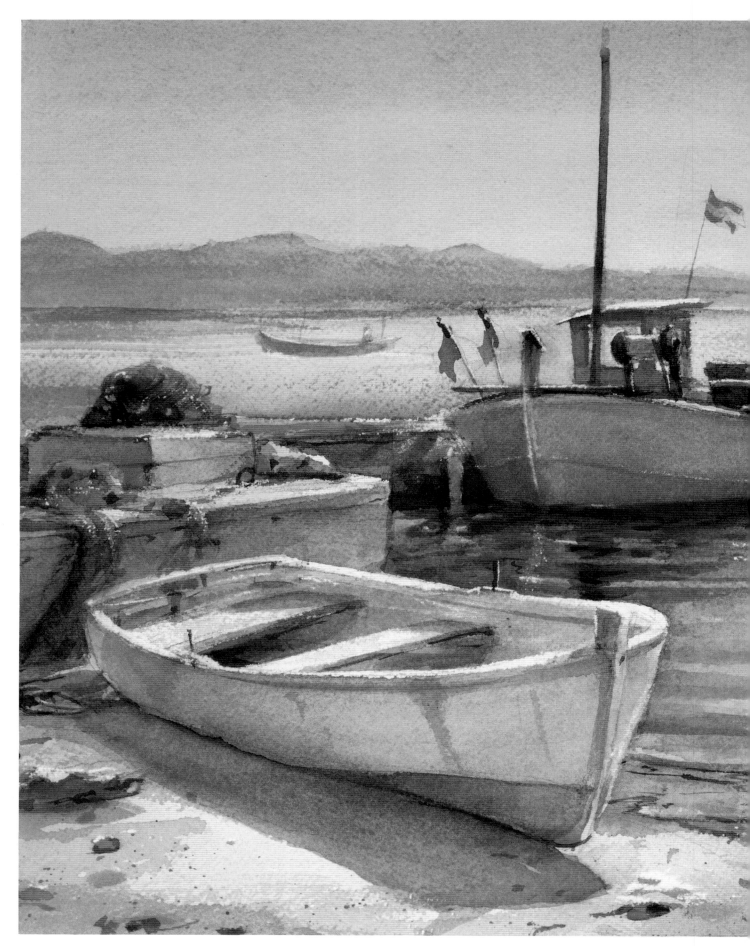

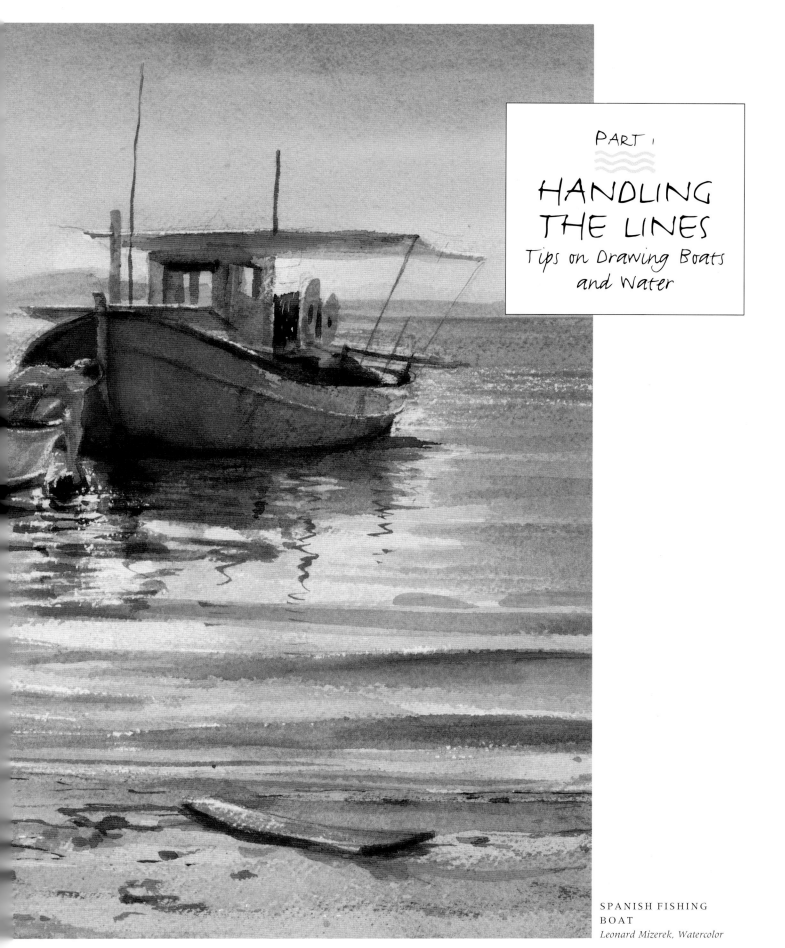

HANDLING THE LINES
Tips on Drawing Boats and Water

SPANISH FISHING BOAT
Leonard Mizerek, Watercolor

Tips for Drawing Boats, Water and Perspective

PETER EGELI

The most important thing about drawing and painting is to overcome an almost universal tendency to see things as you "know" them to be and not as they actually appear to you. The following diagrams are designed to help you see objectively.

There are many ways to visualize the shapes of boats. Picture watermelons with cutoff tops, half-cylinders with pinched ends or oblongs with one or both ends pointed, just as a few examples. You have to find your own way to make the shapes understandable so you can easily express them. We frequently view boats from eye level, that is, near the horizon line, so a flat figure "8" can be used as a basis for many traditional hull shapes.

A **B**

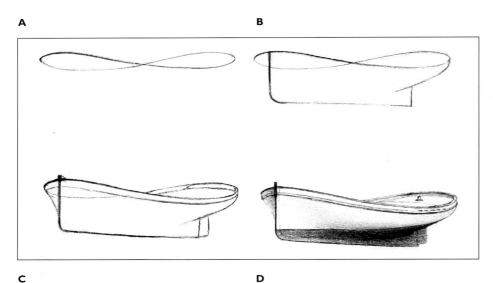

C **D**

Boat Shapes

This illustration shows a hull shape that was once found in many parts of the world and in variations is used in many modern boats. (A) Start with the flat figure "8." (B) Determine where the stem, keel and sternpost would be. (C) Draw in the rub stake. (D) Continue to refine the shapes of the various lines or curves.

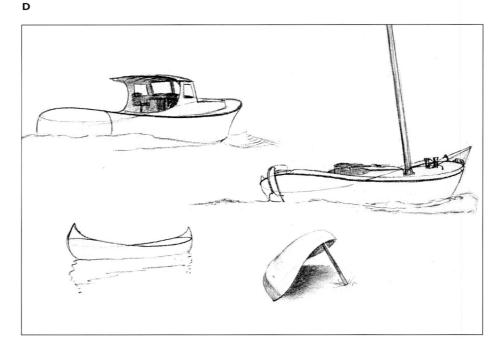

Here are more figure "8" boats.

HORIZON LINE

Perspective, when expressed accurately, shows our relation to what we observe and our position in the environment. With an understanding of perspective, only bare essentials need be shown to present a good, clear picture.

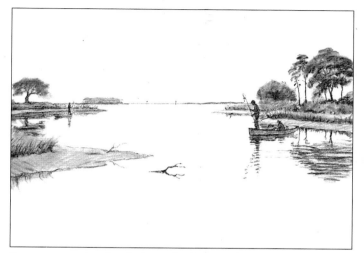

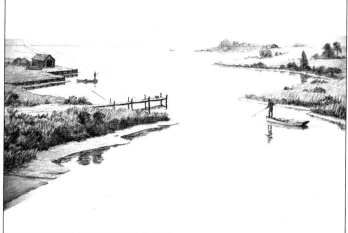

In representational paintings, the horizon line, seen or unseen, is essential to the placement of elements and objects. In this sketch of watermen in skiffs looking for crabs, the observer could also be a crabber, of about the same height as the men in the boats. We know this because the horizon line passes through the middle of both standing men's heads, and the horizon line is determined by the eye level of the observer.

In the tidewater regions of Maryland and Virginia, houses were built close to the water's edge. Rivers and creeks acted as roads and streets. Imagine yourself at a second-floor window in one of those houses making a sketch of the scene before you. The horizon is above the crabbers' heads and reveals that the height of the observer's eyes is about 21 to 22 feet (about 6.5m) above sea level. Here's how to arrive at that figure: 1-foot (30.5cm) height of boat deck + 5 feet (152.4cm) to the crabber's eye line above boat deck = 6 feet (182.9cm). Notice that it's about 3½ times that height from the boat's waterline to the horizon—hence, about 21 feet (6.4m). This would be the approximate height of the observer's eye above sea level. The distant crabber seems to be *relatively* closer to the horizon, but is proportionately the same distance from it.

LINE OF SIGHT TO PICTURE PLANE

The "picture plane" is an imaginary transparent surface at right angles to the observer's line of sight to the viewed object. Its angle controls the apparent size of an object and its reflection. Notice that the horizon line can be outside of the picture plane, which can be any height or width we choose to make it. The horizon line height is completely dependent on the eye height of the observer, and in composing a picture, the horizon line can be moved up or down to change the character and composition of the picture. The picture plane remains at right angles to the observer's line-of-sight to the center of the area to be pictured. Note that the picture plane is not necessarily parallel to vertical objects. And because of that, the reflection of the piling (which is an extension of the piling) is farther from the observer and thus appears to be smaller (shorter) on the picture plane surface.

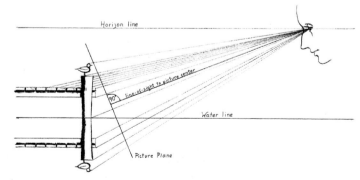

WATER SURFACE

It's important to understand the behaviors of these three types of water surfaces—calm, wavy and rough—because they affect the color of the water so much.

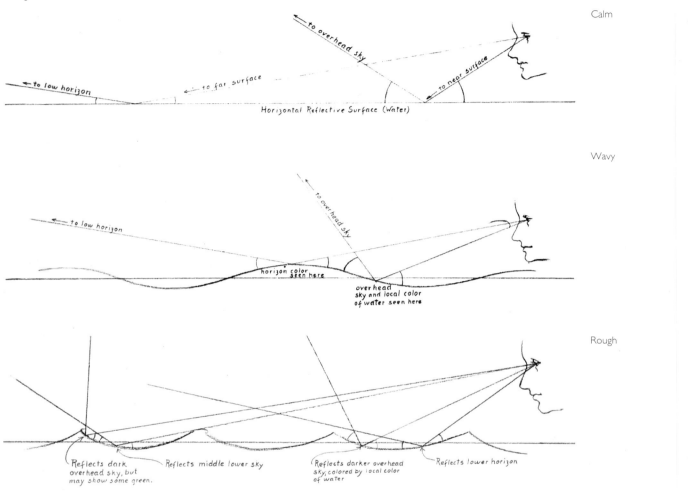

Calm

Wavy

Rough

WAVE SPACING

Wave spacing is important to the scale and depth of a painting. The larger the waves, the greater space each will occupy between the foreground and the horizon. This diagram shows a typical way to space waves. The space between the first and second wave is about one-third the total distance from the nearest crest (first wave) to the horizon. The space between the second and third wave is about one-third (or any fraction) the distance from the second wave to the horizon, and so on until the space is too small to measure. A confused sea can be portrayed by spacing the waves from two or more different points on the horizon.

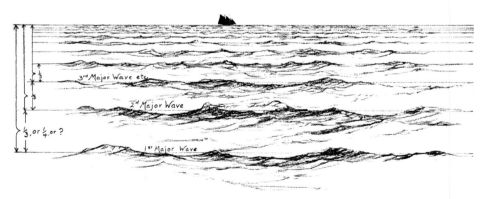

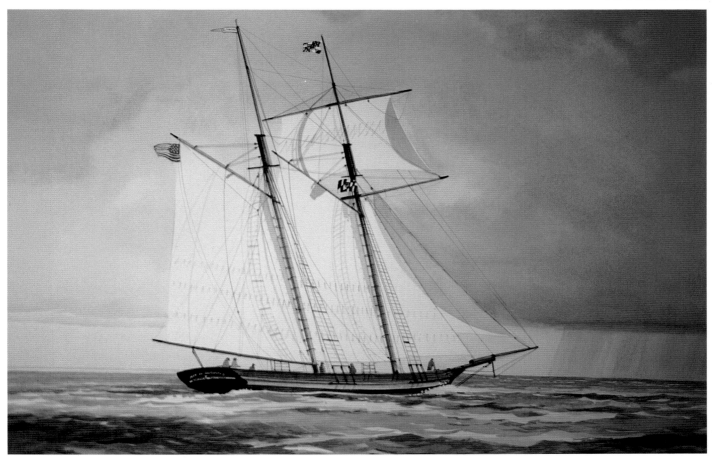

PRIDE OF BALTIMORE
22" × 30" (55.9cm × 76.2cm)
James Drake Iams, Watercolor

The water here shows a confused sea affected by storm winds blowing in several directions. This is seen both in the multidirectional waves and in the color changes where the water reflects the variations in the turbulent sky.

U.S. COAST GUARD CUTTER, ALEXANDER HAMILTON
22" × 30" (55.9cm × 76.cm)
James Drake Iams, Watercolor

Here the wavelengths from front to back nearly follow the idealized version in the diagram at left.

Drawing Sailboats in Action

YVES PARENT

You don't need to be a sailor to be a marine artist, but if you're not familiar with handling a sailboat, this lesson will help you avoid some common mistakes.

It's most important to determine *the direction* of the wind in your painting. It determines the profile and silhouette of the sailboats. To avoid mistakes, make an aerial sketch with the *position of the boats* and the *direction of the wind* noted, as well as *your location* in the scene (the point of view, position of your eye).

Wind Direction

Boat A takes the wind from the rear, so the sails are almost perpendicular to the wind. From where you are you see the full profile of the hull. One says the boat is *running*. **Boat B** receives the wind from the left side. The sails form an open angle with the wind (about 70 to 80 degrees). You see the boat coming and *her bow*. The boat is heeling on her *right side*; one says she is *reaching*. The boat always heels toward the same direction the wind blows. **Boat C** is *reaching*, too. Her course is perpendicular to the wind. The angle of the sails with the wind are more open. You see her *stern*. **Boat D** sails in the opposite direction but receives the wind from the same angle as Boat C. You see her *bow*. **Boat E** is sailing against the wind. Her angle to the wind cannot be smaller than 30 or 45 degrees. You see her heeling more than the others, and you just see her side opposite to the *wind*. **Boat F** is sailing with the same angle to the wind as Boat

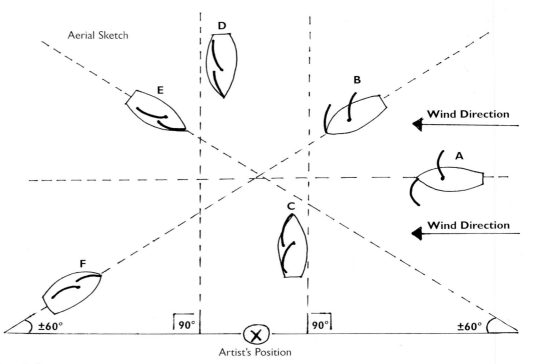

E. But you see the side that receives the wind. One says Boats E and F are *close-hauled*, which means that the angle of their sails is the closest to the wind direction. It is the way to sail against the wind. The boat's progress is made by the pressure of the wind on the sails. A sailboat *cannot* sail completely against the wind. Always remember that!

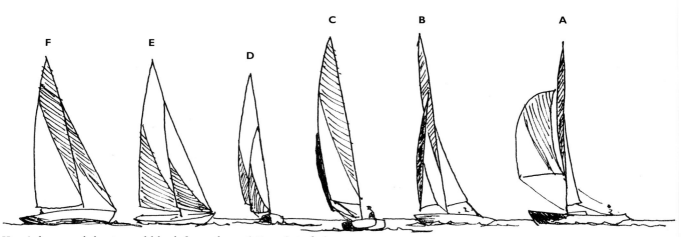

Here's how each boat would look from the artist's point of view.

EDGARTOWN, MASS.
25" × 40" (63.5cm × 101.6cm), Yves Parent, Watercolor

WIND DIRECTION

If there are several sailboats in your painting, always check that they are sailing properly, consistently with the wind direction. The direction of the wind affects the shape and direction of boats and sails and determines the shape and direction of the clouds, which give life and motion to your picture.

—YVES PARENT

The course of the boat at left is not shown exactly in the diagram at left, but it would fit in between Boat A and the dotted line below Boat A marking the 60-degree angle.

NEWPORT, CASTLEHILL
22" × 30" (55.9cm × 76.2cm), Yves Parent, Watercolor

This boat is on a course similar to Boat B in the diagram at left, but seen from the viewpoint directly opposite to the one in the diagram.

Sailboat in Action: Hull Angles

YVES PARENT

Painting a boat at her mooring is easy: The boat is basically all horizontals and verticals and is level with the waterline. Things are more difficult when the sailboat's in action: The power of the wind makes complex angles.

Drawing the sailboat with correct perspective is important; otherwise, the boat's lines will seem distorted. Though a sailboat's design is mostly curves, the underlying angles must be accurate. Avoid any major faults in perspective, such as the mast stepped away from the axis or the topsides not perpendicular to the yacht's beam. An easy way to avoid these problems is to enclose the hull in an easy-to-draw shape: *a simple box*. This will help you figure the proportions of the boat's hull.

The assignment here is to paint a *sailboat seen ¾ aft from leeward in a stiff breeze*. This is the most spectacular angle for sailboats, so it's important to know how to make it.

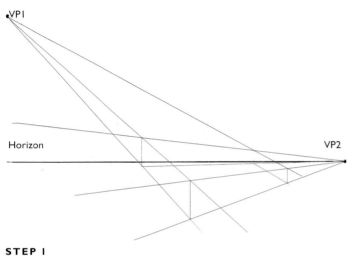

STEP 1

Draw the horizon line and two vanishing points (VP1 and VP2).

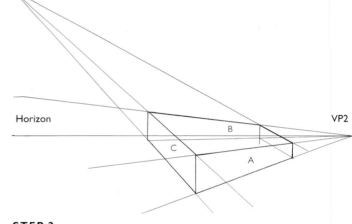

STEP 2

Using lines traced to your vanishing points, build a box for the sailboat's hull. Surface A is the side, B is the deck and C is the transom.

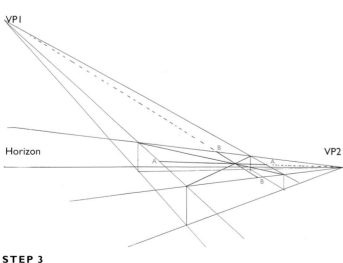

STEP 3

Once the box is built, determine the boat's center axes by using diagonals.

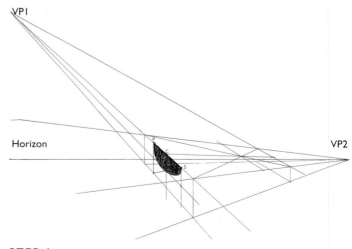

STEP 4

Determine the shape and line of the transom. Line C shows the axis of the transom (S = starboard, P = port). Then draw the shape of the transom, adding appropriate curves.

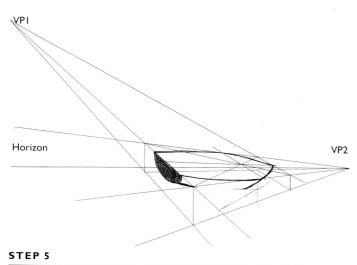

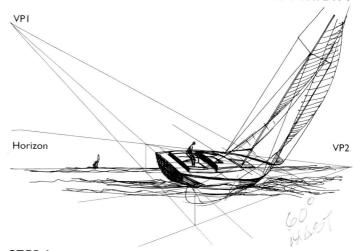

STEP 5

Once the transom is built, you can add the deck line and hull's line using the planes and center axes you have already created.

STEP 6

All that's left is to add detail. Be sure to keep the mast perpendicular to the deck and located at the point where the length/width axes of the hull meet.

OLD SAYBROOK: BREAKWATER
25″ × 20″ (63.5cm × 50.8cm)
Yves Parent, Watercolor
This sailboat is nearly exactly at the same angle as the example in the demonstration.

Capturing Light in Pen and Ink

MARC CASTELLI

Light is an essential component to any outdoor painting—especially when water is involved. Drawing with black and white is a good way to challenge and train your eye to see tonal value.

HAULED AT COCKEY'S, TILGHMAN CREEK
4"×6" (10.2cm×15.2cm), Marc Castelli, Pen and Ink

Not many marine railways are left on the Eastern Shore. A workboat was hauled out for maintenance on this one. I liked the dark interior of the shed framing the opening with the boat centered. So much light streamed between the boards that to do the planks in flat black set up too much contrast. Groups of lines oriented to different directions indicate different surfaces without overworking the areas.

One bright but foggy morning, I raced out to a favorite work dock to draw the boats as the fog burned off. What wonderful light! A minimum of line work keeps the light bright. Using stippling for the opposite shore softens the background without sacrificing light. The darker pilings in the foreground anchor the larger surfaces of water and the planes of the nearest boat. More ripples drawn on the water, would have reduced the light.

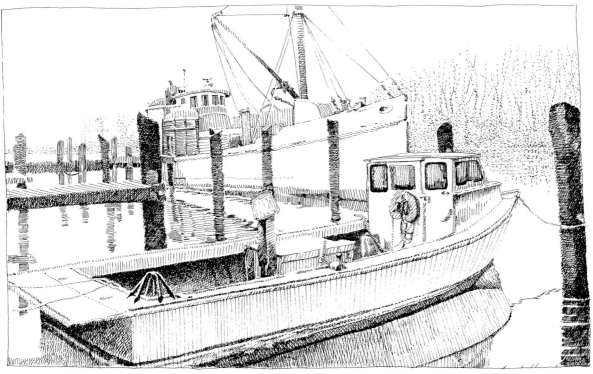

BUY BOAT, J.C. DREWER @ LONG COVE
5"×8" (12.7cm×20.3), Marc Castelli, Pen and Ink

Understand Details by Drawing Them

MARC CASTELLI

A seventeenth-century collector of Rembrandt drawings called them "thoughts" and they were highly prized. It's the quickness and immediacy of drawing that delights the eye in studies of details. The next four drawings are such studies. In order to draw and paint boats convincingly, study, read, photograph, sketch and carefully render them, in parts or in total, up close and far away. This intimacy over time will bring a "ring of truth" to your work and eliminate any nagging doubts of incompleteness. Focusing on small details gives you confidence, even when painting a larger view. Try making a list of each component of a boat you are unsure about, and then devote a sketchbook to drawing each one in detail until you understand it.

JIB SECURED—ISLAND BIRD
4½" × 6" (11.4cm × 15.2cm), Marc Castelli, Pen and Ink

This drawing, despite its near abstraction, is a very detailed rendering of a flaked jib secured by a sail stop to its boom tied alongside the bowsprit of a racing log canoe.

BOARD BOX—
AFT END—
STARBOARD
*4¾" × 6½"
(12.1cm × 16.5cm)
Marc Castelli
Pen and Ink*

This study is of a racing log canoe, Island Bird; she is 114 years old. The board box is a boxlike affair, open at the top to allow the centerboard to be raised when necessary. I liked the contrasting textures of sail, rough wood of the box and smoothness of the board. Using different directions of lines serves to emphasize the different shapes.

MORE DETAILS

UNTITLED
4" × 6½" (10.2cm × 16.5cm)
Marc Castelli, Pen and Ink

This is also a study of the centerboard, focusing on three elements—the sail, centerboard and box. The centerboard occupies a majority of the space. A stainless steel handle to raise and lower the centerboard offers highlights and reflective surfaces. Again, the rule is how much can you get away with by using the minimum of technique. Making each stroke serve as many functions as possible keeps the drawing bright and not overworked.

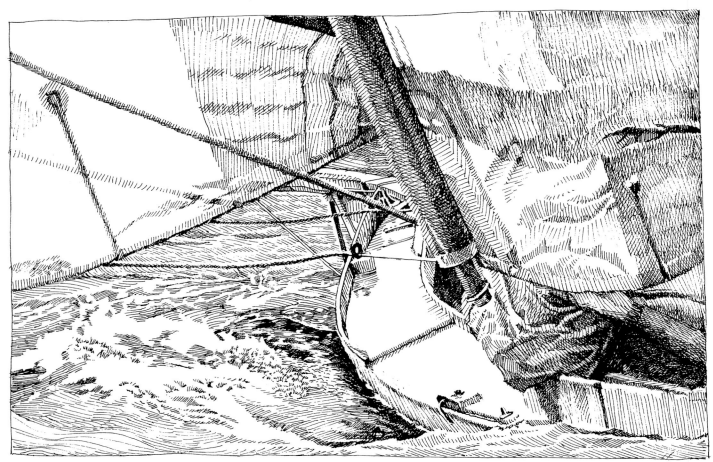

ISLAND BIRD ON THE WING
4½" × 7" (11.4cm × 17.8cm)
Marc Castelli, Pen and Ink

This drawing called for fluid lines building water surfaces in a contour maplike arrangement. The edges are the focus. There weren't many bright areas, but there were many opportunities for multifunctional groupings of lines. In these near abstractions, it's easy to lose shapes. Planes of one linear direction must be played against others. Rather than totally blackening your darkest value, try building layers of fine lines. This way you can maintain control and keep from overworking an area.

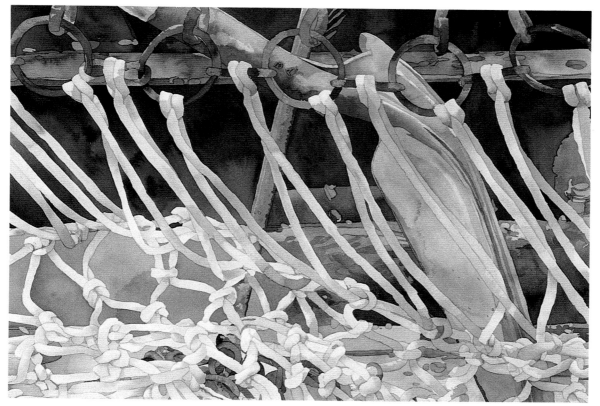

Abstract details make interesting paintings too. This watercolor is about the net bag part of an oyster dredge used on a skipjack. I liked the rhythm of repeated shapes, the spaces between the lines, the function implied by the shovel, the contrast of metal and cordage. All of these speak about a time-honored, yearly repeated labor.

OYSTER MACRAME, *22″ × 30″, (55.9cm × 76.2cm), Marc Castelli, Watercolor*

Nothing cosmic here, no deep message, just an effort to record the cold light reflected on the fish, made humorous by the repeated eyes. I could have composed the image solely of fish, but I chose to contain the action by including the hard-line geometry of the box. There is no sport here, just honest hard work. The boats and watermen are implied by the subject.

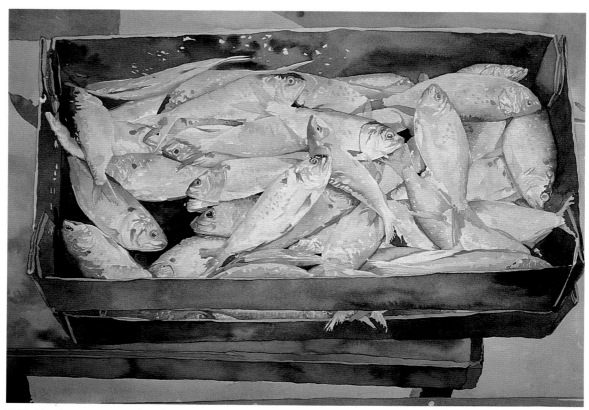

THE AYES HAVE IT, *22″ × 30″ (55.9cm × 76.2cm), Marc Castelli, Watercolor*

Sketchin' on the Dock o' the Bay

GEORGE F. McWILLIAMS

To complete a finished drawing like the ones below, McWilliams sketches and photographs on site and then completes a finished drawing in the studio. He uses three basic pencil densities: 2B, HB and B. All tones are accomplished with the point of the pencil through cross-hatching and other strokes. He uses no burnishing or rubbing.

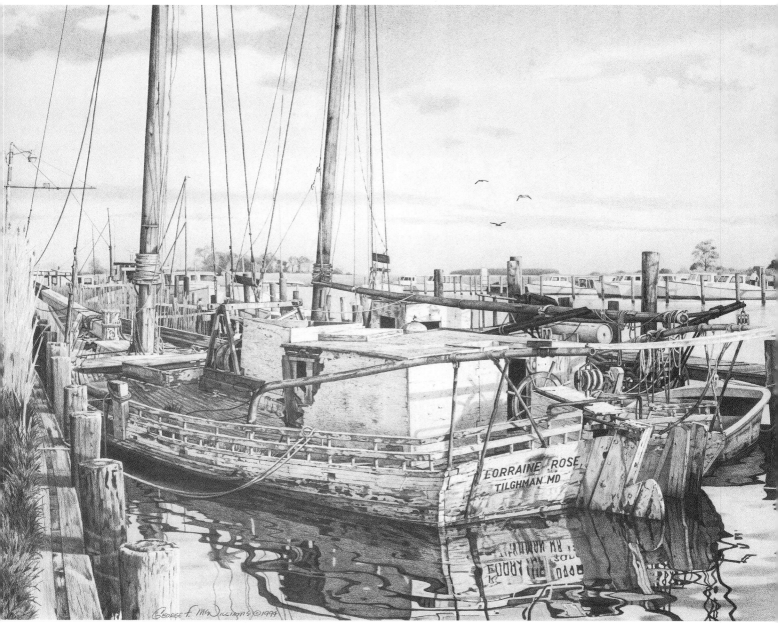

BETTER DAYS PAST
12" × 15½" (30.5cm × 39.4cm)
George F. McWilliams, Pencil on Bristol Board

These two abandoned boats had been lying up on shore at Knapps Narrows on Tilghman Island, Maryland, for as long as the artist can remember. The *Lorraine Rose* is circa 1949.

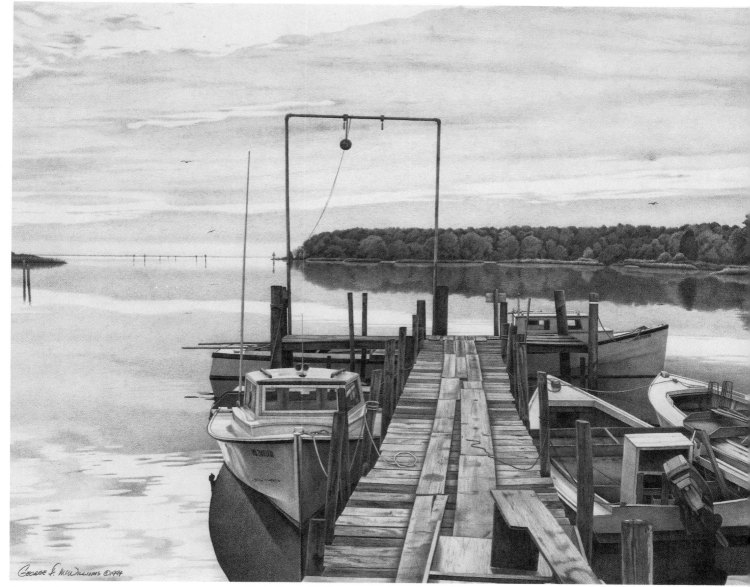

DAY OFF
12" × 15½" (30.5cm × 39.4cm)
George F. McWilliams, Pencil on Bristol Board

This pier, which was wiped out by a 1996 hurricane, is seen from the back door of Thompson's Seafood, where the artist has enjoyed fresh oysters and crabs brought right in off the boat at this location. It's at St. Patrick's Creek in Abell, Maryland. The technique is the same as in *Better Days Past*.

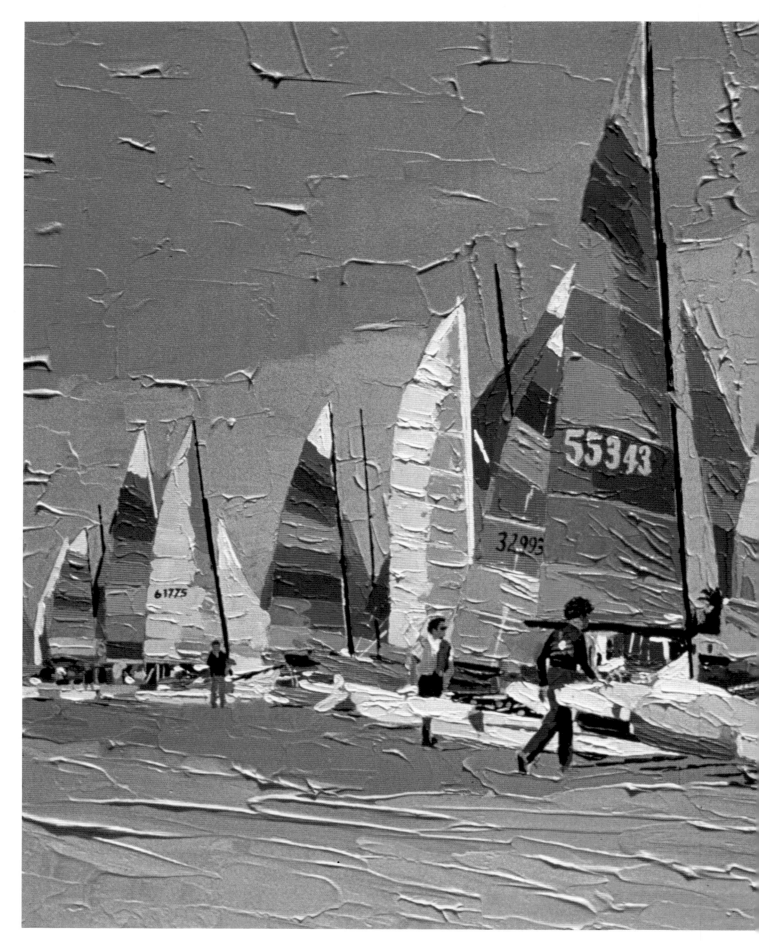

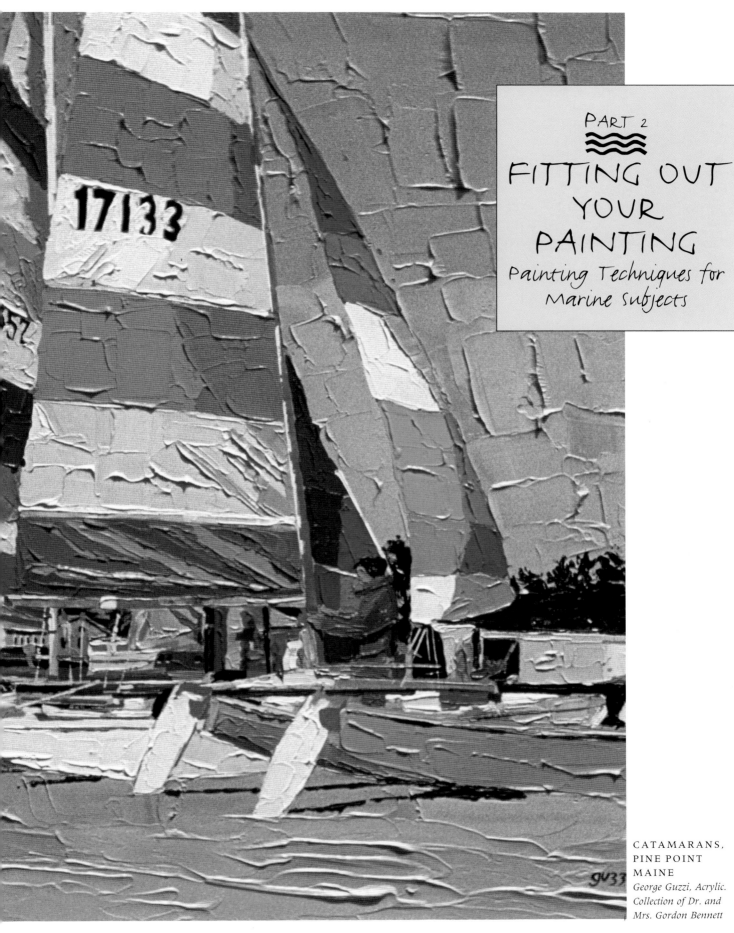

FITTING OUT YOUR PAINTING
Painting Techniques for Marine Subjects

CATAMARANS, PINE POINT MAINE
George Guzzi, Acrylic. Collection of Dr. and Mrs. Gordon Bennett

Two Watercolor Skies

JAMES DRAKE IAMS

The sky sets the mood of the marine painting and establishes the time of day, the conditions (whether bright and clear or overcast, calm or blustery), possibly even the time of the year. It's a defining aspect of the finished work. Visualize the sky as a glass dome or ceiling. Generally, the lower part—at the horizon—is relatively pale, and the higher the sky goes, the more intense the colors become. Distant clouds are soft, and as they come nearer and higher, they become stronger and more defined.

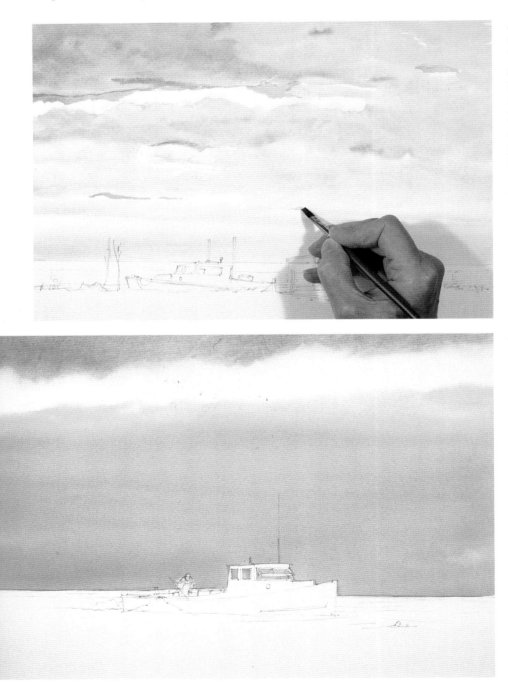

An Overcast Day— Clouds Breaking Up

Use 140-lb. hot-press paper. Wet the entire sky area with a 2-inch nylon brush. Work briskly, taking care that there are no puddles. Use a mixture of Gamboge and Cerulean Blue, just a tint, at the horizon line and work up. Then, continuing up the page, add some Payne's Gray, then a little more, and so on, so the sky becomes stronger toward the top, all the time leaving white areas of the paper to form the clouds. When the paper is dry, use a ¼-inch single-stroke flat brush to introduce some straight Cerulean Blue to show where the clear sky breaks through the clouds.

Threatening Sky

This watercolor, on hot-press paper, shows a workboat with a waterman working his trotline, and a storm front moving in. Use Payne's Gray for the threatening sky, working from the horizon up. The storm here is several miles away, so keep the color flat. Make the sky darker on the horizon and gradually a bit lighter as you paint upward. Then show the white top of the rain cloud and above it, Cerulean Blue for the clear sky.

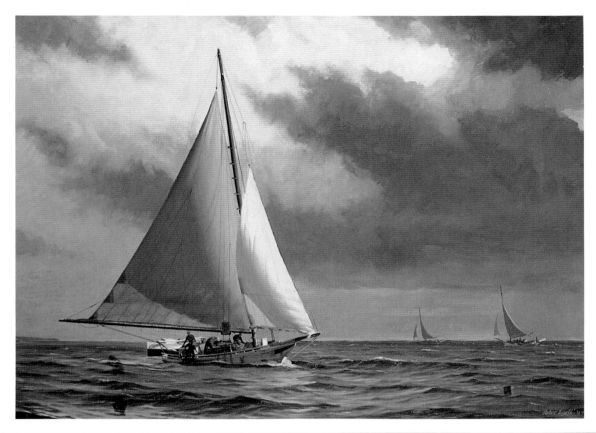

SIGSBEE MAKES
A LICK
24" × 32"
(61.0cm × 81.3cm)
Peter Egeli, Oil

This threatening
sky is similar to the
simplified one on
page 26, showing
just a little blue sky
at the top.

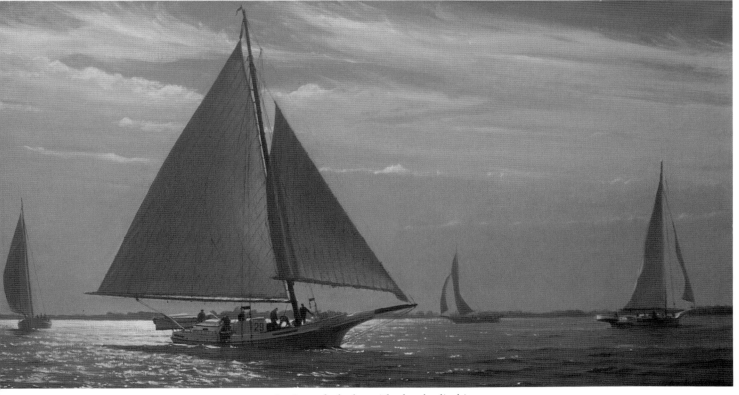

SLOOP *REBECCA T. ROARK*
26" × 40" (66.0cm × 101.6cm), Peter Egeli, Oil

Again, a dark sky with clouds climbing
from the horizon nearly to the top of the
painting. This time, a night scene—and not
as stormy.

Painting Cumulus Cloud Formations

LEONARD MIZEREK, WATERCOLOR

When it comes to skies, things happen quickly. Because you're working with a series of washes—some overlapping, some blending—you need to be bold. Beginning with the sky allows you to try different treatments and minimize worry about ruining a good painting. If it doesn't work, just start over.

To paint a cumulus cloud formation, start with a large flat brush that will complete a wash without drying or running out of color.

Keep a photo reference file with a variety of cloud formations to consider.

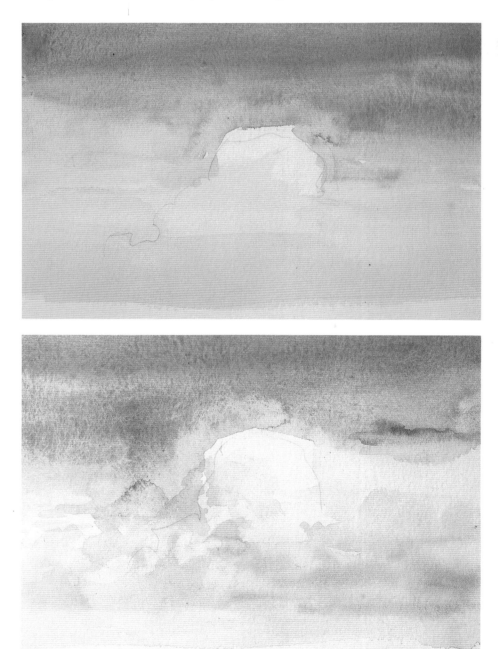

STEP 1

Before painting, sketch a rough outline of desirable shapes. Using a combination of Cobalt Blue and Ultramarine Blue, load your brush with paint. Make sure you have enough paint on the palette so you don't run out. The color should be stronger at the top and lighten as it goes down. To do this, mix a strong color and, starting at the top on dry paper, overlap broad strokes, adding more water as you work down. After that dries, apply Aureolin Yellow, which has a good transparent quality, while the blue mixture is still wet. Let it blend with the blue. Be sure to paint around the cloud areas that you want to remain white. This gives a hard edge at the top edge of the cloud formation. Moving quickly, apply a bottom layer of diluted Alizarin Crimson.

STEP 2

While the paper is still wet, create the bottoms of the cloud using Ultramarine Blue and Alizarin Crimson to give a light purple tint. A no. 6 round sable is good for this. The edges become soft after you apply the color. Still working wet on wet, add Aureolin Yellow with Alizarin Crimson to warm up the center of the clouds and create new formations over the existing larger clouds. Use a paper towel to lift some color to make lighter cloud areas. Now let everything dry.

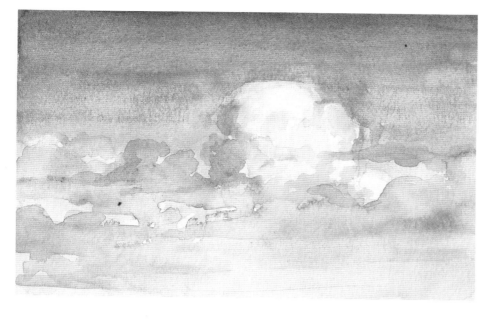

STEP 3

At this stage, add shadow areas on the sides to give dimension and form to the cloud shapes. Darken and overlap more clouds using horizontal strokes to create the feeling of depth. You can add more cloud bottom shapes and lighten the clouds as they recede.

DIRECT THE EYE
WITH CLOUDS

Cloud formations can be used in a painting to direct the viewer to the focal point or to balance your composition. Let a sky set the mood, atmosphere, time of day or season.

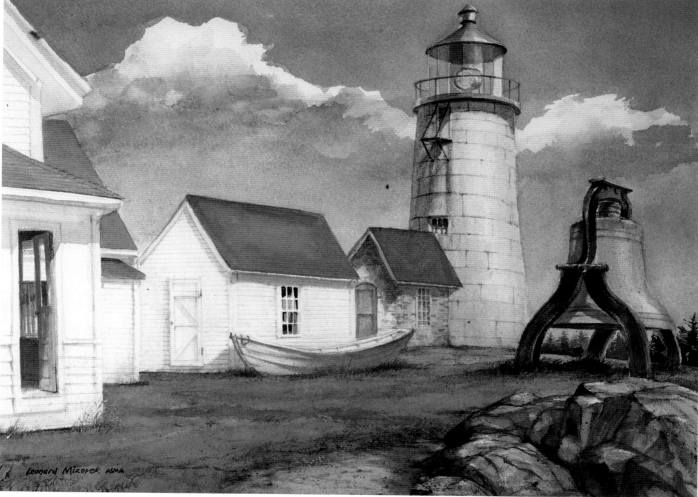

MONHEGAN LIGHT
11" × 15" (27.9cm × 38.1cm)
Leonard Mizerek, Watercolor

I sometimes use clouds as a directional device to fill a void in a sky. In *Monhegan Light*, I used cumulus clouds to help fill the area between the buildings and connect my shapes. The painting was too broken up without the addition of these clouds. Even though there were no clouds, I invented some to do the job.

Painting Cirrostratus Clouds

YVES PARENT, WATERCOLOR

Cirrostratus clouds are not as dramatic as cumulus clouds in shape or contrast. You can design a good background with them because they provide color and interest while remaining subordinate to the main boat subject. Use the shape of the cloud to direct your viewer to the action.

STEP 1

Apply a layer of well-diluted Light Oxide Red with a large brush.

STEP 2

Before the first layer dries, apply loose strokes of very diluted Phthalo Blue. Dry a little with a hairdryer.

STEP 3

Then, with a rigger, build the cirrostratus clouds, giving them the direction of the wind. Use a mix of well-diluted Phthalo Blue and crimson to color the clouds. The strokes must be light and delicate.

Use Cirrostratus Clouds as a Background

YVES PARENT, WATERCOLOR

Over the last fifteen years, Parent has made hundreds of sketches from the water, an angle people seldom see unless they're boating. As a marine artist and a sailor, he tries to paint scenes that will interest people who sail, trying to rebuild scenes they have already enjoyed while sailing, but also appealing to nonboaters. The play of light on the water attracts people; it's an open door to dreams, escape and imagination.

To start a painting, he refers to one of his sketches. Once he's decided on a scene, he develops several thumbnail-size sketches in the same proportion as the painting he wants to make. He also decides on a foreground subject. This gives perspective, deepness and a feeling of space to the painting. For a marine scene, this can be a boat, a dock, a bird, someone rowing a small boat, etc. The small sketch is important. It gives you a vision of the final picture and will be your guide while painting.

Colors:
Alizarin
 Crimson
Bluish Green
Cadmium
 Yellow
Indigo
Light English
 Red
Light
 Ultramarine
 Blue
Oxide Red
Oxide Yellow
Rembrandt Blue
Terre Verte
Warm Sepia

STEP I

Draw and Mask

After making the thumbnail sketch, begin to draw. Always use a good paper. I usually paint on Arches 260-lb. cold-press paper. Remember that an accurate drawing is the key to correct work. Don't hesitate to spend more time than you expected on drawing. It'll make everything easier later, permitting you to concentrate on brushstrokes.

Save time by using masking liquid to cover details you want to keep white. This allows you to work on the sky and water with more freedom. Mask the boats and certain features of the background as shown here.

TIP FROM A PRO

MASKING FLUID

Don't overuse masking liquid, or your painting will look artificial. Use it for lines, sails, hulls, masts, steeples—anything you want to keep sharp. Immediately rinse your brush with soap and water. Masking liquid quickly ruins brushes.

—YVES PARENT

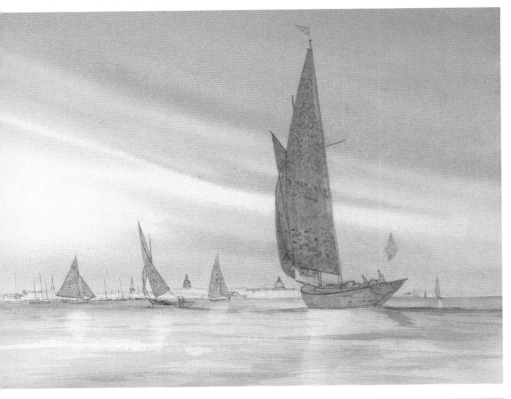

STEP 2

First Washes: Sky and Water

Before applying any colors, lightly soak the surface of the paper with a sponge. The paper must be damp, not wet. Paint the sky first. Start the first layer with a combination of reds. Use the same color and tone for the water as you did for the sky. Water reflects the sky, the clouds, the sun and the shoreline.

Paint the second layer on both sky and water while the first layer is still wet but not soaked. For this layer, use blues. For a cooler sky, use more Ultramarine; for a warmer sky, more Phthalo Blue.

Work quickly. Make large brushstrokes with a 1-inch brush, controlling the water in your brush with a piece of paper towel, if necessary. Keep the brushstrokes in the direction of the wind. *Don't paint* in the opposite direction. Remember the sky is an important part of your composition.

STEP 3

Adding the Third Primary—Glazing

Until now, you've used only two primary colors. The result gives a good feeling of evening light but lacks luminosity. To obtain a natural luminosity, the painting needs yellow as well. "Glazing" is used to keep the necessary transparency of light.

Glazing is risky, because it consists of overpainting the whole painting with a diluted coat of yellow. Work fast so the yellow doesn't infiltrate the former layers and mix with them! Your paper must be dry. Use Cadmium Yellow, very diluted. If you want a warmer tone, use Oxide Yellow or Gamboge. Yellow must be used carefully or you risk a too-greenish sky.

Now apply a first layer of Oxide Red for the brick buildings of Annapolis. For the first layer of the foliage, use a diluted Oxide Yellow. Paint the other buildings. Use Warm Sepia or Oxide Brown to build the waterfront and mark the separation between the water and the shore. When the last layer of the background is finished, wait for the paper to dry and then remove the masking gum.

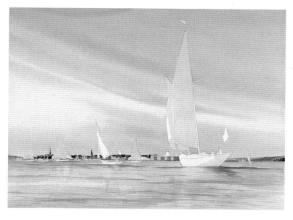

STEP 4

More Foreground Layers

Apply a second series of layers on the foreground to control the balance between the darks and the lights. Darken the sails with Oxide Yellow. Develop the shadows on the schooner's hull and the buildings with a layer of Light Ultramarine and Crimson.

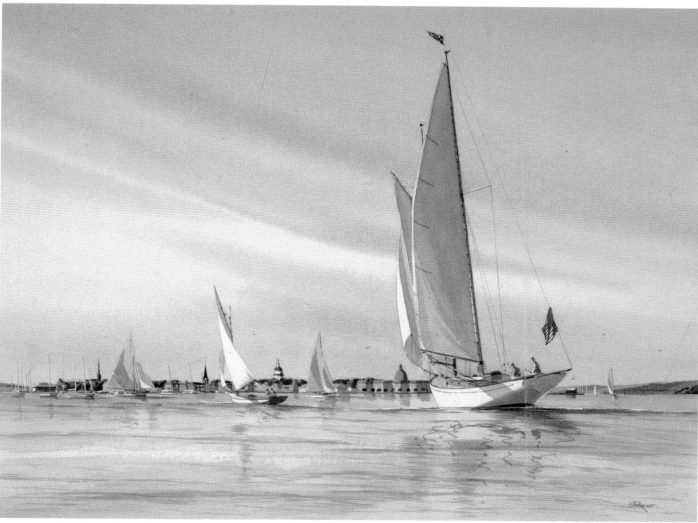

ANNAPOLIS, LATE AFTERNOON
18" × 24" (45.7cm × 61cm)
Yves Parent, Watercolor

STEP 5

Finish

Darken the sails until the schooner stands out against the background, to give the feeling of distance, space and perspective. Suggest details in the foreground to emphasize the main subject. Remember: dark against light and warm against cool. While the shadows on the sails are drying, suggest details on them with a small brush or a rigger.

Paint the flags with their shadows, the rigging and the masts as simply as you can. Draw with your small brush. To give more life and sparkle, add small dots of blue, red and yellow on the background and scratch the paper with a sharp instrument where you want to suggest glints of light.

Reflections

JAMES DRAKE IAMS

Think for a moment about images you see in a mirror. If you look directly at a mirror on the wall—a vertical mirror—you'll see yourself. Your image bounces directly back from the reflective surface. Now picture the mirror lying on the floor. When you look at it, you don't see yourself, but rather the mirror image of whatever is beyond it. This phenomenon is like reflections you see on water.

When water is calm and its surface is glassy smooth, it's a remarkably good mirror. But if there's the slightest movement of waves, the reflection is interrupted. A four-year-old boy once said, on seeing a choppy sea, "I don't want to go in the water; it has too many creases." Broken water interrupts the reflection, making it appear to be in stripes. Really rough water provides little reflection; sometimes there will be no reflection at all. You must look carefully and observe.

Influence of Light

These two examples show the influence of light on reflections. The subject is a Chesapeake Bay waterman's workboat. In the first example (A), the sun is shining on the hull. This lights up the hull, and the reflection is as bright as the hull itself. When the hull is in shadow, as in the second example (B), the reflection is dark, often darker than the color on the hull. In both instances, notice that the reflections are not simple upside-down duplications of the workboat. The quiet movement of the water creates subtle crests and troughs of miniature waves, and only part of each "wave" reflects the image back to the viewer.

Like shadows, reflections in watercolor should be transparent. If they're opaque, they resemble cut paper. Unlike shadows, however, reflections always come directly toward you, regardless of where the light is coming from. As we see in these examples, the light on the hull affects the character of the reflection, but not its position.

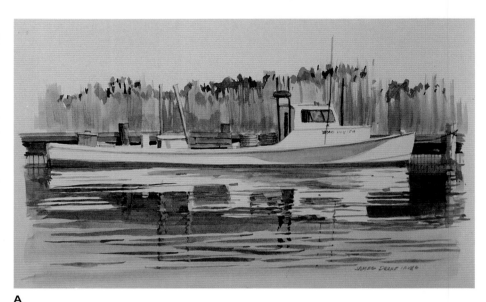

A

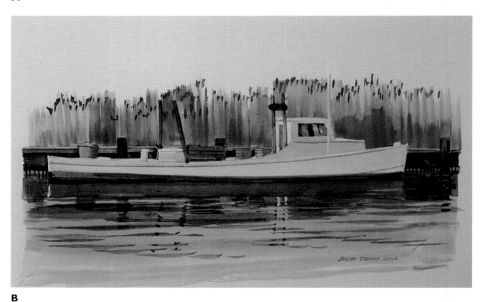

B

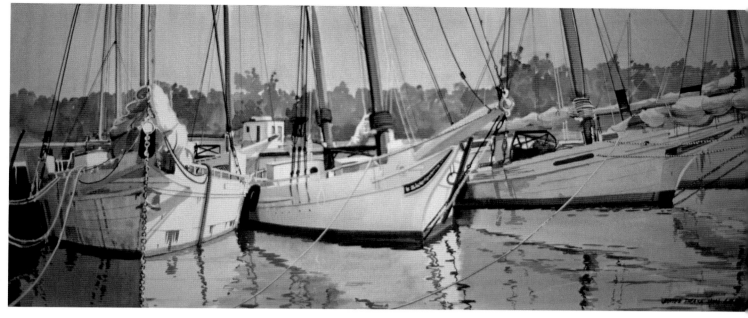

DOGWOOD COVE
14″ × 30″ (35.6cm × 76.2cm)
James Drake Iams, Watercolor

This painting shows reflections on almost still water. In between the reflections of the skipjacks, the blue sky reflects brightly, telling us of the good weather even more clearly than the bit of sky we actually see. Notice that the chain (support for bowsprit) on the left-hand boat, because it's vertical to the eye of the viewer, reflects in a direct straight line, with almost no distinction between object and reflection. However, be careful to get the angle of reflection right for linear objects that appear at an angle, such as the wood moldings on the same boat. The direction of the angle will always reverse in the reflection.

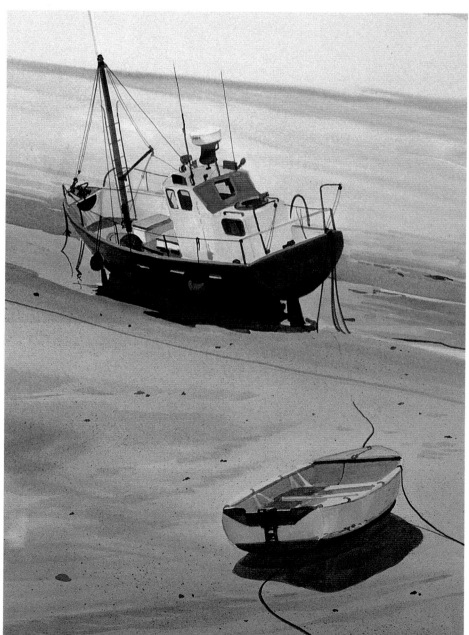

HIGH AND DRY
22″ × 15″ (55.9cm × 38.1cm)
James Drake Iams, Watercolor

Here's an interesting comparison of shadows and reflections. The small dinghy at lower right is casting a shadow on the sand. The larger boat is reflecting in the pool of water, as well as casting a dark shadow directly beneath the hull.

Building Water in Layers

JAMES DRAKE IAMS, WATERCOLOR

Early Morning Arrival is a composite of a tug from a previous sketch and a freighter from a photograph in the artist's file. The paper is a 14″ × 20″ (35.6cm × 50.8cm) block of 140-lb. Lanaquarelle, cold-press. The dark red of the tug is Deep Vermilion and sepia.

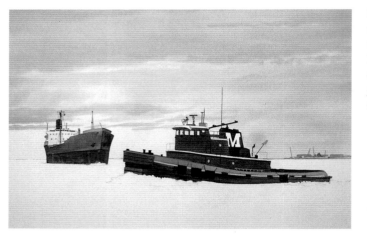

Paint in the sky and the main colors on the tug and tanker, keeping the colors on the tug strong to give it weight and strength.

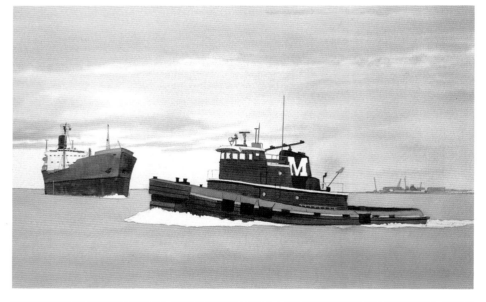

Water Layer One: Lightest Value

Water reflects what is above it, in this case a cloudy sky. Paint the first layer, the lightest color of the water, using a 1-inch flat brush and neutral tint. The trough of the wave is the lightest part of the wave.

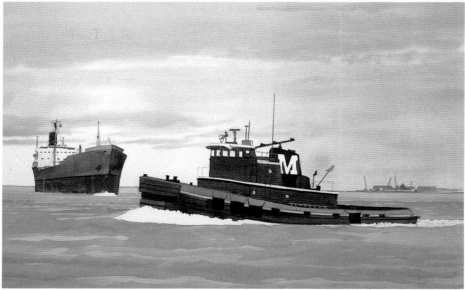

Water Layer Two: Form

It's the second layer, or coat, that begins to give form to the waves. You must first determine the direction from which the waves are coming. They usually come from the direction of the wind. In this composition, I determined that the waves were from the southeast, coming from the direction of the incoming freighter.

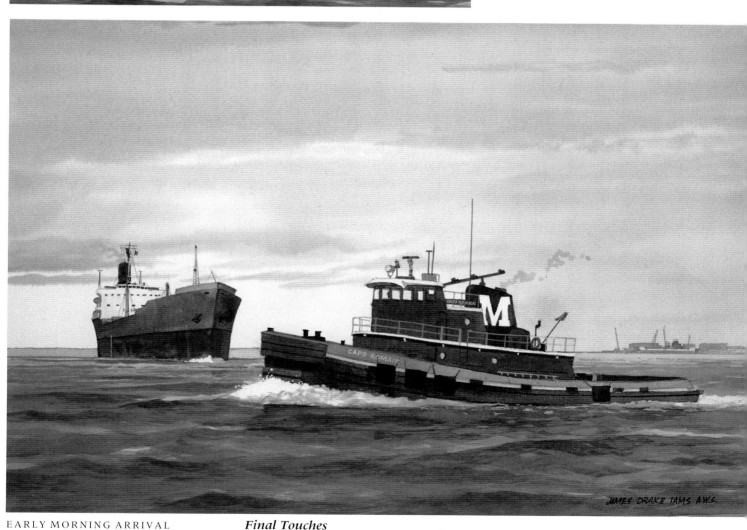

Water Layer Three: Height
Use Cobalt Blue and Ivory Black to build the height of the waves. The top of the wave is the darkest in value. It's important, in layering, to continue with the same colors you begin with. Darken the top of the waves and pull them together so each wave appears to roll into the one in front. Water is heavy and should look so. I indicated some reflection from the tug in this painting, but there usually aren't many discernible reflections in broken water.

EARLY MORNING ARRIVAL
14" × 20" (35.6cm × 50.8cm)
James Drake Iams, Watercolor

Final Touches
Using Opaque White mixed with a little Ivory Black, add the rails, the name of the tug and some foam formed by the bow wash as the tug moves forward. Add deck lights, the stern flag and the life ring.

Painting Rigging

JAMES DRAKE IAMS

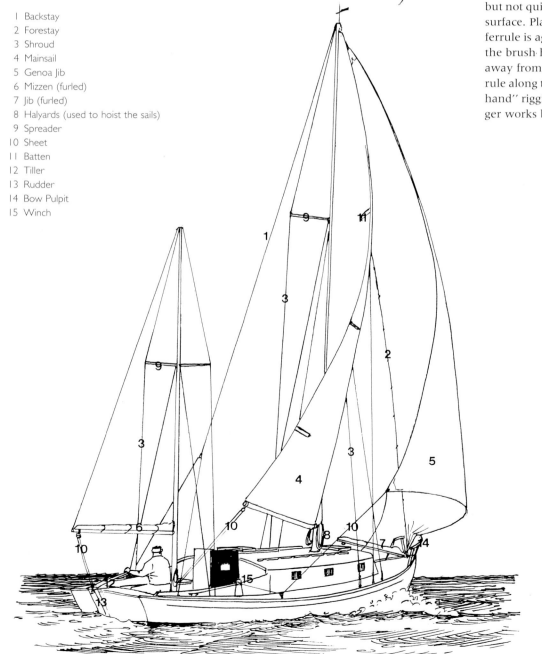

Painting the rigging on a sailing ship should be done freehand as often as possible. An absolutely straight line can look stiff and artificial. Wind and the action of a ship in rolling seas produce movement in the running rigging, sheets and halyards. On the lee side of a ship, the shrouds will be lax, whereas on the windward side, they will be taut.

1 Backstay
2 Forestay
3 Shroud
4 Mainsail
5 Genoa Jib
6 Mizzen (furled)
7 Jib (furled)
8 Halyards (used to hoist the sails)
9 Spreader
10 Sheet
11 Batten
12 Tiller
13 Rudder
14 Bow Pulpit
15 Winch

Painting a freehand straight line, using a ruler as a guide but not as a straightedge, is easy. Tilt the ruler up so that it is almost, but not quite, perpendicular to the painted surface. Place the brush so that the metal ferrule is against the edge of the ruler, but the brush hairs are about an inch or so away from the ruler. Move the brush ferrule along the ruler edge for straight ''freehand'' rigging. A small round brush or rigger works best.

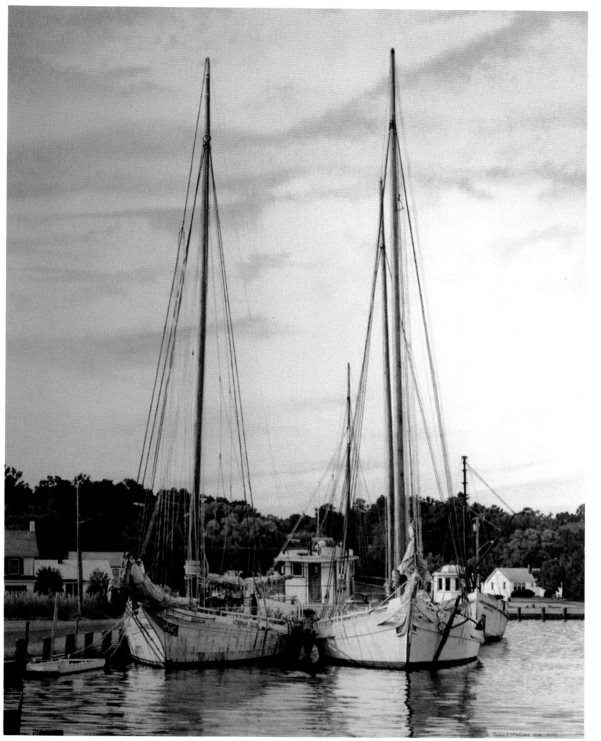

CHESAPEAKE HERITAGE
21"×27" (53.3cm×68.6cm), George F. McWilliams, Watercolor

Painting Rust on Painted Wood

GEORGE F. McWILLIAMS, WATERCOLOR

The boat in this demonstration is a "Box-Stern Dory" developed on the Potomac River.

STEP 1

Sketch in the boat and then do all the basic shading. Note where the rust patterns will go with light pencil marks. Erase the pencil later. Save darker parts like the waterline for later because dark colors are more apt to run when washed over.

STEP 2

Lightly paint details such as cracks in boards, peeling paint, etc. To start the rust wet the area and build the color lightly. Don't overwet. If the paper begins to dry, let it dry completely before applying another wash. The water will push the paint.

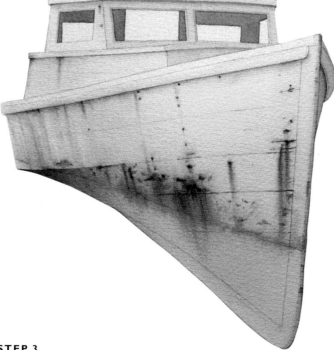

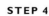

STEP 3

Continue to build the color slowly from light to dark in the following sequence:
1. Yellow Ochre and Cadmium Orange. Use the direction of the streaks of rust to accentuate the shape of the boat.
2. Burnt Sienna, Cadmium Orange.
3. Burnt Sienna, Brown Madder, Sepia.
4. Save the darkest color to show just where the source of the rust is, such as nails or cracks.

STEP 4

Now you can put in the waterline color and other darker areas, such as the gunwales and cabin. Make sure to continue the rust over the waterline color. After it's completely dry, erase the pencil lines using a soft eraser.

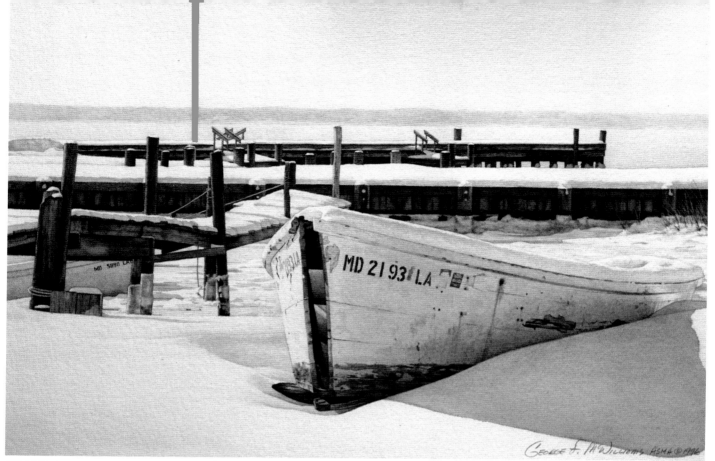

SNOWBOUND
8" × 12" (20.3cm × 30.5cm)
George F. McWilliams, Watercolor

The darkest part of the rust is at its origin, such as where it seeps out from the nail heads.

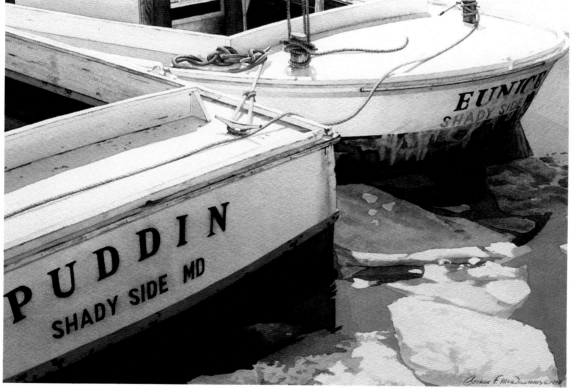

PUDDIN AND EUNICE
11" × 19" (27.9cm × 48.3cm)
George F. McWilliams, Watercolor

Keep the color value light for rust that is just starting on newer boats.

Painting Sand Textures

LOIS SALMON TOOLE, WATERCOLOR

Many coastal scenes include an up-close view of the beach. Here is a way to paint sand texture, based on sand at Sandy Hook Beach.

STEP 1

Mask out a shell shape and a few whites. Wet the paper and lay in soft undulations with very dilute Yellow Ochre. When dry, use a fine toothbrush to pick up slightly diluted Yellow Ochre, and with your forefinger, spatter a grainy texture following the vague color patterns.

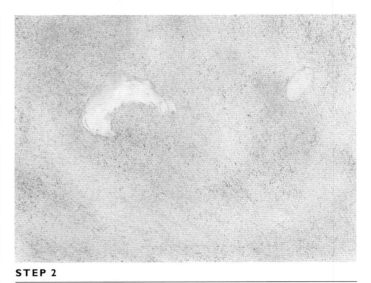

STEP 2

Next, spatter Burnt Sienna. Easy does it. Less is better. You can blot the excess with a tissue, or once the paint dries, gently wet an overdose and blot with a paper towel. The earth colors and transparents here are relatively easy to lift.

STEP 3

Now, splatter Olive Green to build shadows. Sometimes I precede green with a soft brown. Cut or tear shapes from a paper towel to cover areas where you want to preserve highlights. Do this judiciously. Reposition the shapes as you go, letting some spattering soften the edges to avoid an artificial look. Keep in mind that sand is soft and shifting.

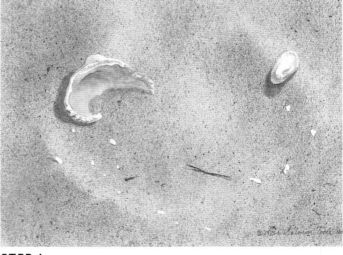

STEP 4

Keep building contours using Cobalt Blue. Concentrate spattering on the shadow sides using smooth, gradual transitions. If necessary, lift excess pigment or add some with the point of a round brush. Use a coarser toothbrush to randomly scatter softened Sepia followed by Cadmium Red. With a gum eraser, uncover the whites and sketch in the shell and pebble for contrast using Cobalt Blue, Alizarin Crimson and Cadmium Orange. Shadows are Cobalt Blue with Cadmium Orange for reflected light.

Painting Grasses in Sand

LOIS SALMON TOOLE, WATERCOLOR

Colors:
Alizarin
 Crimson
Antwerp or
 Ultramarine
 Blue
Aureolin Yellow
Burnt Sienna
Cadmium
 Yellow
Cobalt Blue
Viridian
Winsor Blue
Yellow Ochre

Materials:
140-lb. Arches
 cold-press
 rag paper
1-inch flat brush
no. 6, no. 8, no.
 10 rounds

STEP 1

Sand Base

The focus here is a single clump of grass. Quickly lay in circular sand patterns (not textures) suggesting rises and valleys over which you'll contour shadows later. Paint the first couple of blades in one upward sweep using a no. 10 brush, starting with Yellow Ochre at the base, bringing in Viridian on the upward stroke as you taper to the tip. While still wet, bring in more Viridian and then some Burnt Sienna. Mask out white or light areas to be highlighted against the darks later.

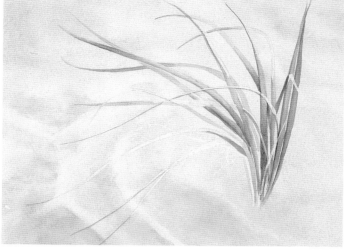

STEP 2

Lay in Blades of Grass

With a no. 6 or no. 8 round and a wash of Viridian, lay in most of the blades of grass, each with one long basic stroke blending the greens to indicate curve and highlights. More shading will come later. Complete the shadows on the sand in one continuous step, right over the masked areas.

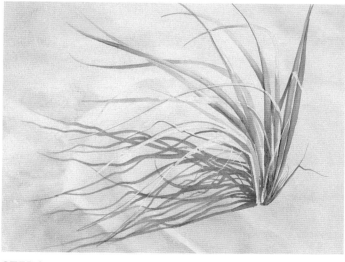

STEP 3

Shadow Patterns

Always keep the source of light in mind. Lay shadow lines in lightly with a Cobalt Blue mix, following the contour of the sand. Darken the shadows with more cobalt adding a little Alizarin Crimson at the base. Shadows are darker where they originate at the base, tapering and fading off at the end. The shadows are continuous, blending into one another. When dry, remove the masking.

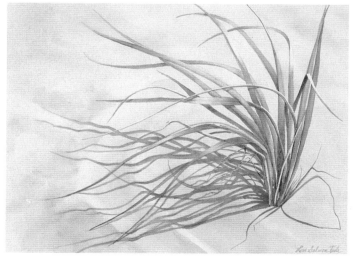

STEP 4

Shade and Contour Grass Blades

Leaves bend and curve, catching highlights in places and darkening elsewhere, sometimes casting shadows on each other. For highlights, wet the whole blade, and leaving the highlighted area white, lay Aureolin Yellow next to that, then a mix of Viridian and Cadmium Yellow, then Viridian followed by Antwerp or Ultramarine Blue. For a very dark green, mix Burnt Sienna and Winsor Blue, but use it sparingly.

Two Grass Clusters

LOIS SALMON TOOLE, WATERCOLOR

H ere are two different approaches to achieve lights against dark. Masking is used on the grass cluster on the left, and scraping is used on the one on the right.

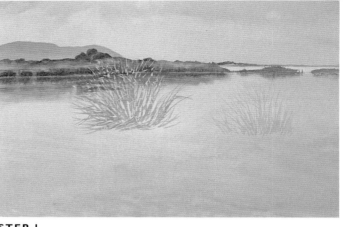

Colors:
Burnt Sienna
Cadmium Red
Cadmium
 Yellow
Olive Green
Sepia
Ultramarine
 Blue
Viridian
Yellow Ochre

Materials:
140-lb. Arches
 rag paper
1-inch and
 ½-inch
 aquarelle
 brushes
no. 6 round

STEP 1

Set the Stage

Though the focus is two grass clusters, place them against a simple background for contrast. Mask highlights on the left clump only, then with a no. 6 round lay in a base of Yellow Ochre leaves on the right clump, and a Viridian-Olive Green mix on the left clump.

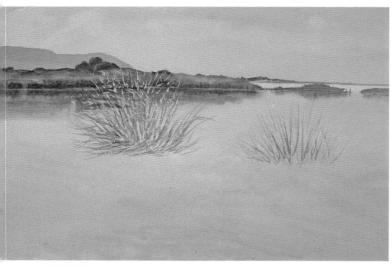

STEP 2

Continue the Leaves

Follow the base colors with Burnt Sienna. For the group on the right, mix Viridian and Cadmium Yellow, then pull in some Olive Green and then darken with Ultramarine Blue, a strong blue. You can use any number of greens or green mixes. For this exercise, stay away from stainers such as Winsor Blue. Stainers sink into the paper and spread. You want transparents or "opaques" (colors that stay on the surface) for this because they're easier to lift.

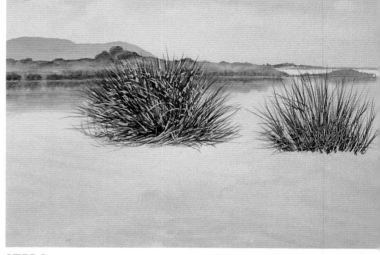

STEP 3

Right Group—Scraped Highlights

Apply a dark green mix to the right group. While the paint is still damp but not wet, use the flat end of the small aquarelle brush to scrape blade lines in the green revealing the lighter colors beneath. Then continue with the dark green mix on the left-hand group, but don't scrape lines.

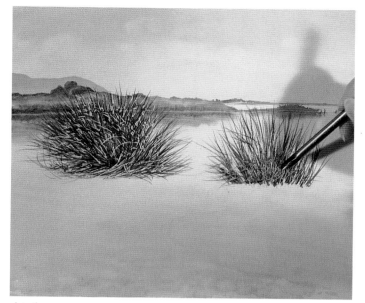

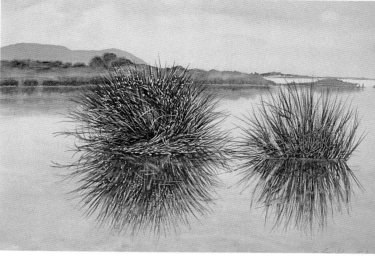

detail

Here you see the aquarelle brush scraping lines out of the dark green of the bush on the right.

STEP 4

Left Group—Masked Highlights

Remove the masking to reveal highlighted blades on the left cluster. Once the masking is removed, go back into parts of the highlighted blades with lighter greens and yellows to soften and contour. Use a mirror to help paint the reflections. For these greens, mix Olive Green and Burnt Sienna, smudging some of the lines with a wet flat.

STEP 5

Comparison and Inset With Hot-Press Paper

Now you can compare the two techniques. If you want stark white highlights, as in the group at left, you'll have to mask if using cold-press paper. In a normal painting (rather than a demonstration), be consistent, choosing one method or the other or possibly a combination of both to be used over the whole painting. The paper surface you choose is important. Here I use cold-press, which has some tooth and captures the paint. I like the texture, soft edges and other effects. If you choose hot-press (smooth surface—shown in the inset), where the paint tends to sit on top, scraping and even lifting with a wet brush are considerably easier.

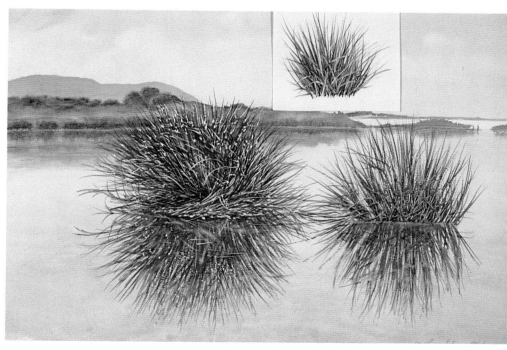

Shell Study

LOIS SALMON TOOLE, WATERCOLOR

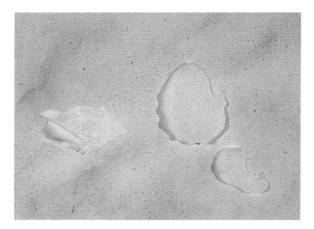

STEP 1

Sandy Base and Lay-In

Draw shell shapes and then mask the outlines. Cut the shell shapes out of a paper towel and cover them. Secure the paper towel with a small piece of masking tape. Then spritz on a sand background like on page 42 to set off the shells. Concentrate on the left shell here. Lay in basic contours with light washes of Cadmium Yellow, Cadmium Orange, Cadmium Red and Cobalt.

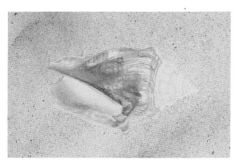

STEP 2

Start With the Brights

Start with the brightest hues—Cadmium Orange, Cadmium Red, Burnt Sienna—and shade with a touch of Alizarin Crimson. The bright part of this shell is smooth and reflective. Do it wet and all at once, charging in colors for smooth transition while paying attention to the subtle striations lengthwise and across. Soften as you move up into the less reflective surface.

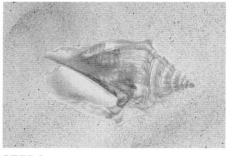

STEP 3

Swirl the Tip of the Shell

Alternating Cobalt Blue with Antwerp Blue, trace in the fine lines to form the conical swirls, which diminish to the tip of the shell. Follow the striations to the tip with a faint line of Cadmium Orange, and shade the barely perceptible undulations with a little Cobalt Blue. Don't overdo. Less is better.

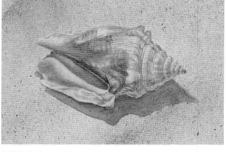

STEP 4

Cast Shadows and Reflected Light

There is reflected light all around. The sand on the underside of the shell reflects onto the shell. The shell in turn reflects onto the sand. The inside curve of the shell even reflects onto the lip of the shell in the cast shadow. For the cast shadow, use Cobalt Blue with Cadmium Orange and Cadmium Red charged in for reflected light. Soften the outer edges of the shadow.

STEP 5

Companion Shells

Even though I concentrated on one shell, I saved these two for comparison and interest. I've always been intrigued with my "tiger" shell. I tipped the shell up to capture the translucency of the thin outer lip.

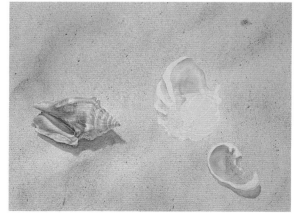

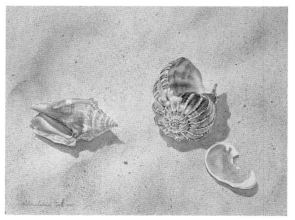

Gull Study

LOIS SALMON TOOLE, WATERCOLOR

Gulls come in all sizes, some even larger than chickens, and range from white through all shades of gray to black. Sometimes they're neat, sometimes mottled and grungy. But mostly they are a gregarious familiar part of the sea, graceful in flight, fun to watch and paint.

Gulls are often an incidental part of the larger picture in marine paintings, usually suggested and not a detailed specimen. The following demonstration shows, on a larger scale than a gull usually appears in a maritime painting, how to suggest gulls without detailing.

STEP 1

Start With Reflected Light

Use a no. 6 round to paint a stroke of dilute Yellow Ochre on the underside curve of the belly and the beak to show reflected light from the sand. Trace a line of Cobalt Blue/Burnt Sienna Gray into the wet paint for shadow contour. Reflected light reminds you the body is round.

STEP 2

Let's Wing It

Tackle the wing feathers all at once. Begin at the top with Antwerp for reflected light from the sky. Move down and softly darken the feathers, moving the paint around until you see a vague overlapping feather pattern. Continue the same process on the tail feathers and head. Keep in mind that the reflected light beneath and on top defines the contours.

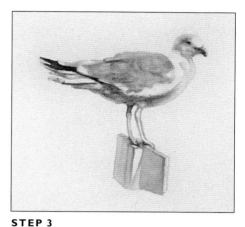

STEP 3

Continue Modeling

Charge in Antwerp Blue and Burnt Sienna, wet-in-wet, for the underbelly. Lift with a moist brush for lighter spots. The dark tail feathers are Burnt Sienna overlaid with blue. Keep in mind how the legs emerge from the body. Run a line of Cadmium Yellow under the chin and belly, softening all the edges after modeling the head.

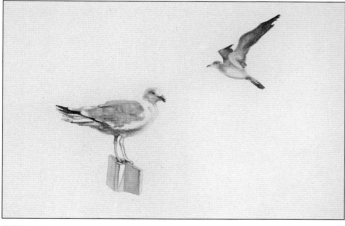

STEP 4

Smaller Flying Bird

Add a smaller backlit flying bird. In one step, shape the whole bird with dilute Antwerp Blue, charging in Cadmium Orange on the belly and contouring beneath with a touch of Burnt Sienna. Brush in Burnt Sienna on the wings, adding blue for darks.

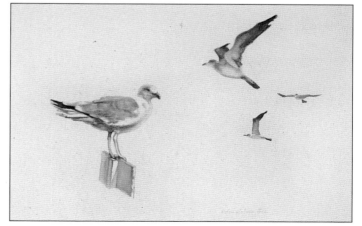
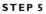

STEP 5

Even Smaller Birds

These two smaller birds are simply small shapes and color patterns done in one step, charging in color. Where they catch the light depends upon the light source. For this exercise, vary the light sources.

Use Drybrush to Enliven Shorelines

LEONARD MIZEREK, WATERCOLOR

Your choice of technique determines much about the final look of your painting. Dry-brush technique is a method of applying a drier consistency of watercolor paint with a brush. Dry-brush technique produces more intense color and is often used for developing more detail and producing a darker and sharper edge. It's effectively used over a paler wash of color. In the watercolor *On the Bay*, Mizerek used drybrush to show detail in the wild grass in the foreground.

To use drybrush, dab your wet brush on a paper towel until it's just damp, then load your brush with color. When you skim the brush across rough paper, only the peaks of the textured paper will be colored. Experiment with different stroke patterns, cross-hatching, skimming or stippling. Different papers affect the results you get from drybrush. A skimming stroke works great for creating distant water reflections.

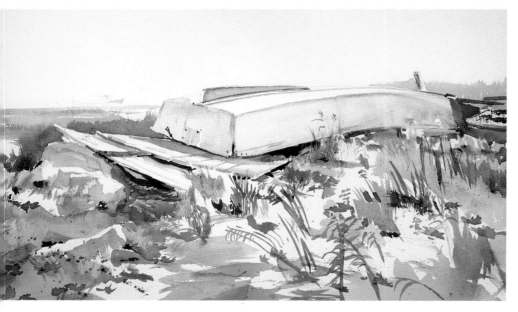

On-Location Start

While on location, I laid in colored washes using broad strokes of fall colors, letting them blend together and complement each other in the foreground area. I enjoy letting my palette change with the seasons. I'll add the details later using drybrush.

Colors:
Alizarin Crimson
Burnt Umber
Hooker's Green Light
Payne's Gray
Raw Sienna
Ultramarine Blue
Yellow Ochre

Studio Finish

I left some areas in the foreground untouched so the smooth rocks would add contrast to the complex grasses. I worked in layers of small dry strokes of color, letting details overlap to keep the feeling of depth. I also used drybrush to skim over the overturned boat, adding a weathered look.
ON THE BAY
13" × 21" (33cm × 53.3cm)
Leonard Mizerek,
Watercolor

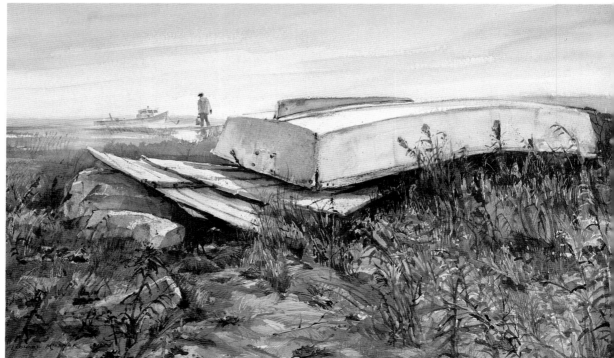

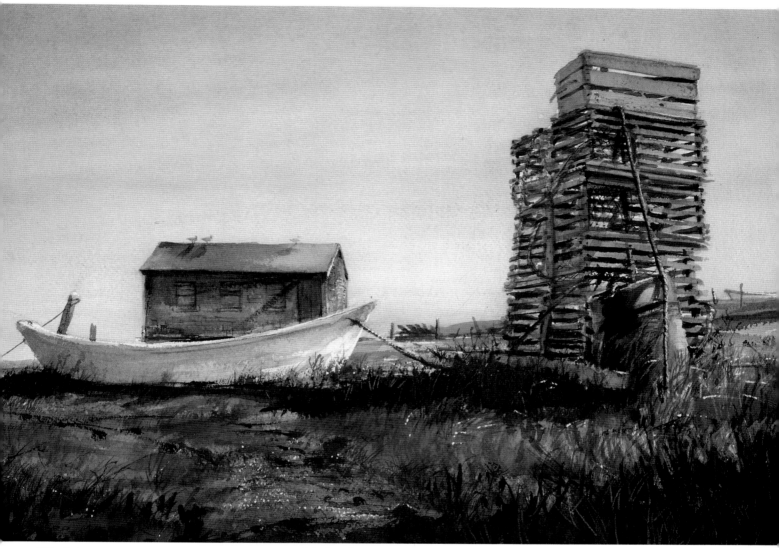

DUSK ON THE CAPE
11" × 14" (27.9cm × 35.6cm)
Leonard Mizerek, Watercolor

I used drybrush to achieve the detail in the wooden lobster cages, the grassy area and the weathered boathouse. Some strokes are drawn in and others just skimmed across the surface.

TIP FROM A PRO

LIMITED PALETTE

By keeping your palette somewhat limited, it is possible to fix more specifically the quality of light and time of day.

—MARC CASTELLI

Painting on Location

LEONARD MIZEREK

Watercolor is an easy medium to work with outdoors. You don't have to carry tons of backup solvents, paints and rags, and watercolor dries rapidly.

LIGHTING Usually there are two hours of sunlight before the light changes so much that you'll be painting a different scene. Time your drawing so you don't use up the good lighting. Use the optimum lighting to begin painting. As you paint, the sun moves and shadows lengthen or shorten; colors change. Try to memorize the effect you want to stick with.

Within the two hours, photograph the scene with color slide film. If conditions are the same the next day, try to return to the same spot. If your subject moves or the weather changes, work from the photos and color notes to complete the painting in your studio.

CONDITIONS You can work in most outdoor situations if you adapt to the conditions. A hot, arid climate that makes your paper dry quickly and dries your washes forces you to work faster. Bright days can turn into misty, foggy days, so be prepared to adapt your approach.

TOOLS Len Mizerek suggests packing the following tools when painting watercolors outdoors:

1. A French easel and 140-lb. Arches cold-press watercolor paper mounted on a piece of foamboard or cardboard.
2. Several sizes of unmounted paper to help you look at the subject in different-size formats.
3. Smaller sheets of 300-lb. paper for quick studies you don't need to mount. Be careful that the wind doesn't blow your paper or palette away! Always secure the paper to your easel.
4. A Pike's (or similar) palette. Weigh down the lightweight plastic palette with a rock in the center of it.
5. Paper towels.
6. Two 1-pint water bottles (one for clean water and one for cleaning brushes).
7. Two or three brushes: a flat ½-inch, a round no. 4 and a wide 2-inch flat for washes are usually enough brushes for outdoors. Take care. It's easy to lose brushes outdoors while immersed in your work.
8. A straightedge is useful for horizons and some rigging.
9. Sketching tools, including a white eraser, a no. 2 pencil, a small sharpener and a 5"×7" (12.7cm × 17.8cm) sketch pad.
10. Masking fluid.
11. A no. 11 X-Acto knife for scratching in highlights.
12. Packing tape for mounting paper.
13. Sunglasses or a visor for looking at your subject in the bright sun, although sunglasses change the colors. Ideally, work in bright shade if possible, or if in sunlight, tilt your board vertically. A white umbrella is the best for shading your paper if you have one.
14. A small watercolor block is helpful for small color notes and sometimes creates brilliant miniatures that later can be sold.
15. A box of watercolor tubes kept in the car to freshen up your palette.
16. A 35mm camera is helpful to take detail photos you will need later.
17. A hooded lightweight windbreaker is a must when near the water, and bring along sunblock and insect repellent.

BE A GOOD CITIZEN

You should be comfortable while working outdoors, but always remember to be a good citizen, too. Leave the spot where you've painted the way you found it. Never empty solvents, dirty water or litter on the ground or in the water. Leave the spot as untouched for the next person as it was for you.

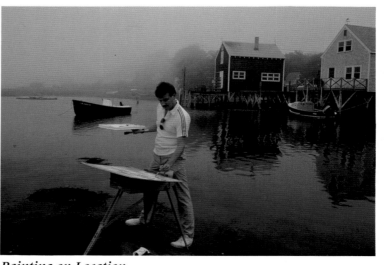

Painting on Location
Have someone take your picture while painting, for your own publicity. A view of the artist painting the subject tells a great story.

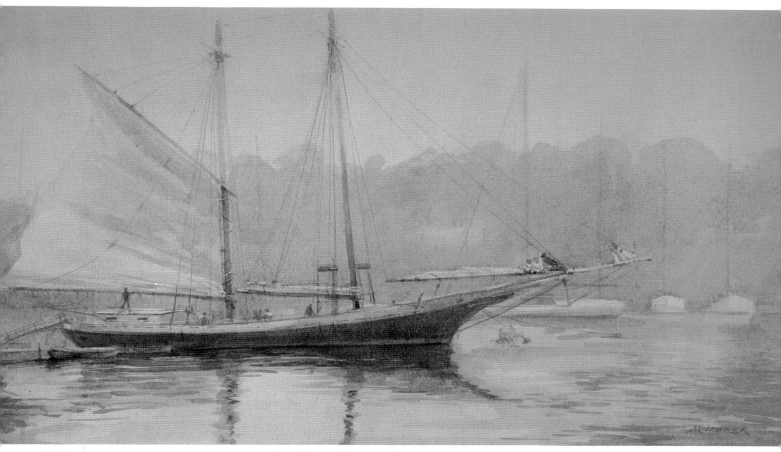

MISTY MORNING
11" × 17", (27.9cm × 43.2cm)
Leonard Mizerek, Watercolor

Len Mizerek began *Misty Morning* outdoors in Maine with a different idea in mind than the final outcome. The air turned moist, and the painting, of its own accord, became a wet-on-wet watercolor. As the paper got wetter, he changed his working technique to meet the conditions. The painting started taking on a misty feeling. The colors blended and softened almost as they touched the damp paper—duplicating the very mood that he was experiencing. He says, "One of the great experiences of the outdoors is to see the effect that the weather can have on your work. This leads to some challenging experiences that break the way one normally works. The reward is there for anyone."

TIP FROM A PRO

HORIZON LINE

There is usually a strong horizon line in marine art, so it's a challenge to use elements creatively to break up the space so part of your painting isn't cut off. Use compositional devices to break that line and to direct the viewer's eye, such as people looking at your subject, clouds that connect to land masses or each other, masts, sails and shadows.

—LEONARD MIZEREK

Direct the Viewer's Eye

LEONARD MIZEREK, WATERCOLOR

S ometimes there isn't the time or opportunity to fully record a scene. The important thing is to "get it down" quickly, especially if your subject is mobile. When Mizerek saw this scene, he saw a story unfolding that would make a great painting. He had to work quickly, so he took some slides and did a small loose sketch to record important elements.

STEP 1

Sketch on Site

This small sketch done on site helps establish values and composition. While sketching, decide what view you like and what would make the best angle.

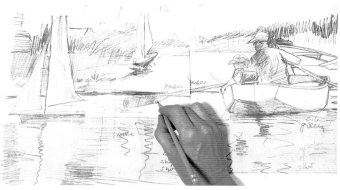

STEP 2

Position Elements Carefully

Back at the studio, experiment with full-size sketches from your notes and photo references. Use layers of vellum and draw each element on its own sheet so you can move things around until you're satisfied with the size, position and composition. The main figure and the boy are to the right looking in the same direction. This creates a directional device pointing toward the main subject—the model boat. The placement of other elements reinforces this. After finalizing the drawing, carbon the back with a no. 4B pencil and transfer the main elements directly onto the 140-lb. cold-press medium-rough watercolor paper stretched onto foamboard or Masonite.

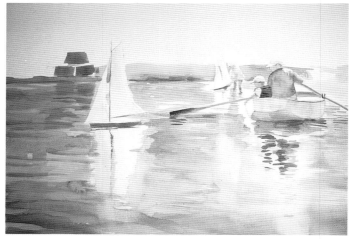

STEP 3

Water—First Wash

This piece is large, so start with large Chinese watercolor brushes to lay in the first washes and establish overall color. At this stage, paint on dry paper, keeping the Winsor & Newton colors strong.

The figures in the foreground are kept warm by using the life jacket color and picking up the same in the reflections. Using warm colors at the points of interest helps focus attention on those points in an otherwise cool painting. The reflections also give vertical balance to this horizontal painting.

The first wash is light because a lot is absorbed into the paper. Another wash will intensify the colors. Work fast but carefully in order to leave white paper showing for highlights and strategic areas, such as the sails.

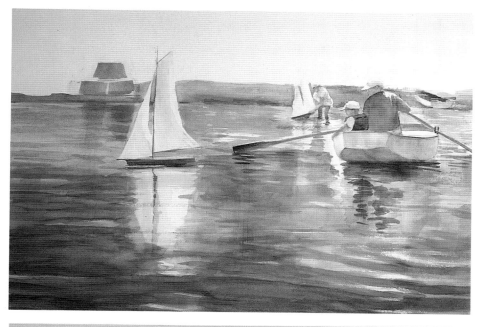

STEP 4

Increase Values

Slowly increase the values. Cool down the water and darken the reds in the jackets.

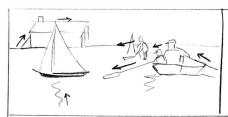

Using Directional Elements

This simplified sketch of the composition shows how you can place your elements to point toward your center of interest and also (see the boathouse) keep the viewer's eye inside the frame.

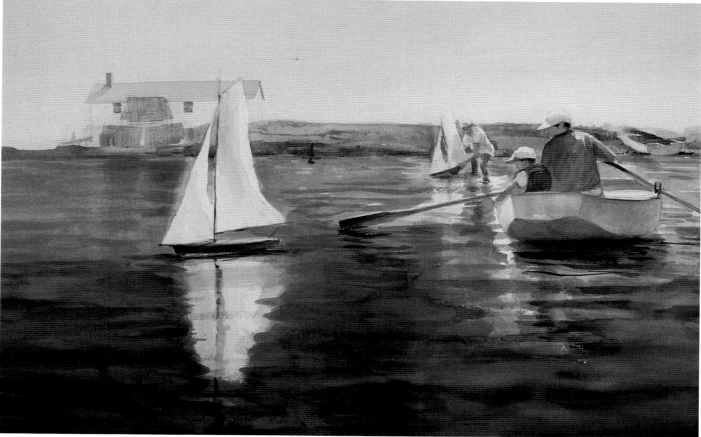

FIRST SAIL
22" × 30" (55.9cm × 76.2cm)
Leonard Mizerek, Watercolor

STEP 5

Finish and Crop

I wasn't satisfied with the background, so I lifted some color off the lobster cages and added a boat shed in the distant background to tie in the left side of the painting and increase contrast at my point of interest. It's lighter in value than the figures so it doesn't compete. The overlapping of the sail and the stack of lobster cages increases the sense of depth. I added another layer of washes, especially to increase the intensity of the water. This added stability and weight to the bottom of the painting.

Importance of People in Marine Art

ROBERT C. SEMLER

Adding one or more figures to your boat paintings can keep them from being static, as well as add a human aspect we can all identify with. You can broaden your audience base by telling a story through the placement and action of the figures that will interest the general viewer, and not just the boat enthusiast. In addition, figures can help you establish perspective and proportion. When there's a boat in the background, placing a figure in the foreground can help your viewer perceive how far away the boat is. A figure placed next to, or on, a specific vessel will clearly identify size. Though usually seen as secondary in marine paintings, figures can even be the main subject, as in *Their Trick at the Wheel*.

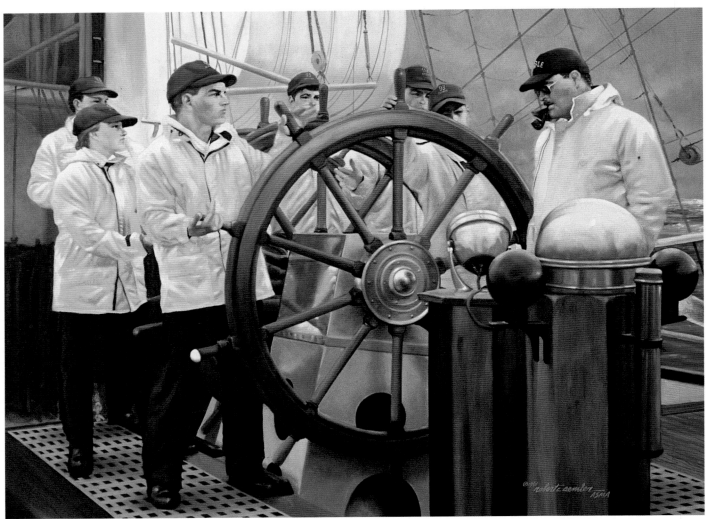

THEIR TRICK AT THE WHEEL
18"×24" (45.7cm×61cm), Robert C. Semler, Oil

This painting depicts cadets of the U.S. Coast Guard training barque *Eagle* during a sail on the Delaware River, Philadelphia, Pennsylvania. This is primarily a "people painting" with a maritime theme showing the intensity of the cadets under the watchful eye of their sailing master. The weather was turning rainy, with a storm brewing in the distance. The figures in yellow rain slickers provided a compelling color statement. The rain slickers, the compass, the wheel and all metal parts were painted using the glazing method shown on the following page.

Developing a "Seaworthy" Figure

ROBERT C. SEMLER, OIL

This demonstration uses two methods of painting. The face, pipe and hat are painted in the traditional opaque method of oil, dark to light, mixing the proper colors as you go. The yellow rain jacket and the brass compass are *underpainted* and then glazed. Semler uses Burnt Umber and white to first paint these items to completion in monotone because it's difficult to keep the yellows clean and pure if you mix "as you go." By underpainting and then glazing with pure pigment, the painted subject shows through the pure color and has a special brightness all its own.

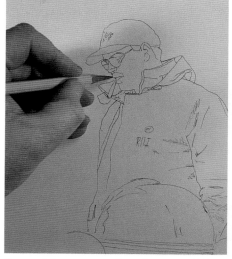

Start with a contour line drawing of the general shape and features. I use a soft HB graphite pencil because I'm painting on a clay-surfaced art board.

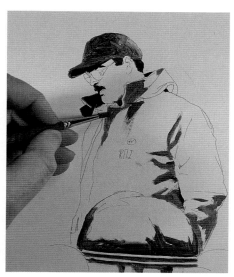

Use a small sable brush to paint in the darkest areas with a Burnt Umber/White combination. Paint the dark hat using Ultramarine Blue and Burnt Umber.

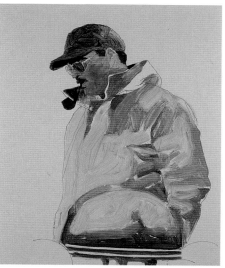

Roughly paint in the large areas of the monotone underpainting—dark, halftone and light—on the figure. I use traditional portrait colors for the face.

The slicker and compass, completed in monotone, are now ready for the glaze. The underpainting *must* be dry before applying the glaze, and each additional glaze layer must dry completely to avoid softening of the previous glaze. I use Liquin medium in this process as it dries overnight, thins the glaze beautifully and makes it adhere properly.

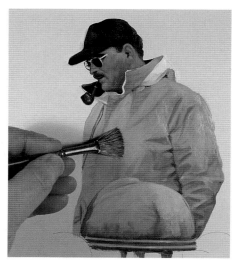

Use pure Cadmium Yellow for the glazes, thinned with Liquin. Apply a thin layer and before it sets, lightly smooth it with a fan brush. This evens the color. Paint the face, hat and pipe in a traditional manner.

I used four separate yellow glazes to get the desired saturation of yellow!

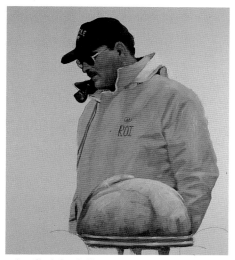

The finished figure
Paint the piping, insignia and other details after the four separate glazes are dry. Glaze the compass with Yellow Ochre. Some dry-brushing creates a brass appearance.

Put People in Marine Paintings

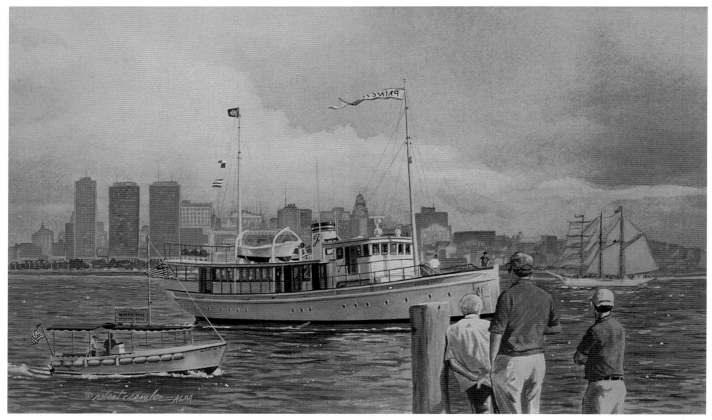

PRINCIPIA
12" × 18" (30.5cm × 45.7cm)
Robert C. Semler, Watercolor/Gouache

The Independence Seaport Museum in Philadelphia purchased this yacht as a flagship and charter vessel. The painting shows her at Philadelphia with some of the local vessels in the background. I felt that the figures standing on the docking pier, watching the *Principia*, added interest and realism to the scene. They also strengthen the composition and add to the depth of the painting. I've linked the figures and the primary subject to give the composition unity.

Tossing the Line shows working tugs in action. I could have painted this scene of tugs pulling the battleship *Wisconsin* out of the mud without the figures and with only the taut lines showing, but tossing the line is an important part of this procedure and brings a certain tension to the story. What happens if the line misses? How many times does this man have to throw it? Questions like these make the painting more personal and interesting.

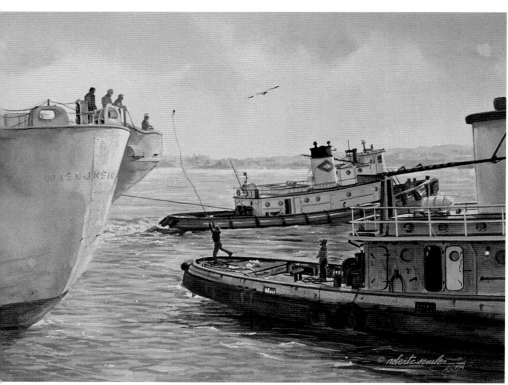

TOSSING THE LINE
12" × 16" (30.5cm × 40.6cm)
Robert C. Semler, Watercolor/Gouache

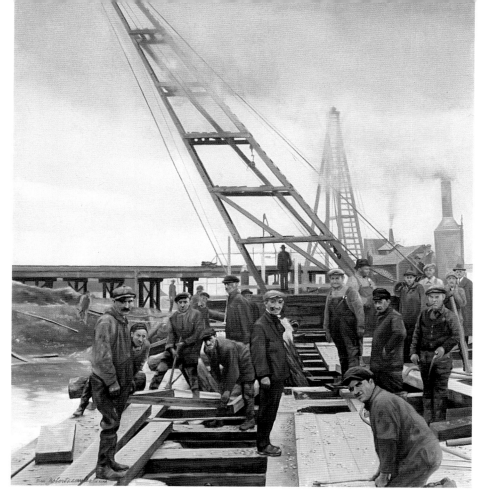

PIER PRESSURE
40" × 30" (101.6cm × 76.2cm), Robert C. Semler, Oil.
Collection of Harbour League, Camden, New Jersey

This painting was commissioned from a turn-of-the-century black-and-white photograph showing the construction of piers in Marcus Hook, Pennsylvania. It was a family-owned company, and the man who commissioned it wanted a lasting portrait of his father's crew. The main challenge was painting multiple portraits, as well as coming up with a color scheme. These are real people who had to look like who they were. Research into the condition of the water, which was very dirty at the time from coal and oil, came into consideration when planning this painting.

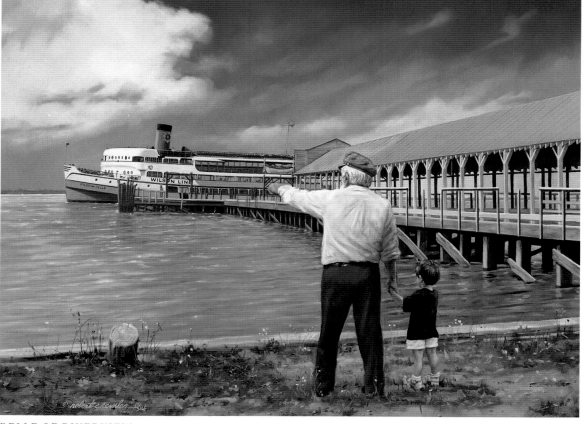

This painting depicts a nostalgic remembrance of days gone by. A grandfather and his grandson watch as the Wilson line's excursion steamer, *Pilgrim Belle*, arrives from Philadelphia at Riverview Beach Park, Pennsville, New Jersey, circa 1948. His white shirt and arm form an important part of the composition.

BELLE OF RIVERVIEW
22" × 28" (55.9cm × 71.1cm), Robert C. Semler, Oil

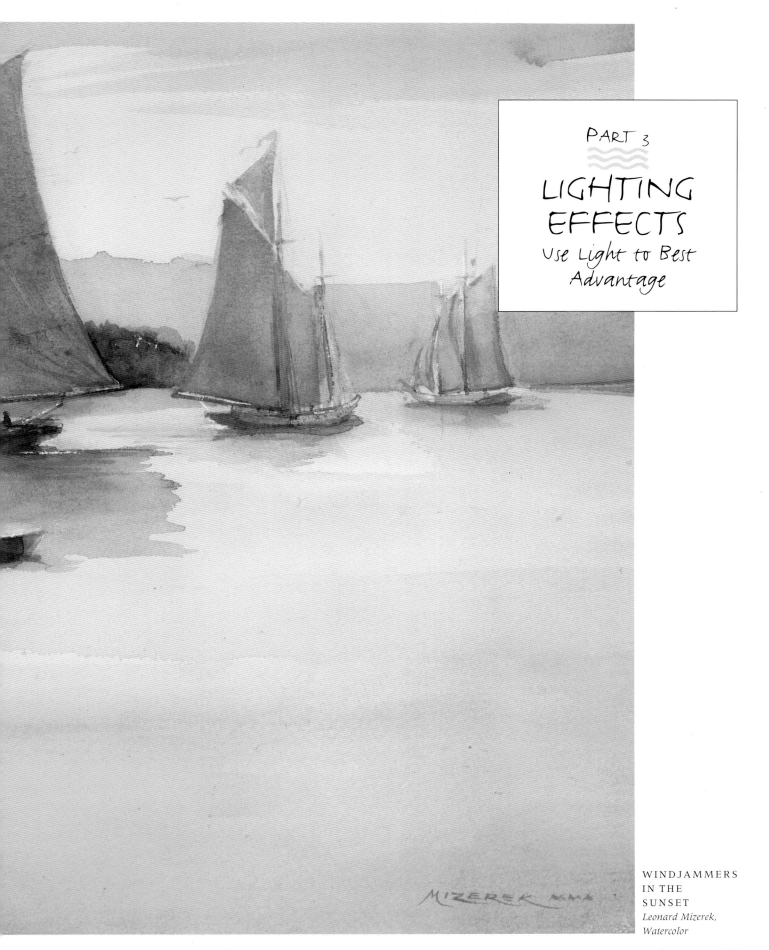

LIGHTING EFFECTS
Use Light to Best Advantage

WINDJAMMERS
IN THE
SUNSET
*Leonard Mizerek,
Watercolor*

Painting the Translucence of Sails

MARC CASTELLI, WATERCOLOR

The title of the painting featured here—*Shoji*—is a Japanese word for the paper screens and walls used in traditional Japanese architecture. The translucence of these screens matches the quality of light that fascinates artist Marc Castelli about sails.

Sails seen from the opposite side of sunlight have a glow. It's this glow framed by the masts, spreets and clubs that reminds one of shoji. Shoji panels slide open to reveal views to other rooms or to the outside world, and the opening between the sails represents

just such a possibility. The dark water across the bottom of the picture plane anchors the boat and indicates wind strength and direction. It also provides an opportunity to show the boat's angle of indicating speed.

PHOTO BY JOHN MICHAEL

STEP 2

The sail areas, now complete, must be contained. This is accomplished by painting in the spreets, clubs and mast. Here Castelli is painting in the mast on his angled painting board in his studio.

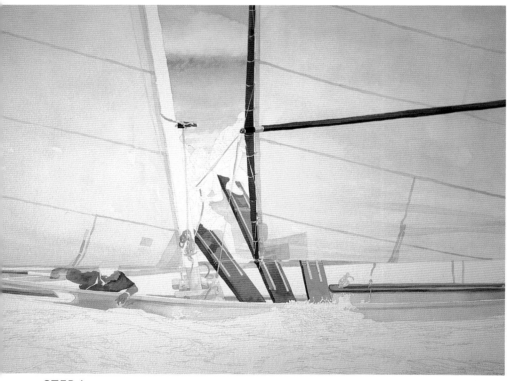

PHOTO BY JOHN MICHAEL

STEP 1

Drawing. Complete a detailed drawing before any color is put on. Add details after major shapes and their proportions are correctly composed. A complete drawing relieves you of concerns for correctness.
Sky. The sky was painted first with a no. 12 Robert Simmons White Taklon brush onto dry paper with a lot of water. This small section of sky serves as an escape to a greater distance, something I learned from studying the Flemish painters of the Northern Renaissance.
Sails. The sails and their light-saturated shapes are painted second. The sails are

large, powerful shapes and should reflect confidence and strength; so throw paint, drop water and blot. Any white space left competes with the light in the sails, so it's important to tone everything around them, and throughout the painting, a value darker than the sails.
Wood. The pieces of wood on a racing log canoe are usually varnished and thus become reflective surfaces. Their darker color gives the sails good contrast.
Figures. Figures are established in stages starting from skin tones to clothes then shadows using a no. 4 brush.

LOG CANOES

Racing log canoes bring to mind crude dugouts paddled by rough types. In reality they are small clipper-bowed sharp-sterned boats with little freeboard. These elegant overpowered sailing craft, indigenous to the Chesapeake Bay, are direct descendants from traditional workboats. Many are in fact over one hundred years old. I have raced on them for six years now, collecting stories, drawing and photographing, and painting them has become a passion. There are few sensations akin to riding on the springboards of a canoe beating to windward.

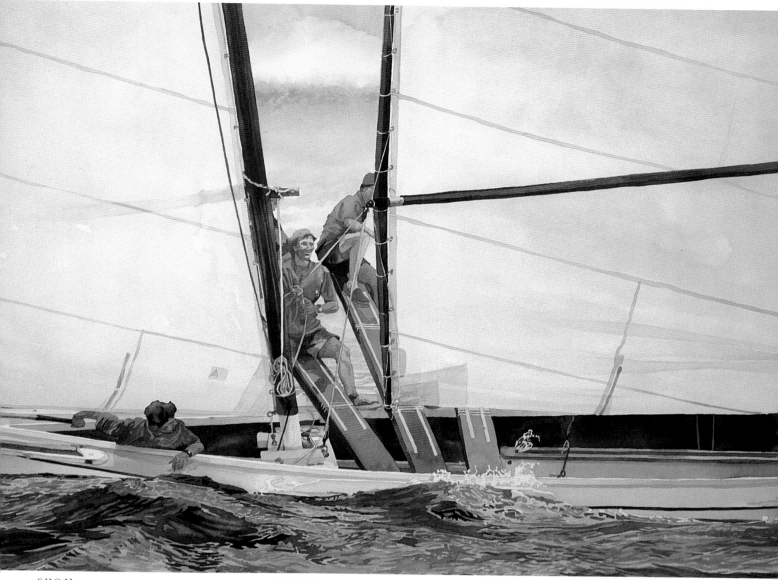

SHOJI
22" × 30" (55.9cm × 76.2cm)
Marc Castelli, Watercolor

FINISH

The shape of the cockpit interior is one of the darkest masses. Since it's darker than the mast, club and spreet, it returns light to those areas. The waves around the boat are full of detail. The detail lessens as the waves work out into the boat's wake and then even farther out. Since this boat is on a windward leg, the leeward rail is close to the water. The boat isn't only riding on the water, but it's forced into the water and pushes water away causing a wake. The low angle of perspective only gives the viewer glimpses of wave tops and troughs. These angular slashes tell much about the wind and hull speed and can also impart action. These qualities play against the calm area of the sails and sky. In increasingly darker values of Indigo Blue, Antwerp Blue and Burnt Sienna, the deeper values of the water are established. Foam along the hull is left white. Into these areas, a pale mix of Purple Lake and French Ultramarine Blue is lightly brushed on. All of these strokes must suggest form and volume and be active.

Look, see, sail, get wet, breathe the wind in your face. See into your painting with all of what you are.

The Effect of Ambient Light on Water

PETER EGELI, OIL

The reflective surface of water makes it a source of wonder and interest to the marine artist. Water reflects the source of light and all ambient light with amazing precision infusing its environment with qualities of light and color. It's a mirror to all above and below and requires only that artists observe carefully. Below are some points to note about painting ambient light.

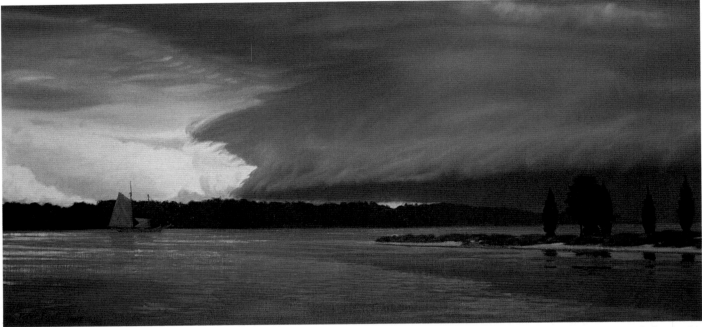

APPROACHING STORM
20" × 42" (50.8cm × 106.7cm), Peter Egeli, Oil

In *Approaching Storm*, the sun is the source of light but is shown only by its light on the bank of clouds where its light is brighter and more neutral. There's also a combination of water surfaces revealing a variety of ambient light.

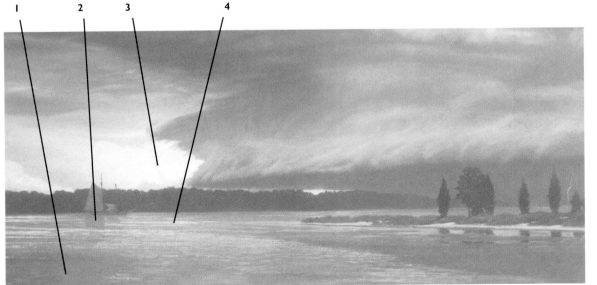

1 Darker water in foreground
2 Reflection of sail in water
3 Key the values to the brightest light
4 Reflection of light in sky

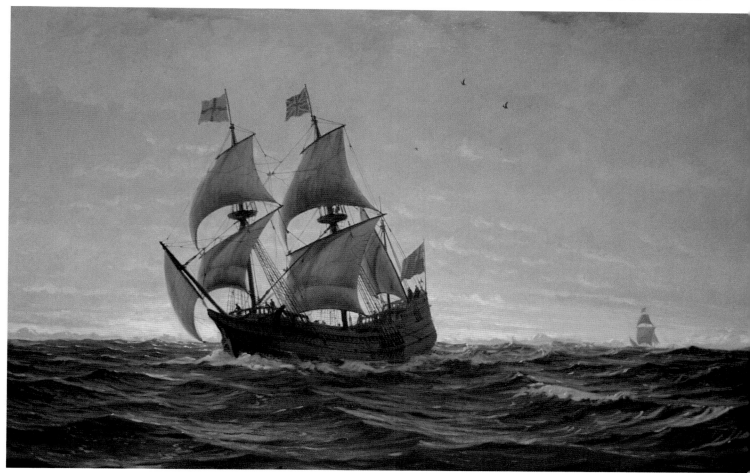

ARK OF MARYLAND
24" × 40" (61cm × 101.6cm), Peter Egeli, Oil

Ark of Maryland is the ship that brought the first colonists to Maryland. The sun is over the horizon, so the low clouds and sky become the immediate source of light. The yellow and red clouds become the reason for yellow and red on the water. The blue and violet in the sky become the reason for the cool colors on the sails. Notice that very distant vessels appear to sit on top of the water or "hull down." These effects are the consequence of a relatively low observer height and the curvature of the earth.

1 Hull down
2 Low horizon
3 Reflection of
 overhead sky
4 Reflection of lower
 sky light
5 Local color of water
6 Color of sky light on
 sail
7 Color of sky light on
 hull
8 Bow wave
9 Bow wave trough
10 Sky color permeates
 sky and water

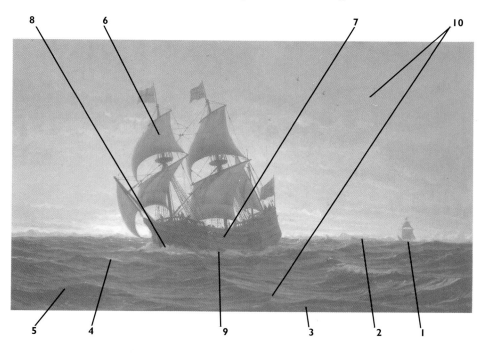

Reflection of Ambient Light

PETER EGELI, PASTEL

Still water is the best subject for studying the principles that govern the appearance of water surface. As the diagrams on page 12 demonstrate, the water farthest from the observer reflects the lower sky unless its surface is broken by wavelets or a wake. The surface closer to us reflects more of the overhead sky, and still nearer, the water begins to show its local color. Finally, if it's shallow enough, we can see the bottom, its color and what lies there. In *The Creek* there is no visible light source, just a soft ambient light reflecting in the still water.

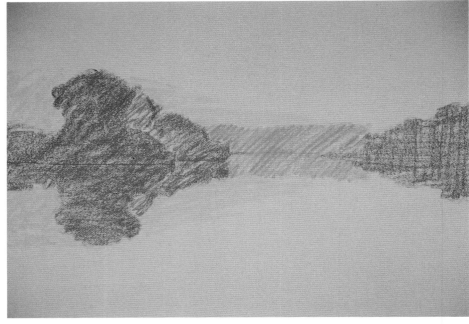

STEP 1

Drawing and First Color

Mark the major shapes on medium-gray Canson paper using medium or soft vine charcoal. After blowing and wiping off the excess, there's sufficient left on the paper to follow.

Complete the drawing and "search out" your colors. Schmincke Cold Green is in the darker areas, Leaf Green on the right (it's in a warmer light) and Chrome Oxide in the distance. Sennelier Light Ultramarine is in the left middle and Schmincke English Red (no. 22) in the lower sky.

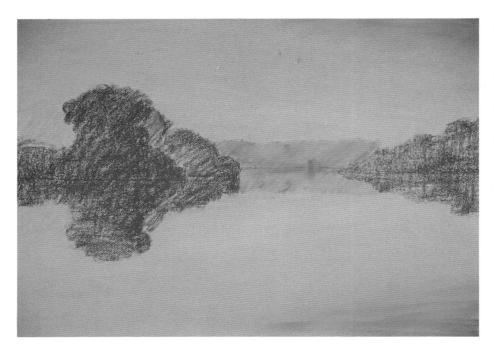

STEP 2

Sky Color

You need a good intermediate base color for the sky. I found Sennelier Violet (no. 335) works well. The upper and lower right side is Sennelier Ultramarine Blue (no. 137). Things are working well so load on a little more of the earlier colors into the sky and water. Whatever goes above the water's surface also goes into the reflection.

STEP 3

Trees

Modify a little now. Use Schmincke Olive Green on the left side of the trees on the left, some Schmincke Neutral Gray in the far shore and some Schmincke Chrome Green on the middle-left trees.

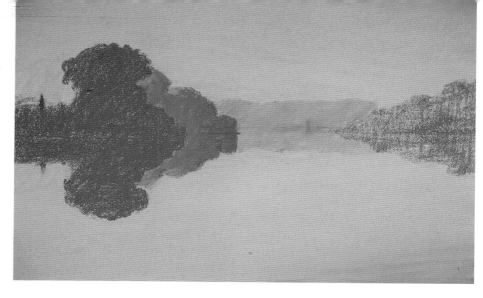

STEP 4

Shore on Right Side

Refine the shapes of the trees now and "punch holes" through them to the sky with English Red. Develop the shore on the right as sunlit with Schmincke Greenish Umber. To bring some of the atmosphere around the right-hand bank of trees, give it a "wash" of Sennelier Blue-Violet (no. 335). Carry English Red up into the sky with Schmincke Permanent Red (no. 42). Also use some in the center upper-right sky.

Load on the colors in the flatter areas to fill in the voids (which is why I frequently use the back of the Canson paper). Also, at this stage, check the symmetry of the reflections by mounting the picture vertically. I like to use a reducing glass and a mirror, too, to critique my progress.

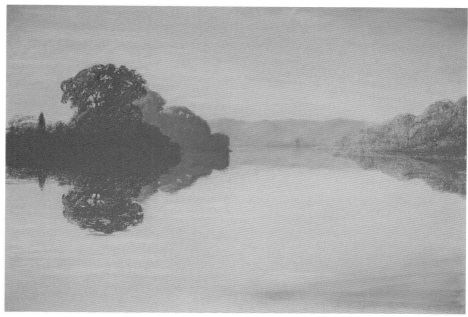

STEP 5

Log Canoe

The little boat—a Chesapeake Bay log canoe of the Poquoson model and converted from sail to low power—adds a sense of scale, depth and presence to your view of this evolving scene. To place it, cut out a rough profile of the boat from a scrap of gray Canson paper, and using the principles of perspective discussed earlier, hold it in place with points of a divider and mark the place with charcoal. The base color is Schmincke Gray Blue (no. 91), Neutral Gray (no. 98) and Permanent Red (no. 42) for the light part. Use Greenish Gray (no. 94) in the reflection to show the water's local color.

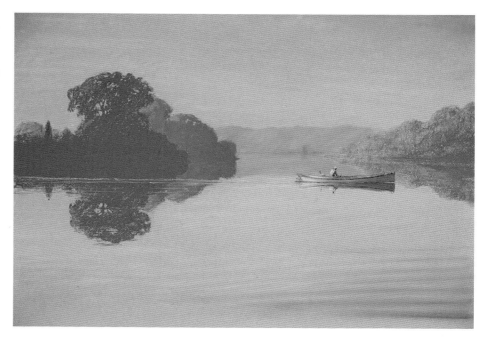

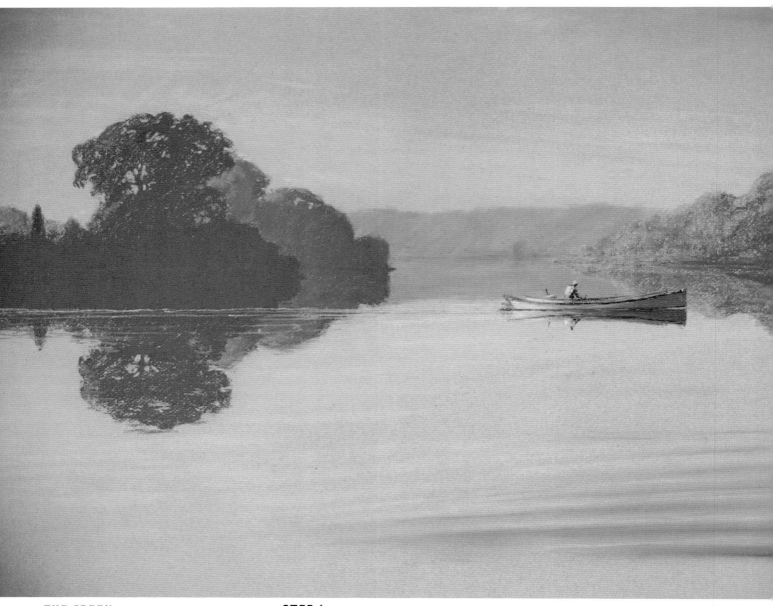

THE CREEK
16" × 24" (40.6cm × 61.0cm), Peter Egeli, Pastel

STEP 6

Finish

Put a few more holes in the left foreground trees and the middle trees with Schmincke Chrome Oxide Green (no. 84), just to make them less dense. Give a little more Schmincke Olive Green (no. 85) to the near faces of the foreground waves to better show the local color of the water.

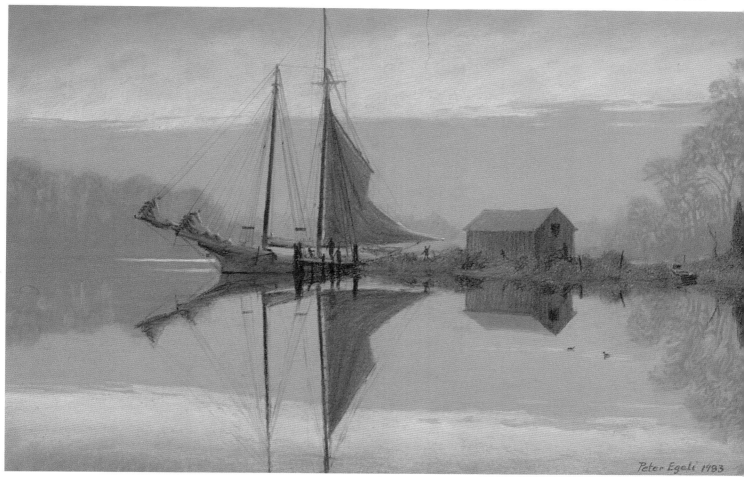

THE ICE LETS OUT
16" × 24" (40.6cm × 61cm), Peter Egeli, Pastel

The theme here is similar to that of *The Creek* with somewhat of a reversal of color. Here the darkest part of the sky is at the horizon, while it gets warmer and brighter a bit farther up.

TIP FROM A PRO

SPECIFIC LIGHT

If you live somewhere long enough and really see where you are, the light will become specific to the locale. "Really seeing" is an act often enhanced by drawing, painting and photography. These three tools used in conjunction with constant submersion in your subject will give the light to your paintings.

—MARC CASTELLI

Color Harmony: Sky, Water and Sails

LEONARD MIZEREK, OIL

Though you can certainly create color harmony with a full-color palette, marine painting offers a terrific opportunity for a monochromatic color scheme. Water reflects the sky, and sails take on the surrounding colors; so by nature, marine paintings can become tone on tone of the same related colors. *Skipjacks at Sunrise* uses only one dominant color throughout—yellow. Its complement and adjacent colors are used to create form and contrast. The limited palette consists of Aureolin Yellow, Alizarin Crimson, Cerulean Blue, Raw Sienna, Ultramarine Blue and white. The palette for *Twilight at Tilghman's* is the same with the addition of Cadmium Red.

SKIPJACKS AT SUNRISE
13" × 11¹/₂"
(33cm × 29.2cm)
Leonard Mizerek, Oil

Skipjacks was painted in one sitting, wet-on-wet. Here, I'm not that concerned with detail. I want a warm feeling, letting one color dominate. All the objects are bathed in the warm light of the sun; values are close. The distribution of light and dark shapes is key. The dominant color is mixed into most of the colors in the painting. Even the shadow colors have been warmed up. To create distance, keep values light.

TWILIGHT AT TILGHMAN'S
11½" × 13" (29.2cm × 33cm), Leonard Mizerek, Oil

Twilight skies are similar to sunrise skies but often contain more reds and violets, rather than yellow dominance. Here the clouds on the horizon reflect the red-violet rays of early evening. Notice that the water is lightest just below the light source and, in this case, reflects the sun's light yellow, rather than the red-violet clouds on the horizon.

ABOUT SKIPJACKS

Skipjacks are wooden oyster boats that are still seen sailing on the Chesapeake Bay in lower Maryland. Some of these vessels date back to the 1800s. They dredge the bottom of the Chesapeake for oysters while under sail. They lie gracefully low in the water and are one of the last wooden working vessels of their kind. You can still see the shrinking fleet of skipjacks and their hardworking owners on the Chesapeake.

MAST COLOR

When painting the mast of a boat, observe the subtle changes in color as it reaches skyward. A mast reflects the color of the sky and becomes lighter as it rises. In *Twilight at Tilghman's*, I use a stronger mix of Raw Sienna and Cadmium Red and some yellow at the base of the mast and add more sky color as I work my way up.

Evening Skies Add Color to Harbor Scenes

LEONARD MIZEREK, OIL

E vening skies vary with every painting. In addition to individual variations, different seasons seem to have different skies. Some people feel that early fall has the best colors and strongest contrasting skies. However, you need to take care not to paint your glowing sunset too intense. Even if you see one of the most brilliant sunsets ever—and want to paint it—no one will believe it if you use the strong colors you actually see. Keep your colors in close relationship with the overall tone of the painting.

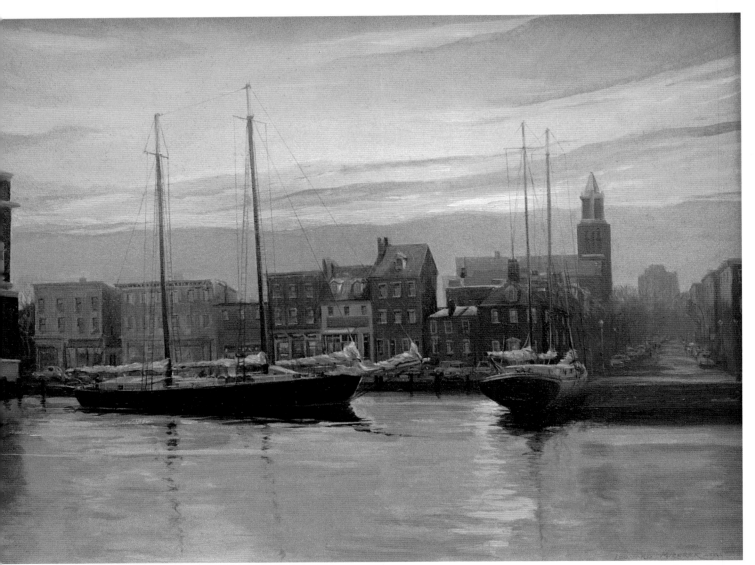

FELL'S POINT HARBOR
9" × 12" (22.9cm × 30.5cm), Leonard Mizerek, Oil

Fell's Point Harbor was painted using the same sky treatment as in *Annapolis Harbor*. I kept the edges of the sky darker to frame the piece. I particularly like to do an evening harbor scene because of the warm cast of light on the redbrick buildings and the water.

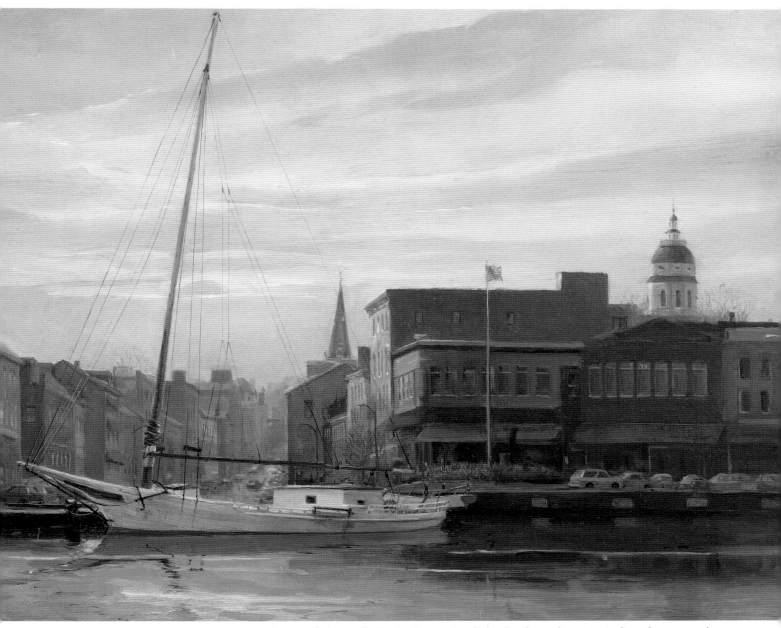

ANNAPOLIS HARBOR
9" × 12" (22.9cm × 30.5cm), Leonard Mizerek, Oil

I painted *Annapolis Harbor* in evening light that kept changing. It forced me to make several trips on subsequent evenings for further observation. Photos didn't capture the subtleties of the lighting.

Evening skies are generally warm. After beginning with a mixture of Cadmium Yellow, Alizarin Crimson and Ultramarine Blue, adding white for the right value, I then applied Cadmium Yellow mixed with Cadmium Red to finish covering the sky area in short strokes. I used the red of the sky in some of the buildings and water to harmonize the painting. I mixed my paint with Liquin medium and began layering thin layers of Ultramarine Blue and Alizarin Crimson over some clouds. This gave the translucent effect of lighter sky showing through some clouds.

Liquid medium dries quickly, so I was able to add several layers until I reached the desired effect. I wanted the warmth of the sunset to spill onto the surrounding buildings and water reflections. The sky was streaked with low clouds overlapping the setting sun. To create depth, I deepened the lower part nearest the horizon by adding Ultramarine Blue.

The boat is situated directly in front of the light source to make it a focal point. The mast almost dissolves into the color of the sun and then, at its top, takes on the sky color.

Portraying Luminosity in Oils

CHARLES RASKOB ROBINSON, OIL

Luminosity is elusive. Yet if one is fascinated with light, one is easily drawn into its pursuit—however difficult that pursuit might be. One dictionary describes luminous as "shining; emitting light; bright; brilliant; clear." Well, easier said than done! How can one capture these qualities in reflective, two-dimensional art? Before showing some of Robinson's paintings, a word or two about the technique he uses to produce luminosity are in order. For him the pursuit of luminosity is best described as trying to capture the brightness and clarity of watercolor paints while retaining the brilliance and richness of oil paints.

CAPTURE LUMINOSITY

The approach Robinson uses is time and labor intensive. He seeks to modify the light that falls on a canvas ("incoming light") as it passes through translucent layers of thin oil veneers, strikes the ground of the primed canvas and returns ("outgoing light") through the same layers to meet the viewer's eye. The goal is to capture the luminosity as opposed to merely having the incoming light strike the painted *opaque* surface and reflect back to the viewer's eye in what may be a colorful fashion but a relatively flat one. It's like the difference between how light is affected by a film transparency (like a slide) verses a photographic print.

LAYER UPON LAYER

These translucent layers, or "films," of paint must be painted one at a time. In other words, the whole picture must be painted several times. Since each layer must dry before the next "glaze" is applied, the process can take a good deal more time than the popular "a la prima," or opaque, approach. Each layer is slightly different in color, adding a richness to the light as it passes through the layers of films. In fact, to a degree you can "mix" your colors in these layers instead of on the palette—that is to say, lay a transparent yellow glaze over a transparent blue to create an apparent green.

BASIC TECHNIQUES

Here's a list of the basic techniques Robinson follows in all of his oil paintings in this book:

1. Paint from dark to light.
2. Paint darks more thinly than lights.
3. Cools recede and warms advance; keep the proper locations in the space plane of the painting.
4. "Put on the Miles!" Walk back from your painting *frequently* and look at it from a greater distance to see what is working and what is not.
5. Use a pencil with a rather hard lead (7H or 8H) to do the initial drawing on canvas. The drawing will hold its own when glazed and will not produce a lot of loose carbon dust as with softer leads. However, in order to get the amount of pressure the harder leads require, a firmer backing is needed than stretched canvas can provide. So tape or pin the unstretched canvas to a foamboard or something similar, do the drawing and then stretch the canvas.

VARNISH

Once finished and signed (with a fine pen), the work is given a light coat of Retouch Varnish to recapture any darks that have gone dull. This brings them back to full richness and protects the painting while it dries over the next months. It also allows the painting to be professionally photographed without worrying about high gloss reflections or the darks going dull. After a couple months or more of drying, a damar varnish can be applied for further protection.

The crew of the "Fitted Dinghy," right, is speeding toward an approaching thunderstorm, which is drawing wind into it to feed its growing thunderhead, but the race course requires them to round a marker in the immediate proximity of several exposed and, one can assume, unexposed reefs. I once crewed on a square rigger that was hit by a severe line squall with winds over sixty miles per hour. To the extent one could see, the sky and the entire atmosphere around the ship turned an unnatural green, while the sea itself, so windblown and beaten by the heavy rain, was a uniform sheet of white foam.

In the foreground, the sun is shining and the waters are shallow, so the famous Bermuda aqua blue-green waters should be quite in evidence. However, as one goes out toward the horizon, the sunlight gives way to the storm and the bright aqua blue-greens give way to blue-green-grays. Less and less light is hitting the sandy bottom and reflecting back to the surface, and more and more of the light seen on the water is reflected from the dark gray sky.

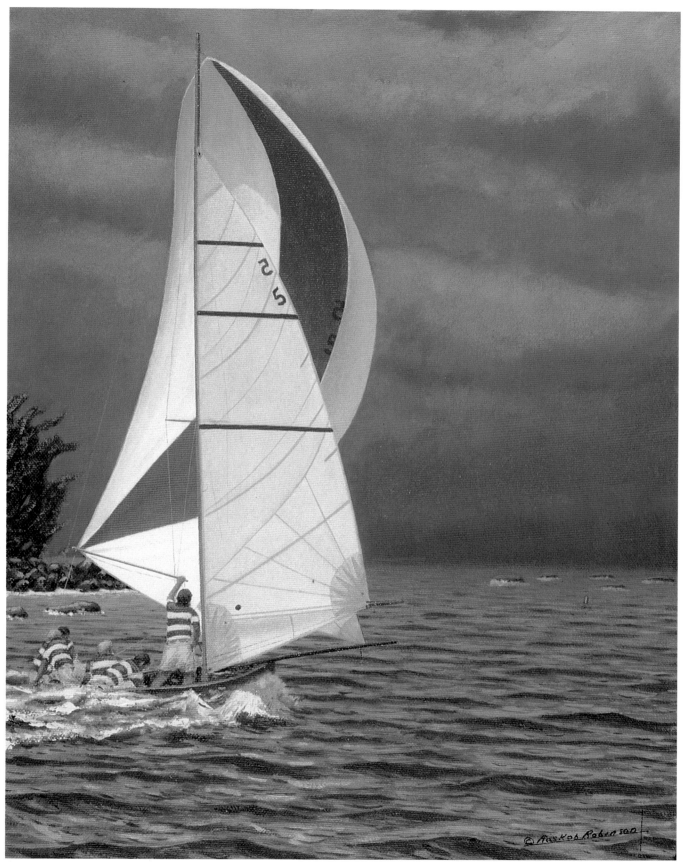

SPINNAKER RUN
14″ × 18″ (35.6cm × 45.7cm)
Charles Raskob Robinson, Oil on Canvas

Achieving Luminosity With Transparent Glazes in Oil

CHARLES RASKOB ROBINSON, OIL

STEP I

Sketch In

Sketch in the sailboats on a Burnt Sienna toned canvas, a ground I use for warm subjects. The toning serves to "fix" the pencil drawing; however, take care not to remove or wash off some of the pencil drawing with the mostly turpentine wash. Once the canvas is stretched, only the jib of the boat on the right will be evident—just enough to convey the competitive atmosphere of the setting.

STEP 2

Block in With Paint: From the Sky to the Horizon

Block in the sky and the land features, as well as the first glaze of the sails on the principal boat (with no. 5 on its sail). The paint used in these layers/glazes is mixed very thinly, using mostly turpentine but also a little medium. On the palette, the paints diluted in this fashion look more like watercolors than oils. Since they are so thin, they could be easily affected by solvents in subsequent layers/glazes, so it's important that one layer is thoroughly dry before the next one is applied.

Sometimes even the diluted film/glaze is too much, and in this case, the paint is allowed to sit for a few minutes before it is rubbed very gently (more like a dragging motion) with a crumpled-up paper towel. This has the effect of revealing on the tooth of the canvas whatever tone or underpaint appears below. This approach was used to complement the warm colors of Burnt Sienna and Cerulean Blue, which are found in the sky (the former at the horizon and the latter higher up in the sky) and in the clouds, where more white was used than in the sky.

Note the beginning of the "egg" effect—developing the roundness of the sail—in how the whited underpainting of the sail allows more of the undertone to come through where the sail bends in toward the mast.

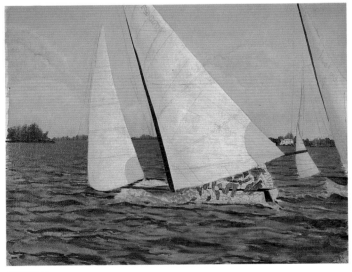

STEP 3

Block in With Paint: The Water and the Boats

Work "back to front." Paint the ill-defined water at the horizon, and move forward to the better defined water of the middle and foregrounds. Reinforce the pencil outlines of the waves with a mixture of Ultramarine Blue, Burnt Umber, Viridian and Winsor Violet. The halftone colors used for the rest of the wave structure should show it's a sunny day, and the famous blue-green color of the water should be evident to a degree. Some white mixed with these halftones gives interesting colors for breaking water at the bows or in the wakes of the boats.

Unpainted parts of the boat, houses on land, etc., receive a wash to help adjust the value to the surrounding painted areas. Use additional washes to shape up arms and legs of the crew.

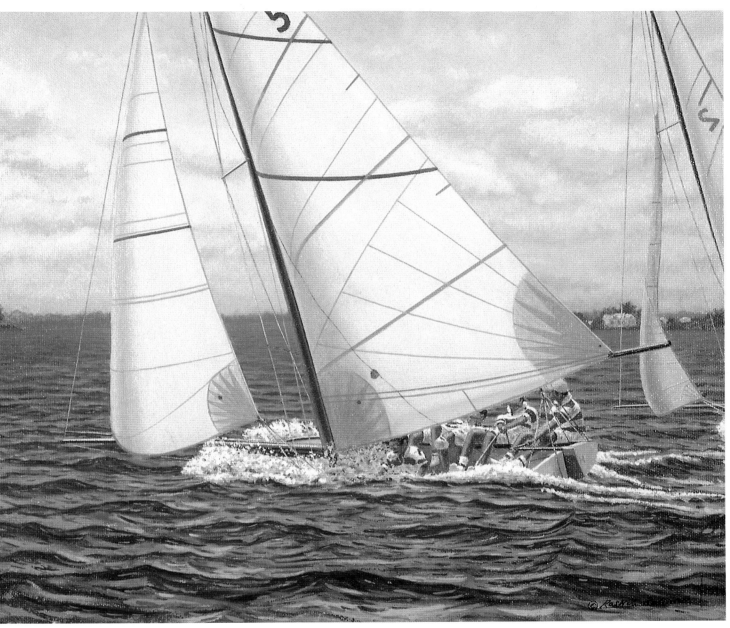

ACROSS MANGROVE BAY
17" × 25" (43.2cm × 63.5cm)
Charles Raskob Robinson, Oil on Canvas

STEP 4 AND MORE!

Layers of Glazes

Once blocked in, the real odyssey begins: painting the same work another half-dozen times or more. But in these glazes of different colors and hues lies the power of luminosity. Each session should lead to a completed additional veneer or layer of paint, thinly applied and allowed to dry thoroughly before the next layer of glaze is applied.

This technique of painting thin layers each slightly different is continued three to five times more. These glaze layers gradually add a depth and richness, but it takes more than just one more glaze. It is not until the last layers are painted that the detail becomes apparent, especially in the sails, rigging and crew members.

Once finished and signed with a fine pen, I apply a light coat of Retouch Varnish to recapture any darks that have gone dull. This brings them back to full richness and protects the painting while it dries over the next months. It also allows the painting to be professionally photographed without worrying on the one hand about high gloss reflections or the darks going dull. After a couple months or more of drying a Damar Varnish can be applied for further protection.

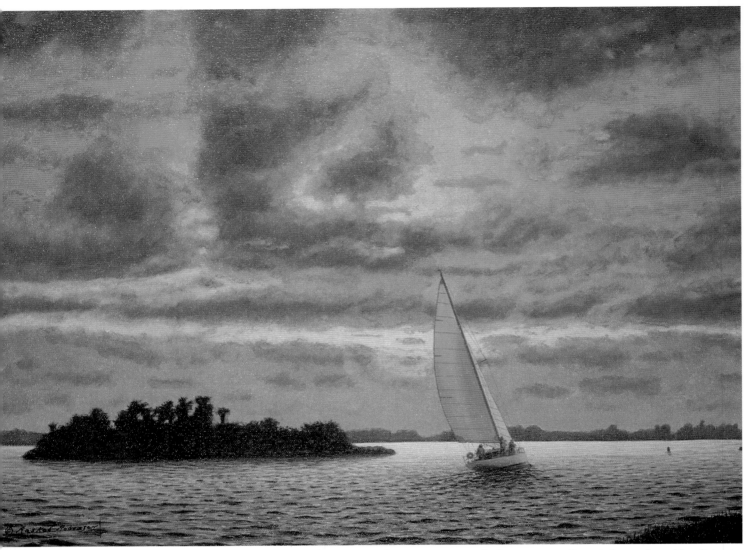

HOMEWARD BOUND, BERMUDA
17"×25" (43.2cm×63.5cm)
Charles Raskob Robinson, Oil on Canvas

Since this is primarily a sunset scene, it shows a complicated sky anchored by distant and middle-ground land masses. Alizarin Crimson combined with the intensity of the Cadmium Yellows gives a strong underpainting for the warmest part of the sky. The layers of glazes described in the demos are particularly important in creating luminosity, depth and space in a sunset sky. In the far distance, the water is dominated by the reflected sunlight; there is virtually no definition of the individual waves. As one nears the middle and foregrounds, the other colors of the sky play a more important role and the individual waves take on character.

BERMUDA'S "FITTED DINGHY"

The "Fitted Dinghy" of Bermuda, as seen in *Spinnaker Run, Homeward Bound* and *Across Mangrove Bay*, is a small (14 feet in length) craft. They are over-manned (a crew of five) and overcanvassed (carrying as much sail as a 40-foot sloop). As a result they, along with the Chesapeake Bay Sailing Log Canoes and the Sydney Harbor Racing Dinghies of Australia, epitomize pushing crew, canvas and craft to the limit, and then some. From an artist's point of view, the geometry of the sails (and even the way the sails are seamed), the color of the crews' uniforms, the great variety of sky-sea combinations found in Bermuda all combine with the dynamic action of the race to provide interesting painting material.

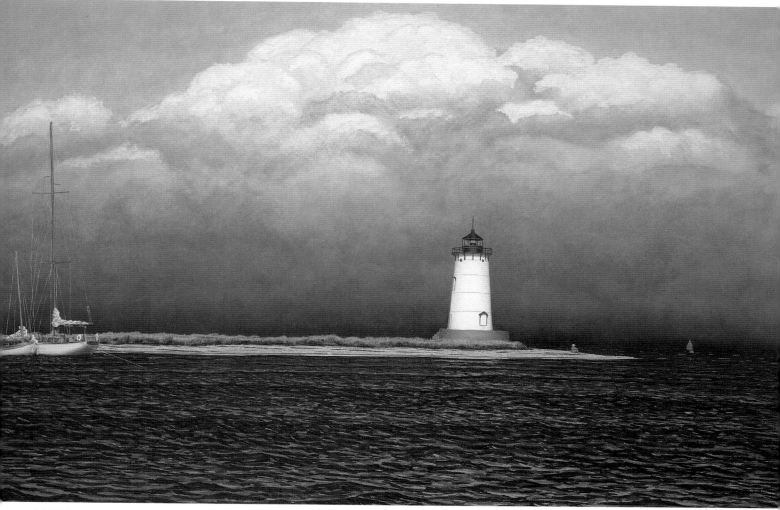

SAFE HARBOR
19" × 30" (48.3cm × 76.2cm)
Charles Raskob Robinson, Oil on Canvas

A classic sloop is anchored safely in the Edgartown Harbor as a summer storm approaches behind the Edgartown Light (lighthouse), which is lit by low afternoon sunlight. A seated observer watches a "Doughdish"—a local gaff-rigged sailboat—hasten into port in advance of the storm.

REMOVING PAINT FROM A GLAZED PAINTING

With all of the blotting, dragging and repeated painting this technique involves, you should know how paint can be removed from an area without endangering the veneers of paint below it. Use a sable bright (the flat, square brush often used in watercolor painting). Larger ones work better than smaller ones; a no. 8 to no. 10 is best. Dip the brush in turpentine, drag the flat side across a paper towel to draw off most of the turpentine and then apply the flat side of the brush to the area to be cleaned. Keep the angle of the brush less than 45 degrees to the surface of the canvas. Move the brush from side to side once or twice, lifting the wayward paint. Then dip it back in the turpentine and blot it on a paper towel, holding the flat edge of the brush to the towel. Repeat as needed.

CIVIT II
Charles Raskob Robinson
Oil on Canvas

Portraying Traditional Wooden Working Boats

DEE KNOTT, WATERCOLOR

Many of Dee Knott's paintings portray traditional working boats. The boatbuilders who labored over them and the fishermen whose livelihood depended upon them are all important parts of history. Wooden boats, from working Core Sound skiffs to masted schooners, are great passions of hers.

Living in a coastal community as far east as one can reach on this continent, she's able to quietly and diligently observe moments when the light, wind, colors and sounds reveal the inner beauty and feeling of the wooden boat—as when the sun illuminates the sail and throws brilliant reflections to dance in the sea, or when one hears the sounds of a wooden spritsail rocking back and forth on a calm day as the sea makes a gurgling sound beneath the hull.

WOODEN SPRITSAIL

A spritsail is a canvas sail, and there is also a traditional wooden fishing boat native to the Outer Banks of North Carolina known as a spritsail (after the sail). These nearly flat-bottomed sailboats, about 16 to 20 feet in length, were developed before engines came into use. Their flat bottoms were useful to the fishermen who fished the many shallow marshes and canals of the Outer Banks and are still found in that area.

STEP I

Sketch and First Wash

Make a brief, loose sketch on 100 percent rag premium watercolor board (Crescent), concentrating on the shapes and their placement in the composition. Wet the surface with a 3-inch hake brush leaving the white of the boat and reflections in the water. When the sheen of the wet paper is almost gone, use hake brushes to stroke the sky and water horizontally using wispy strokes with a mixture of Alizarin Crimson, Cadmium Yellow Pale and a touch of Payne's Gray. Leave the whites untouched. When dry, deepen the sky mixture with Raw Sienna and put down the first shapes of the rocks using a no. 6 round brush.

Additional Background Color

Re-wet the sky and water, and with a wash of Antwerp Blue, Payne's Gray and Alizarin Crimson, make wispy strokes. Dry, and then use Winsor Violet and Cadmium Yellow Pale to build up shapes of the rocks. Be careful to leave the whites.

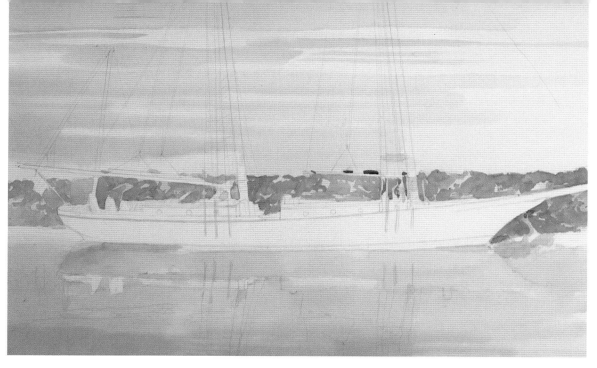

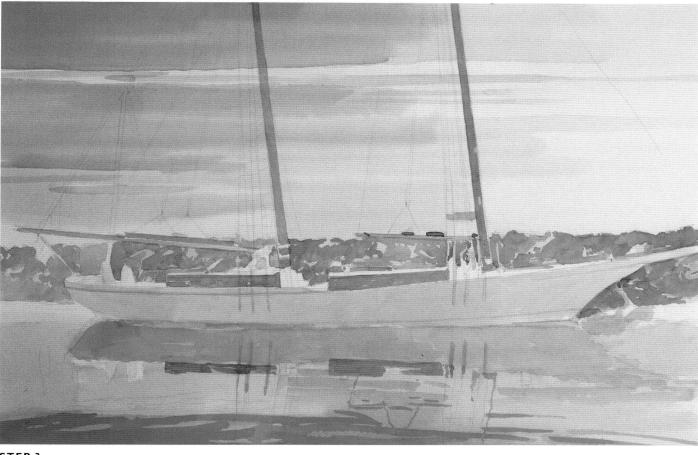

STEP 3

Layer Glazes Slowly

Warm up the rocks a little to show the absorption of the evening sun. Use Raw Sienna, Cadmium Red and a touch of Payne's Gray to begin work on the masts and reflected rigging, using very loose strokes. I like a painterly quality versus a more rigid ruled stroke. Repeat several layers on the hull, waiting until each layer dries, alternating French Ultramarine Blue and Alizarin Crimson to build up a translucent quality of the soft twilight reflected on the schooner. When dry, use Alizarin Crimson to define the waterline.

I was unhappy with the sky so I re-wet the sky and water again and used a hake brush to streak more colors across the sky and water, also laying in the reflections of the hull.

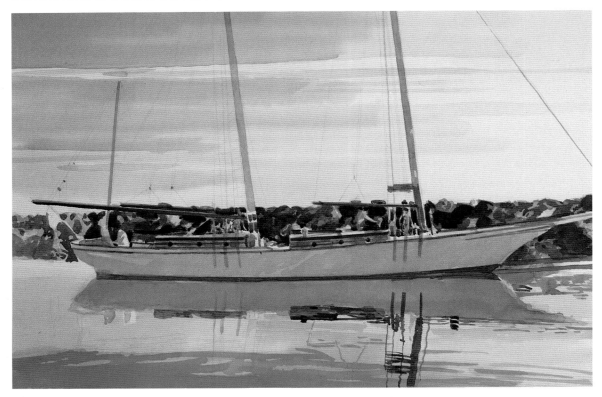

STEP 4

Get the Hull Right

Alternate more layers of Ultramarine and Alizarin on the hull, then add a touch of Payne's Gray to the mixture until you have the right hue for the hull. Add details to the trim and deepen the schooner's reflection by adding more Payne's Gray to the hull mixture. Lightly add more rigging at this time with Raw Sienna and Cobalt Blue.

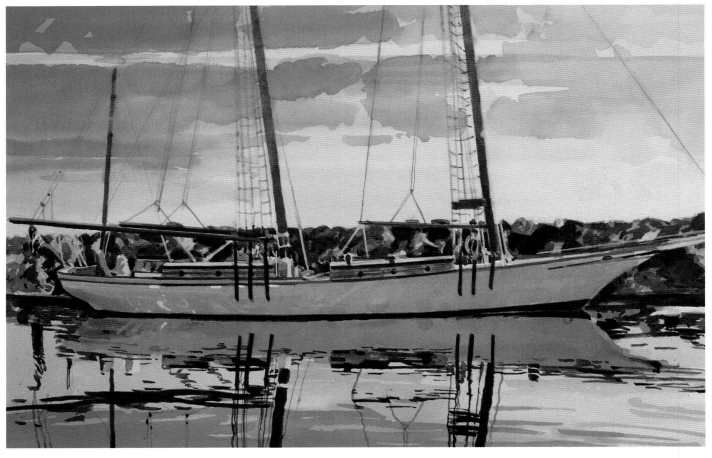

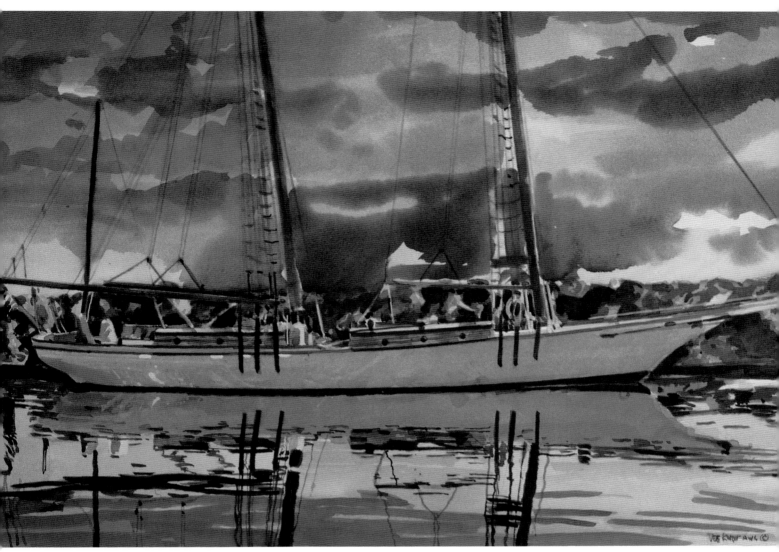

EDGE OF THE SEA
20" × 28" (50.8cm × 71.1cm)
Dee Knott, Transparent Watercolor

left
STEP 5

Paint How You Feel

Put final touches on the rocks, deepening areas behind the schooner to help push the hull to the foreground. To get the feel of the reflections in the water, indicate the important shadows and rigging. Don't try to duplicate exactly what you see. The feeling I had when I saw this schooner was very emotional; it wasn't the technical rigging that inspired me. Using a no. 6 brush with a fine point, put in fine loose rigging, making sure it doesn't get too dark. The quality of light is what's most important here. With this in mind, put a wash of Yellow Ochre over the hull and wood trim and the schooner's reflection.

STEP 6

Bring the Painting to Life

The painting was basically completed in the previous step, but it wasn't what I felt inside. I knew the problem was still the sky. I didn't know exactly what to do, but as in so many other paintings, you go get some fresh water and take a deep breath knowing all your hard work could go right out the window. So I wet the entire sky, made a mixture of French Ultramarine Blue and Cadmium Red and, leaving some of the previous blue sky intact, I just felt the sky. I wasn't sure where to put each stroke (no. 12 brush); I just felt it. I was so excited when the painting finally said what I felt. Taking a risk brought my painting to life.

TIP FROM A PRO

WOODEN BOATS

When painting wooden boats with watercolor, alternately paint every other board to keep one from running into the other.

—GEORGE F. McWILLIAMS

Depicting a Tugboat

ROBERT C. SEMLER, WATERCOLOR

Diamond Swells study depicts a Curtis Bay tugboat, *Cape Hatteras*, cruising the waters of the Chesapeake Bay in Virginia. The distinctive blue diamond on the tug's stack was a familiar sight in days gone by. The line is now owned by Moran Tug, and the remaining vessels carry the white *M* on their black stacks.

Using several black-and-white photographs Semler took of the tug and background, he decided on a high-key color scheme, a bright horizon against the blue-green of the water.

The painting has the appearance of a lot of detail, but a good deal of it is implied. In small places, a spot of light color next to a darker shade will cause one's eye to see more than is actually there. One thing that makes paintings of vessels accurate is their proper identification, that is, the name. Also, make sure your identification colors are correct. When painting small de-

tails, try using a magnifying glass. Railings, antennas, lines of all sizes, etc., may be put in this way.

Semler decides whether to use transparent or opaque paint depending on the desired effect. However, he's a purist when it comes to the sky and never uses gouache there. The sky should be well planned and painted quickly.

STEP 1

I pencil in a relatively detailed drawing of the tug on 140-lb. paper. When painting specific vessels in watercolor, it's best to get the correct placement and proportions penciled in before applying paint. Should you have too many portholes, or doors in the wrong place, it's not easily corrected later. I wash in the medium tone of the water, having already washed in the sky.

STEP 2

Paint in the basic tones on dry paper with watercolor. No detail work is done yet, just base colors to establish the overall value scheme. Transparent watercolors give a glow to the finished work.

STEP 3

A lot more detail is added now. Use gouache to darken the stack, add the portholes, emphasize the bumpers on the hull and generally emphasize the darks and lights. Use gouache for details and overpainting. It's especially nice for fine lines and covering previously painted dark areas. The hull is painted with washes of Burnt Umber, drying thoroughly between each application, and then washed with greens and blues to indicate age. Scumble rust colors over the hull with a dry brush. I haven't touched the water yet except for the base coat. Establish the subject first to help place the boat *in* the water. After the boat's painted, you can overlap the water and place the waves to establish clear location.

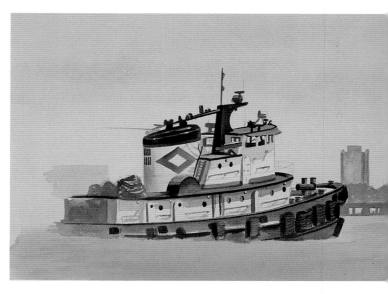

STEP 5

To put in details such as the name of the vessel or small lights, using a magnifying glass helps a lot. If it looks good under the glass, you can be assured it will look good in the finished painting.

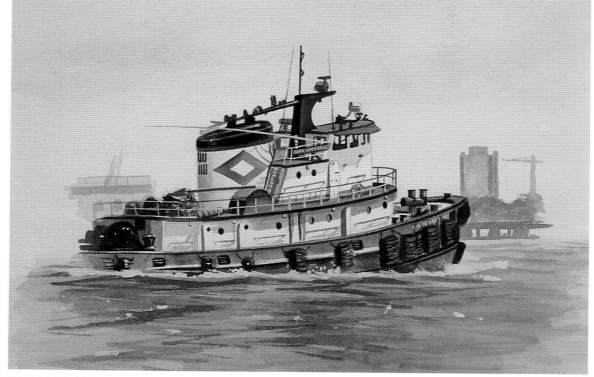

STEP 4

After I put in the darker blue-green tone to the overall area of the water, I find that a small hairdryer shortens the drying time and keeps the paper flat. After this is thoroughly dried, use dark and light tones of gouache to add waves and highlights to the water. Pure white gouache with a touch of yellow used sparingly places sparkles from the sun and whitecaps.

above

STEP 6

Use pure white gouache to place the small opaque details, such as the antennas, railings, wave foam, etc. The combination of traditional watercolor and gouache can make a painting vibrate with color and good values.

DIAMOND SWELLS STUDY
12" × 18" (30.5cm × 45.7cm)
Robert C. Semler, Watercolor/Gouache

Here is the finished study.

More Tugs...

H ere are some important points to remember when painting tugboats.

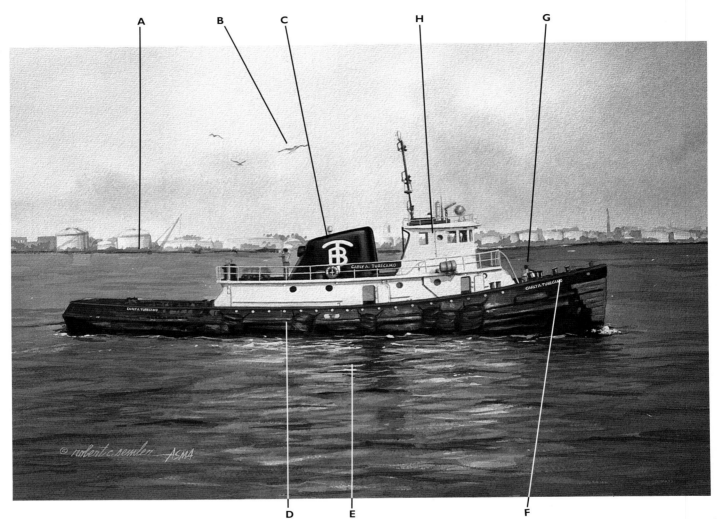

CARLY A. TURECAMO
14" × 18" (35.6cm × 45.7cm)
Robert C. Semler, Watercolor/Gouache

A. Make sure your horizon line and the view of the tug are on the same plane. This is especially important when combining several photographs to create a specific scene. And remember the rule of aerial perspective: The foreground subject will be sharper and brighter than the background as viewed at a distance.

B. Gulls add interest and can cover mistakes.

C. Company logo is important to collectors.

D. Tugboat hulls are loaded with browns, blues and rust colors. Remember, they are *working* vessels. People don't like tugs bright and shiny. Show character.

E. Pay close attention to the reflections, not only from the boat itself, but from the surrounding sky. Using the sky colors ties the painting together. Make sure the water washes *over* the boat, and add small highlights of foam to show movement.

F. Tug name identifies vessel for collectors.

G. Add figures for additional interest.

H. Make sure you research the color scheme.

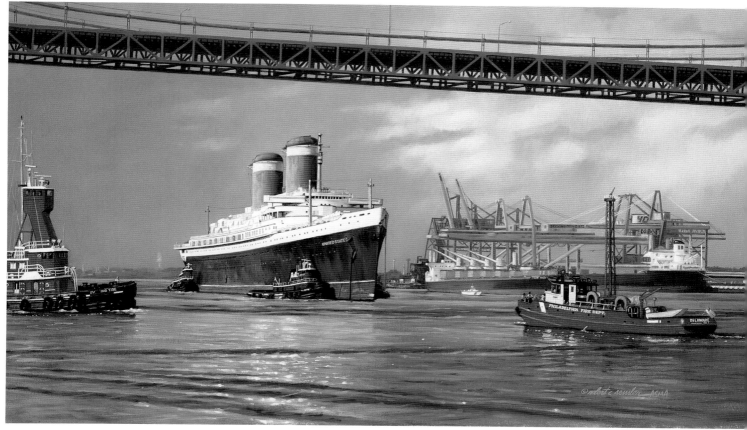

ANTICIPATION
14"×24" (35.6cm×61cm)
Robert C. Semler, Watercolor/Gouache

The SS *United States* luxury liner was moved to a temporary berthing in Philadelphia in August 1996. There's not only anticipation of what lies in the future, but anticipation from all concerned as to whether she will clear the approaching Walt Whitman Bridge.

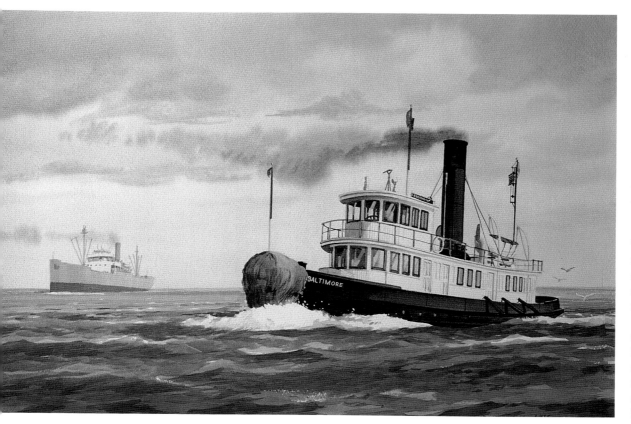

STEAM TUG BALTIMORE
15"×20"
(38.1cm×50.8cm)
James Drake Iams
Watercolor

This historic steam tug was built around 1910. It's riding out to meet a freighter circa the 1930s. This tug is still harbored in Baltimore and can occasionally be seen chugging around as an exhibition piece.

Painting a Morning Fog

LOIS SALMON TOOLE, WATERCOLOR

This demonstration explores the influences of a common shore atmospheric occurrence: a dense morning fog that is about to be burned off by the sun. The entire painting will be permeated with the shrouded aura of fog. Sky, water and horizon will merge and disappear, and out of the void will begin to emerge illusory shapes. As the shapes advance diagonally forward, the monochromatic fog reluctantly gives way to reveal form, detail, range of values and color. The still air barely moves the water.

Materials:
300-lb. Arches rag paper
3-inch hake brush for washes
1½-inch, 1-inch and ½-inch flats
assorted rounds with good points
Winsor & Newton transparent watercolors

STEP I

Basic Drawing and Miniature Study

Draw in the composition. Keep in mind the elusive quality of the emerging images and the relationship of the two lines of boats. I use my miniature painting as a guide. Mask the whites and lights you want to save. Eventually the background whites will be softened with skyglow color. Work quickly on mostly wet paper to keep edges soft for when you start to paint. Fog softens all edges, particularly in the distance.

STEP 2

Establish the Light

The light source is from the upper right, so concentrate the highest light there. With the hake brush, wet the entire paper. Then apply Aureolin from the upper right grading downward. Bring in Yellow Ochre from the upper left and lower right, tipping the paper to let them all mix and achieve a gradual transition to fade-out at lower left. Let the paper dry completely.

Mix a large puddle of Antwerp Blue, smaller ones of Cobalt, French Ultramarine, a Cobalt/Alizarin mixture, and Cobalt with a bit of Burnt Sienna. With a 3-inch hake brush, wet the entire paper, then start applying Antwerp from the upper left fading to the right. Change to a 1½-inch flat and add Cobalt and Ultramarine as you progress downward into the darker water. Keep tipping the paper to blend. Finally, with a 1-inch flat, stroke in the Cobalt-Alizarin Crimson mix for the ripples. Once the paper starts to dry, stop. Let it go. Dry with a hairdryer, then re-wet the whole thing and continue. Bear in mind, blues dry a shade lighter; you may even have to repeat this step.

STEP 3

Bring on the Elusive Images

Using round brushes and Antwerp Blue, start to reveal the line of boats at left. Start where vague shapes begin to emerge from the fog, working right to left, gradually bringing in tones of Burnt Sienna and some Cobalt Blue as more detail is revealed. It should be soft and flowing, no hard edges, so keep the whole area wet. It's easy to go too dark. Masking leaves a hard edge to soften.

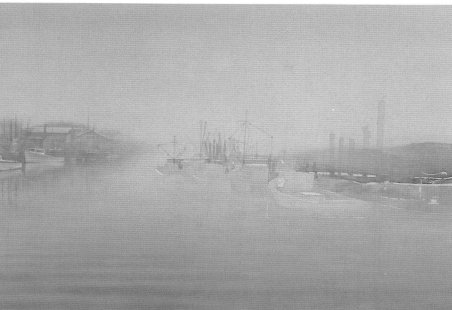

STEP 4

Shore Grasses and Background

Sketch some of the masts and pilings behind the boats with very dilute Antwerp Blue to give a value against which to begin the grasses. With a 1-inch flat, wet the marsh area and lay in grass mass with a light wash of Antwerp Blue. As the grasses advance, overlay with Burnt Sienna, adding Antwerp-Burnt Sienna mix as they begin to assume vague form. To maintain a filmy misty look, keep it soft, keep it light, don't go too dark. You can always add more later.

STEP 5

Float the Boats

My palette is established, and I'll use all the colors in the boats. Antwerp Blue is basic. Again the trick is to remember foggy—soft, not too detailed and not too dark at the beginning. The darkest values and the hardest edges are the objects and reflections at the right foreground. Introduce some Cadmium Orange for reflected light and Indian Red for the flags. Try to uncover the masking as soon as possible because you'll have to play with softening the edges.

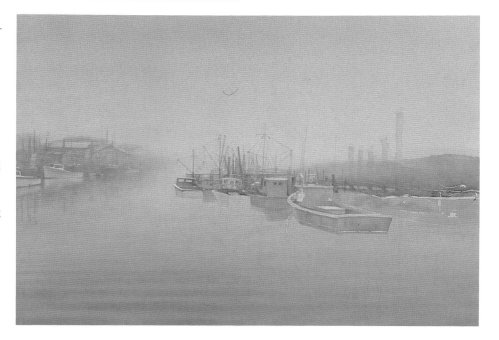

STEP 6

From Boats to Mudflats and Pilings

Continue the boats and start laying in the mudflats. I used a base of Antwerp Blue and mauve, toned down with some Burnt Sienna. Now is the time to form the five tall verticals. To do this, wet each shape with dilute Antwerp Blue and charge in the other colors on your palette. These are knobby, bark-stripped tree trunks. This is the area of darkest values.

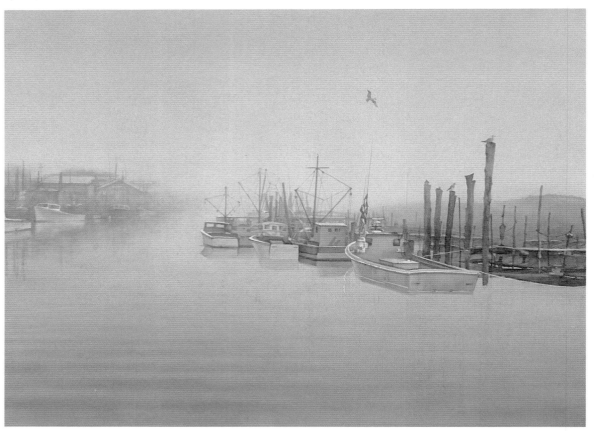

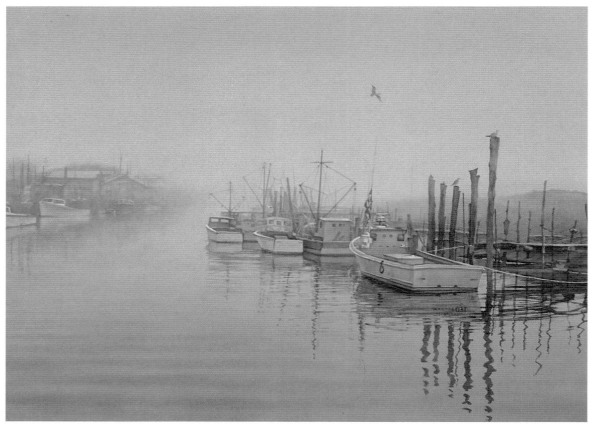

STEP 7

Reflections

Before painting the reflections, check your values. What is done so far will determine the values of the reflections. Do them all in one step if possible. You'll need ample color mixed on the palette and a no. 10 round with a good point. Keep the tones soft so you can add more color or value if necessary.

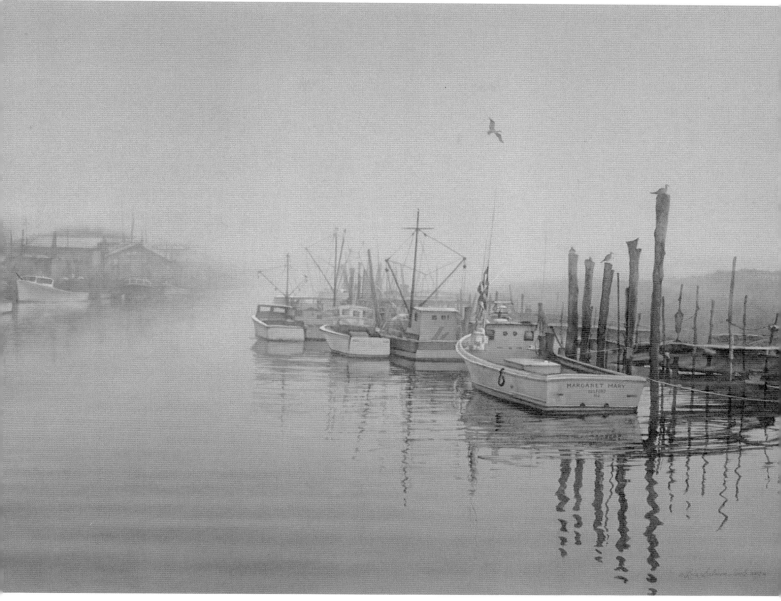

BATHED IN MISTY LIGHT
21"×28" (53.3cm×71.1cm)
Lois Salmon Toole, Watercolor

STEP 8

Make Adjustments and Finish

Now use your trusty mirror: Looking at the painting backward or even upside down gives you a different perspective. I saw right away that the reflections of the foreground boat were too dark, out of sync with the rest, so I extend some of the embankment reflections downward for a better line. When satisfied, I remove the remaining strand of masking and tone in the ropes. In my miniature, I floated a box as another object to play off the fog, but after positioning a cutout shape in various places in the water, I decided to eliminate it.

Settling the Boat Into the Water

MARC CASTELLI, WATERCOLOR

There are people who can paint fantastic water and those who can paint wonderful boats. The challenge is to create convincing water that the boat not only rides on, but with which the boat is a full participant.

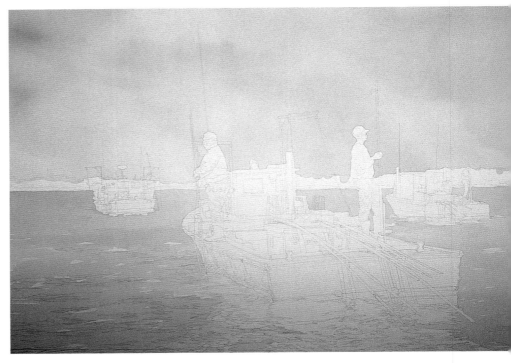

STEP 1

Sky and Water

Do the sky first. Complete a very detailed drawing and then mix Antwerp Blue with lots of water and paint around whites and over the areas that will later be darker. While it's wet, tilt the paper to one corner so the excess water and paint run off the upper left corner. Use horizontal applications to do the water, leaving some white areas between strokes. Reflections are left white for now. The aft deck and engine cover lid are pale blue.

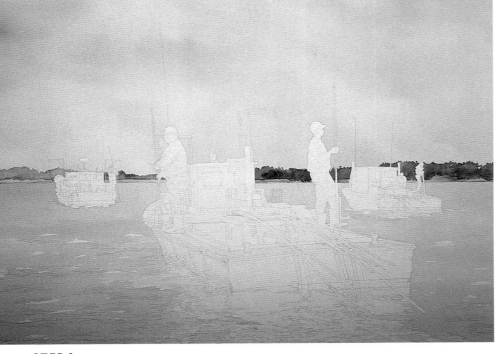

Here is a close-up of the "change-up" technique in the shoreline.

STEP 2

Shoreline

With a no. 8 brush, fairly wet, use mixes of Antwerp Blue, Burnt Sienna, New Gamboge and Winsor Red to work across the shape with "change-ups," sometimes called "charging color." This technique is accomplished by dropping a new color into a previous wash. This can be repeated with several colors, adding variety in color, value or tint.

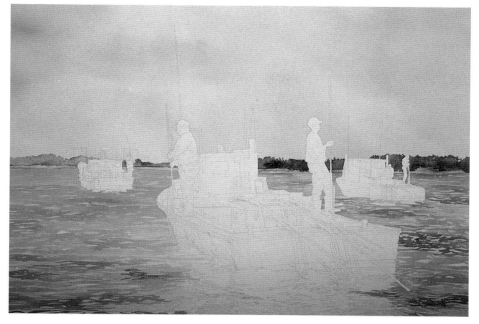

Water

Work over the water with a second layer. Use a no. 4 in the background in and around the boats and figures. Nearer the foreground, change to a larger brush (no. 8). Larger, more informative strokes up close and smaller strokes with less information in the distance create a depth of field. There are many ways to build depth using an active and informed brushstroke. I use Indigo Blue here, which is nearly black when used rich.

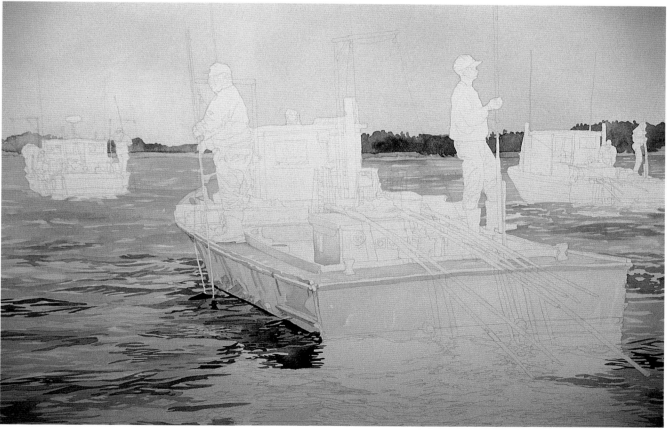

STEP 4

Settling the Boat Into the Water

Paint the boat and water in conjunction with each other. Working new colors into the water creates the variety of surfaces and values that indicate an active surface. The more agitated the surface, the less cohesive a reflection. The reflection's irregular edge must fit into the surface with the surrounding strokes. Draw much of the wave action in and around the reflection. Using varieties of values, build a very active surface using a no. 4 and no. 8 brush. Brush on the reflection of the shadow side of the boat in sections. The waterline in the shadow is Payne's Gray. Now go to the shaded side of the boat to keep visual unity. Reflections in the hull are glazed layers of Antwerp Blue, Burnt Sienna and Raw Sienna. Lightly wash in the areas of boat receiving direct sunlight.

STEP 5

Water and More Details

You'll continue to work on the water until the painting is complete, but now is the time to add some details, such as tong shafts, culling board, tong heads, windows, waterlines (boot tops), engine dials, interior. Here's where you'll realize the importance of ''palette grays'' made from the main colors used: Antwerp Blue, French Ultramarine Blue, Burnt Sienna, Raw Sienna, Purple Lake, Payne's Gray.

Using the ''palette grays'' for the details is important to the integrity of the overall boat. Tong shafts hanging off the transom serve as the viewers path into the sweep of the picture. To capture the air between shafts and transom, make use of their shadows. The transom reflection receives a few pale glazes of Payne's Gray and Raw Sienna to build the swell.

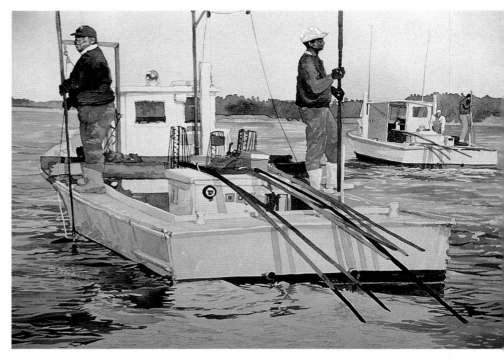

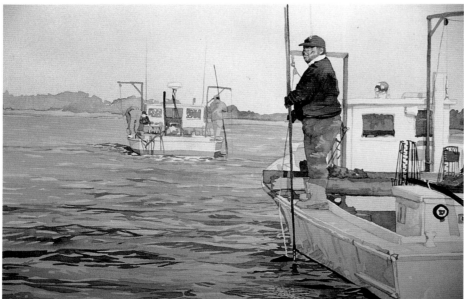

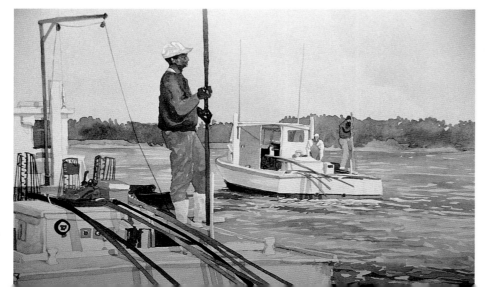

STEP 6

Figures, Background Boats

Work the distracting white unpainted areas up to their appropriate values and contrasts. Leave the white transom reflection for the end as the light in it can only be properly adjusted when the remaining whites are resolved.

There are subtle indicators of the wave, tide and swell actions: The foreground boat has a swell just cresting along the port stern. This reveals more of the boot top and bottom paint on the starboard side. The boat lists to port because of the waterman's size. The boat to the right is listing to starboard (slightly), the opposite direction. This difference in tilt between the boats reinforces the activity of swells and tides, keeping the picture from being too placid.

With the take-up posts painted in, the boat's retreat into the picture plane is enhanced. The figures become posts for the eye to wander in between. Bring up the water with small brushstrokes. This busy texture is an important foil against the relative calm of the boat's larger shapes.

STEP 7

Finishing the Details

I leave the reflection of the nearest transom as the "keystone" piece. It will define the light specific to early morning on the Chester River. Using pale washes of Payne's Gray and Raw Sienna, shape the passing swell. Reflections of the shafts and their shadows help give this water some form. Work a thin wash of Burnt Sienna out from under the shafts on the right, thinning this wash toward the waterline. Taking the same brush load, stroke it onto the reflection.

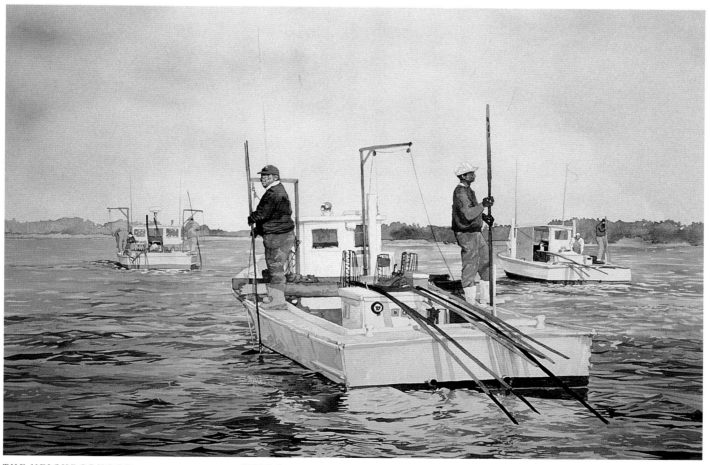

THE NEIGHBORHOOD
22" × 30" (55.9cm × 76.2cm)
Marc Castelli, Watercolor

STEP 8

Finish

Tighten up the water with strokes of Phthalo Blue and some areas of Purple Lake mixed with French Ultramarine Blue. Carefully scan the painting for unwanted white spaces and paint them out. This tightens the image.

More Tips: Settling the Boat Into the Water

IN YOUR FACE—TEAM
NEW ZEALAND
22" × 30" (55.9cm × 76.2cm)
Marc Castelli, Watercolor

The challenge in this painting is the darkness of the hull, its interaction with the water and the water reflections on the hull. The intensity of the hull, the wave slapping up on the bow, the spray against the sky are elements both difficult and attractive. I don't mask anything as I've found Fabriano Artistico, which is the paper I use, doesn't maintain surface integrity when tape or masking fluid is used, though it's a wonderful paper.

One device for settling the boat into the water is to capitalize on the angle of heel. Its implication of the port side being underwater is reinforced by the starboard side's exposure to the air. The verticality of the figures pushes down on the hull, while the angle of the mast and its right angle to the deck dramatizes the heel and the boat's speed.

TIP FROM A PRO

PLACING BOATS IN THE WATER

Boats at rest sit in the water. Lightweight boats appear to float lightly and high. Heavy boats "displace" much water, and deep boats such as "fixed keel" sailboats are said to "draw" much water, regardless of whether they are heavy or light. Make your boats reflect their type in your pictures.

—PETER EGELI

STUDIED INDIFFERENCE
22″×30″ (55.9cm×76.2cm)
Marc Castelli, Watercolor

I've painted racing yachts for nearly twenty years. Over the years, I've received commissions to paint the last several America's Cup events, enabling me to gain access to the boats used by photojournalists covering the event. This is a great opportunity to get close to the contestants throughout the race. This painting deals with the dogfight-like maneuvering while each tries to gain the best side of the starting line. The first race of the '95 Cup was run in very rough conditions of huge swells with towering chop, giving me a chance to work through some very rough conditions. Fitting the boats to the waves, painting the hull graphics through sheets of water and the sails rigged for prestart maneuvering were challenging in this painting.

TIP FROM A PRO
BUILD DEPTH INTO WATER
Keep darker values up close as the water is reflecting the sky's zenith, while farther away, the graying effect of distance softens contrasts.

—MARC CASTELLI

Painting the Wind: Willard Bond's Painting Process

Willard Bond combines realism and abstraction to paint "the way it is out there." For thirty-five years, Bond has been painting on hollow construction "flush doors" ordered from the lumberyard. These doors can be cut to any size, but a plug must be inserted into the cut edges. The resulting panels are light and won't warp. After applying a couple of coats of gesso, he's ready to start. Below is a description of his technique, used for the three diptychs shown on the following pages. For reference he works from marine scenes forwarded to him by some of the world's best marine photographers.

DRAWING PROCESS

As he works with his whole body, Bond completely uses up four or five 2B pencils laying in his initial feelings about the painting. The entire drawing (and painting) process exists on two completely different levels: (1) placing the subject matter in implied space and (2) placing the graphite and paint pigment on the flat surface, creating realism and nonobjective abstraction simultaneously. Bond can get carried away in his drawing, so he sometimes backtracks by partly painting out lines with fresh gesso. He gets quite detailed, though he knows he will "lose" many of these lines in the next process. Bond says, "These lines are committed in my mind!"

ATTACKING THE PAINT WITH "GARBAGE"

He usually has a coffee can of "garbage," old paint and turpentine from soaking brushes during the last painting. He uses this "gunk" to attack the pencil drawing with a 4-inch house-painting brush—white is the enemy! Many of the accidents of this process inspire the rest of the painting; some of the pencil lines remain as an anchor. Much of the graphite mixes with the turpentine, softens and starts to become new movement. The initial concept gives way as the painting starts to paint itself.

DEVELOPING THE PAINT

Much of the process at this point is watching and waiting; watching the painting and waiting for it to tell him what to do next. Most of the work is done from this point on with 2- and 3-inch brushes. The pigment is laced on impasto with some loose mixing done on the palette directly.

ACHIEVING A NONOBJECTIVE REALITY

Bond feels that the painting *is* the paint. The work must exist 99 percent nonobjectively. It should not need the subject matter to make it complete.

Bond explains, "If some world-class racing sailor comes to the painting and says, 'Willard, that's the way it is out there,' I know he is reacting to the abstraction not the subject matter, and I know I have succeeded in painting the wind!"

Bond's palette is usually a discarded glass window he found at some building site or junkyard, and when it gets too raunchy with built up dried paint, he simply turns it over! He uses pigment directly from the tubes—jumbo tubes of Winsor & Newton, 6.75 oz. (200ml).

Drawings for **Hard A Lee!**
Bond works out the expression of his ideas in graphite first, often using up four or five 2B pencils.

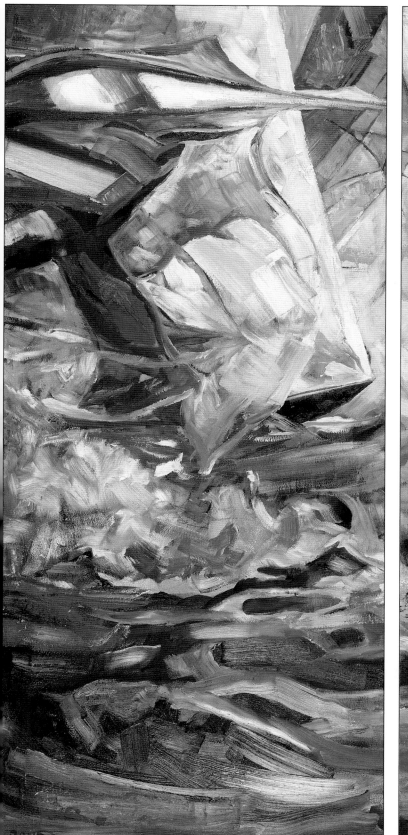
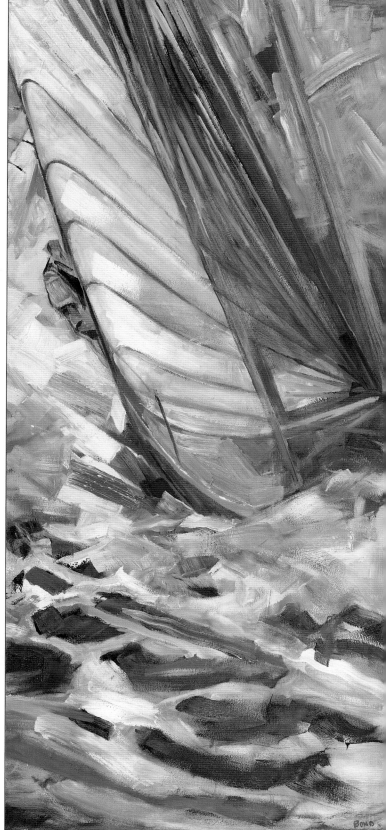

HARD A LEE!
Two panels 3' × 6'8" (91.4cm × 203.2cm)
Total painting 6' × 6'8" (182.8cm × 203.2cm)
Willard Bond, Oil on Mahogany

This example is one of a series of diptychs (two complete paintings displayed side by side creating a third large painting). A complete demonstration of another follows.

PHOTOGRAPHY FOR ALL OF WILLARD BOND'S ARTWORK WAS DONE BY HANK SCHNIEDER.

Painting the Wind

WILLARD BOND, DIPTYCH, OIL ON MAHOGANY

STEP I

Defining the Drawing

Draw on the gessoed "flush doors" with no. 2 pencils. I wear out about eight or ten pencils on a painting this size. In the lower left corner is a crew member I find expendable as the painting progresses. The pencil work defines my thinking and is not set in stone.

details
When drawing, concentrate on shape and movement. Too much detail would be pointless, as it's lost in the wash that follows.

detail

STEP 2

Pull Ideas Together

With a 3-inch housepainting brush, begin to pull ideas together using the turpentine and "garbage" from the sediment in the brush jar. These mix with the pencil carbon to give the effect shown here.

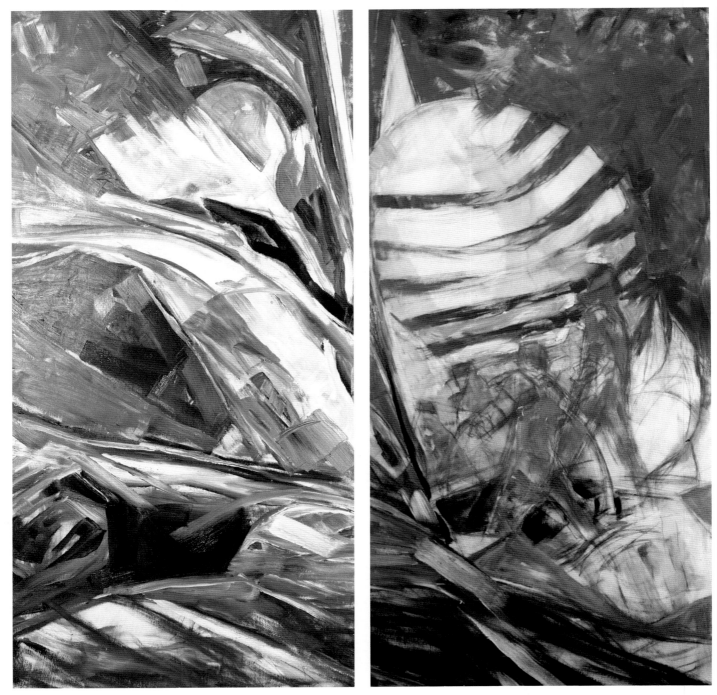

STEP 3

Color Ideas Begin to Gel

This step introduces tentative color ideas. Paint is thinly diluted with turpentine as I try
to get rid of all white. Some color ideas begin to gel only to be changed later. The left
half of the diptych gives you no idea of what the subject matter is.

detail

STEP 4

Impasto Layer

Continue to lay in impasto—color from the tube with no added medium.

detail

STEP 5

"Drawing" With Paint

Sometimes straight lines are laid in by applying paint to the edge of a long straightedge and pressing it into the semi-wet paint.

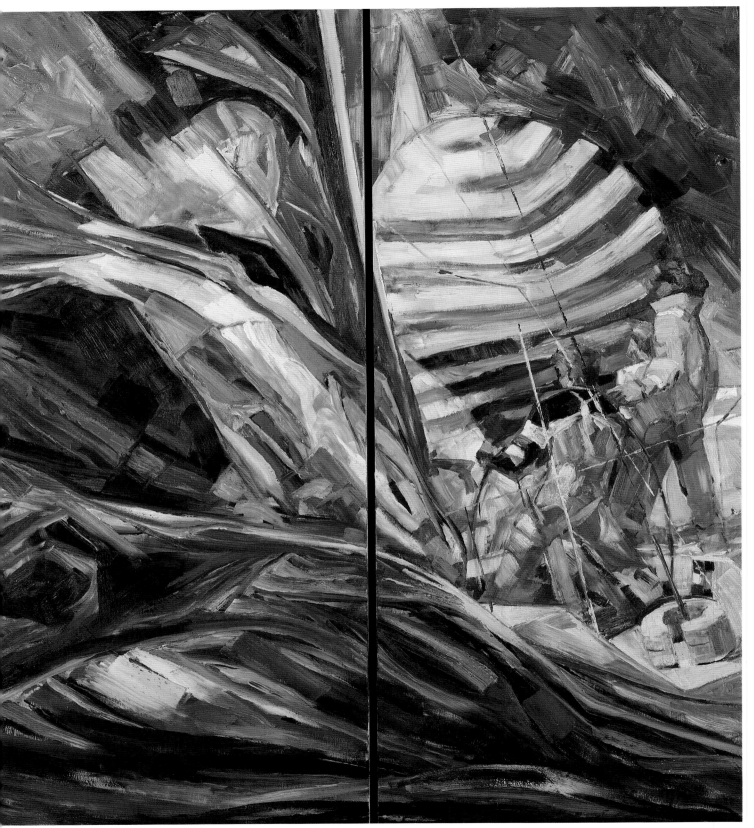

CHAOS AT THE MARK
6′×6′8″ (182.8cm×203.2cm), Willard Bond, Oil on Mahogany

Finished painting.

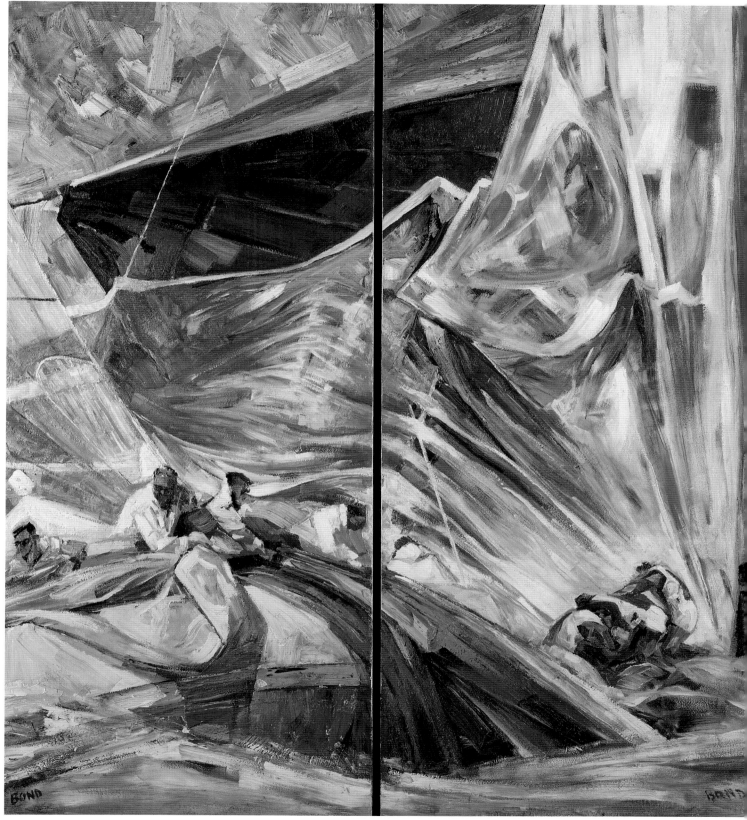

OFF DARIEN
6′ × 6′8″ (182.8cm × 203.2cm)
Willard Bond, Oil on Mahogany

Here is another from Bond's diptych series.

Painting Turbulent Seas

DEE KNOTT, WATERCOLOR

Knott saw this wooden boat in turbulent seas from a bridge. She quickly returned to a pier in the same area as the schooner approached. The wind was enormous as she clung onto the pilings in order to photograph this beautiful vessel.

STEP 1

Paint the Sky and Water in One Wash

Make a loose sketch and apply masking fluid to parts of the schooner, sails, masts and whitecaps. Then wet the entire surface with a 3-inch hake brush, leaving the whites in sails and boat. Just before it's completely dry, make a mixture of Ultramarine Blue, Alizarin Crimson and Ochre. Quickly drop in the mixture starting at the top (I use a no. 12 Kolinsky tail brush). Toward the horizon, add more Ochre to the mixture, then continue with Ultramarine and Alizarin toward the middle of the paper, adding Ochre for reflections.

After it dries, re-wet the entire surface and add a touch of Payne's Green to the previous mixture. With a no. 12 brush, drop this into the sky color, leaving some areas untouched. Add a pale green color to parts of the water, and deepen the bottom areas with more Alizarin and Ultramarine, creating deep purples.

STEP 2

Deepen the Water Color

Re-wet the water areas, and just before the shine disappears, deepen the color of the water mixture, dropping it in certain areas to form the waves. While this mixture is wet, add shadows at the base of the painting with Ultramarine Blue and Payne's Gray.

Remove the masking liquid after the paper is dry. With a mixture of Antwerp Blue and Alizarin Crimson, lightly brush over some of the formerly masked areas, deepening the color toward the bottom of the painting. Indicate the masts and wood trim, and then put a wash of Antwerp Blue over the entire water surface.

STEP 3

Build the Boat in Layers

Put down the first layers of wood trim using Cadmium Yellow Pale, Cadmium Red and Ultramarine Blue. I use a no. 8 Kolinsky brush. Use Ultramarine Blue on the hull of the boat, which will eventually become a deep dark blue. Wet the sail and just note a shadow shape. Watercolor stays translucent if you gradually build in layers allowing underneath areas to show through.

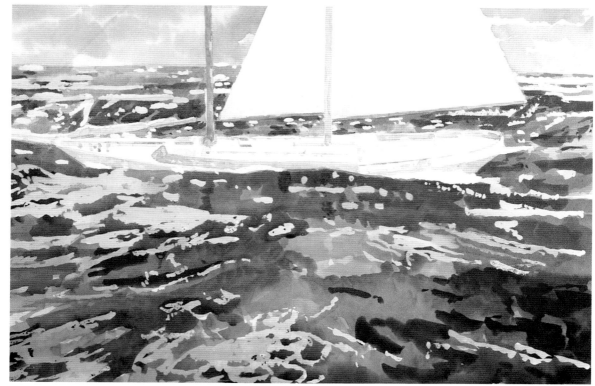

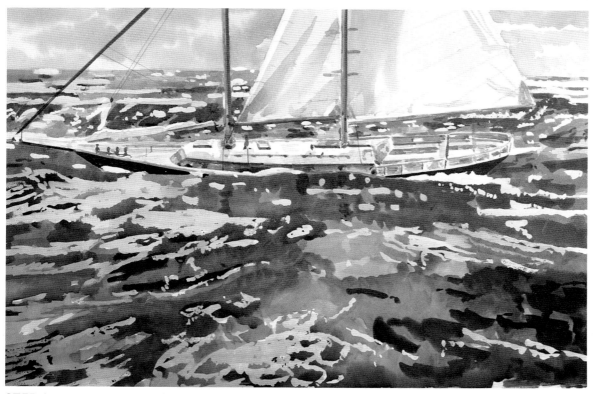

STEP 4

Consider the Location of the Sun

Add Ultramarine Blue to the wood mixture to darken it, and carefully place strokes on the boat and mast. Add Alizarin Crimson and Ultramarine Blue to the hull, letting the paper dry between each layer. Consider the location of the sun and where the shadows should be, then wet the sail. Create shadow areas with Ultramarine Blue, Alizarin Crimson and Payne's Gray, and use small strokes with a no. 8 brush to deepen the shadows on deck. Paint rigging with a no. 3 brush.

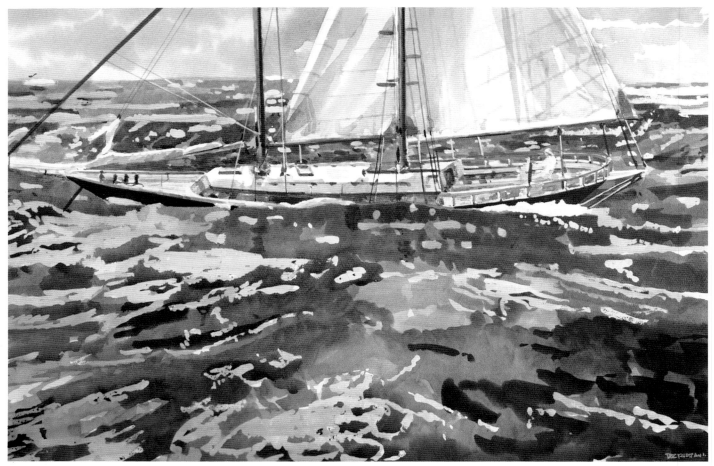

BEAUFORT WINDS II
20" × 28" (50.8cm × 71.1cm), Dee Knott, Watercolor

STEP 5

Finish

I want more illumination from the evening sky so I re-wet the sail. Now you can add more reflections and shadows to the sails, deepen some of the background water with Cobalt Blue and finish the detail on the wood trim.

SAVING WHITES IN WATERCOLOR

The foresail whipping in the wind is captured by leaving the white of the paper along the upper rim of the sail.

The whites that were left untouched on this schooner make you feel the strong sun on the deck, sails and rigging. The contrast of the whites along with the strong brushstrokes of the waves create the exciting image of a wooden boat in turbulent seas.

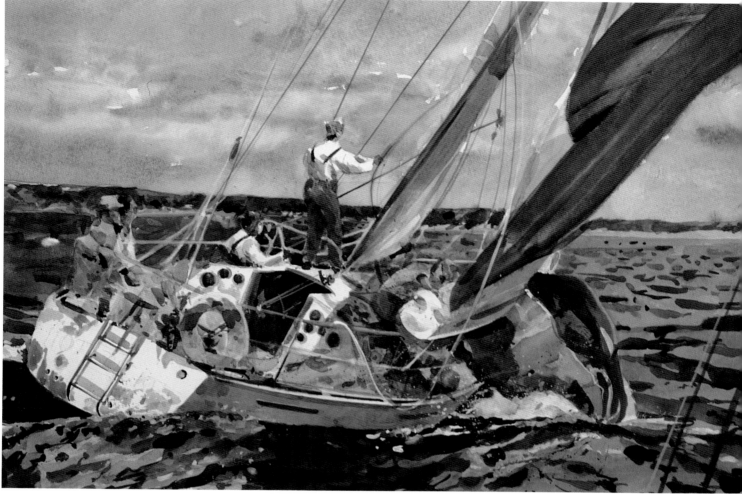

JAZZ MAN
20″ × 28″ (50.8cm × 71.1cm), Dee Knott , Watercolor

Another boat fighting turbulent waters.

Add Interest With Surface Texture

GEORGE GUZZI, ACRYLIC

With few exceptions, George Guzzi starts every acrylic painting with a dark background. This background could be any mixture of Burnt Umber, black, Ultramarine Blue or any dark from his palette. Part of the reason for using this underpainting is that with the painting knife technique he uses, it's easy to miss small areas of the canvas, and he doesn't like any white to show through. He doesn't mind the dark ground showing through; in fact, it heightens the brilliancy of the already bright colors he prefers. Occasionally, when he paints a scene with a large area of water, he'll cover the canvas with a pale wash instead of his usual Umber-based backdrop.

Guzzi likes the speed of painting in acrylics. However, he found that he couldn't get the built-up impasto texture that he was used to when working with oils. His acrylic brushstrokes would smooth out after they were laid down. So he devised a method, combining acrylic gel and paste, to lay down a physical texture on certain areas of the painting before adding the final color. The good news is that rather than waiting the three or four months it would take oil paint of this thickness to dry (Guzzi has tried it!), it takes only minutes, or hours at the most.

The following demonstration of *Port Clyde, Maine* comes out of Guzzi's lifelong interest in marine subjects. He grew up in Maine one-half mile from Winslow Homer's studio, watching the fishermen go in and out with the tides. However, after painting in Europe (see the demonstration on page 116, *Positano Beach*), he decided he liked "European colors" better than the pervasive greens, grays and browns of New England, and so he uses his artistic liberty to add colorful roofs, etc., to the Maine scenery.

Colors:
Alizarin Crimson
Burnt Sienna
Burnt Umber
Cadmium Orange
Cadmium Red Light
Cadmium Yellow Light
Cerulean Blue
Cobalt Blue
Dioxazine Purple
Golden Ochre
Hooker's Green
Ivory Black
Naples Yellow
Payne's Gray
Phthalo Blue
Raw Sienna
Raw Umber
Titanium White
Ultramarine Blue
Unbleached Titanium
Viridian
Yellow Ochre

STEP I

Burnt Umber Base Coat
I cover the stretched canvas with Burnt Umber. The drawing is done with a Berol Verithin Black no. 734 (white) pencil. I feel the umber showing through lends a unifying presence and an intensification of the color.

STEP 2

Mix Paste and Gel for Texture Base

To build an underlying texture for trees, grass, fields, etc., mix two parts of Utrecht modeling paste to one part acrylic gel. When it's mixed—it's still white at this point—add umber and black paint until the mixture is dark brown. Also mix another batch with Viridian or Phthalo Green, Ultramarine Blue and Ivory Black. The dark brown mixture is applied to the background field area behind the buildings with a large painting knife. The greenish mixture is applied to the background tree area. Keep a batch of the white mixture so that if you want a certain part of the painting heavily textured, such as a roof, you can mix the appropriate colors with it and apply it with a knife.

STEP 3

Brush on More Texture

As soon as the paste-gel-paint mixture is applied, take a bottle brush (the kind used to wash dishes) and twirl it in the mixture. Drag the brush vertically up and down for the grass texture and move sideways, at an angle, to impart the texture of the trees. If a broader texture is needed, use a scrub brush. The texture needs to dry for a couple of hours. It will be painted over, and when the brush hits the raised areas of the texture, it gives the perception of grass or trees without painting each blade of grass or each leaf.

STEP 4

Sky and Water

Apply the sky with a large painting knife, using a mixture of Yellow Ochre, Cerulean Blue, Phthalo Blue, Cadmium Yellow Light and white, giving the feeling of a warm summer sky. The water is painted a slightly grayed-down version of the sky color, with Cadmium Red Light added. Clouds are applied with a knife and white paint and are also reflected in water.

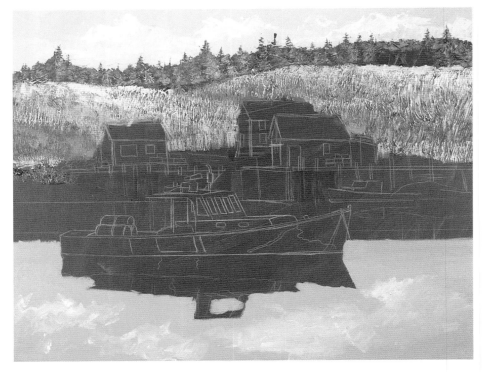

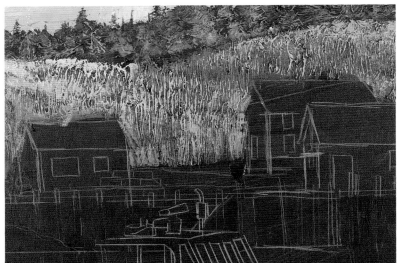

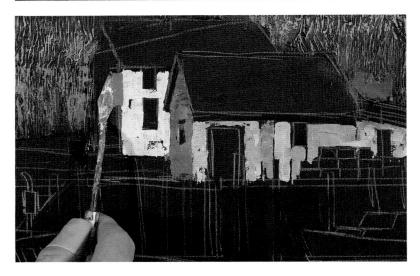

detail
STEP 5

Add Color to the Trees and Grass

Paint trees using a no. 4 bright bristle brush, dragged across the texture. Colors are Permanent Green Light, Phthalo Green, Hooker's Green, Yellow Ochre and white.

The grass in the background is painted by dragging a no. 10 filbert across the texture to impart a more European, warmer palette. Colors are mixtures of Cadmium Yellow Light, Burnt Umber and white; Naples Yellow, Yellow Ochre and umber. Using a no. 8 and no. 10 bright bristle, drag a mixture of Cadmium Orange and white over the grass.

detail
STEP 6

Knife in the Buildings

Using a ½"×2" (1.3cm×5.1cm) painting knife, apply a mixture of Burnt Sienna and white on the left of the door; on the right of the door, mixtures of Burnt Umber, Naples Yellow and white, Yellow Ochre, white and Cadmium Red Light. Payne's Gray, Ultramarine Blue, and Dioxazine Purple are added to the above mixture for the shadow side. Other buildings are white and Cadmium Yellow Light on the sunny side. I make no attempt to cover all the background color as it adds a continuity to the painting.

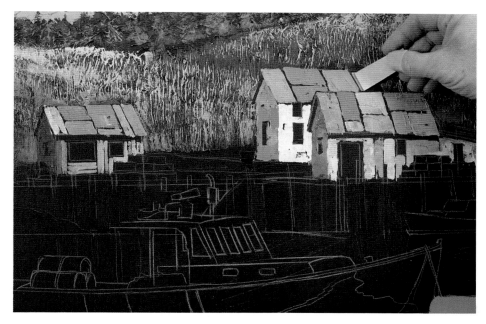

detail

STEP 7

Cardboard Paints the Roof

Use painting knives and pieces of illustration board cut into various sizes to paint the roofs, again using a Mediterranean palette—Cadmium Orange and white, Cadmium Red and white, Cadmium Red Medium and white. Make sure separations of umber are left in the roof when you apply the paint with the cardboard sections, thus enriching the colors.

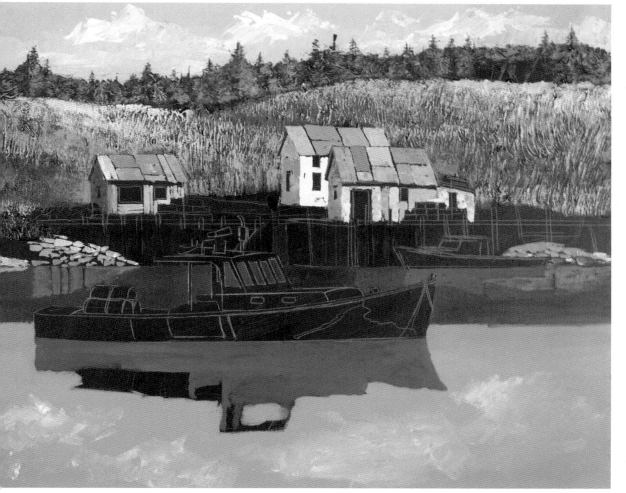

STEP 8

Rocks and Reflections

Paint the rocks using a small painting knife with Burnt Umber, ochre and white, with Dioxazine Purple and Ultramarine Blue added for darker, wetter rocks. Reflections are loosely brushed in with the above colors, Ultramarine Blue and white to cool them off.

STEP 9

Apply Highlights With Cardboard

Using large pieces of cardboard for straight lines, mix Ochre, white and Raw Umber to paint the top of the pier (at left). Umber and Cerulean are used for the pilings under the pier. Apply darks to the shadow side of the pilings with painting knives and cardboard sections. Naples Yellow, white and Raw Umber are applied with cardboard to the light side of the pilings (shown).

STEP 10

Window Details

Use cardboard to paint in the white window frames. Also paint the green shutters and traps with varying sizes of cardboard.

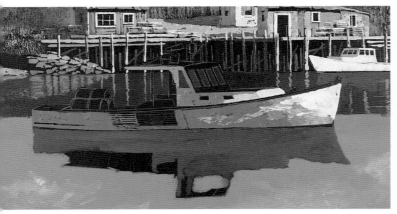

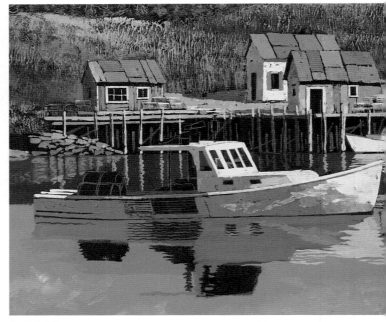

STEP 11

Developing the Boats

Put in reflections from pilings with a no. 2 round brush. Paint the small boat with a knife—white or yellow on sunny side, Payne's Gray and white in the shadow. A knife is also used to paint the shadow side of the large boat.

STEP 12

Boat Details

White and Cadmium Yellow Light are put on the front windows of the cabin with cardboard. The white house in the background looks wrong, so I redo it by taking off one floor. Paint a reflection of the water on the side of the boat with white, Payne's Gray and Yellow Ochre. Paint the reflection of the boat in water with no. 4 bristle and no. 2 round. Put in ribs on the side of the boat with edge of cardboard.

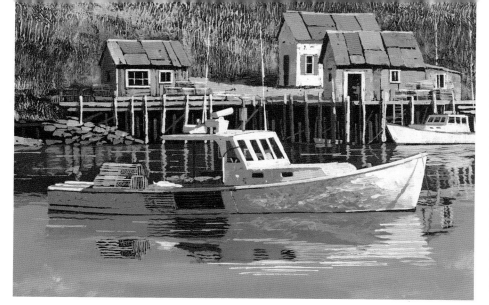

STEP 13

More Details

Lobster traps on the boat are done with the edge of cardboard, using Naples Yellow and white, Burnt Umber and white, and Payne's Gray and white. Add splashes of white, orange and ochre in the boat, and add reflections of these colors as well as white reflections of the cabin. Also paint out the bottom part of the reflection of the large boat because it is distracting. With a no. 2 brush and cardboard, paint the radar equipment on top of the cabin. The tall antenna on the large boat ties it into the background.

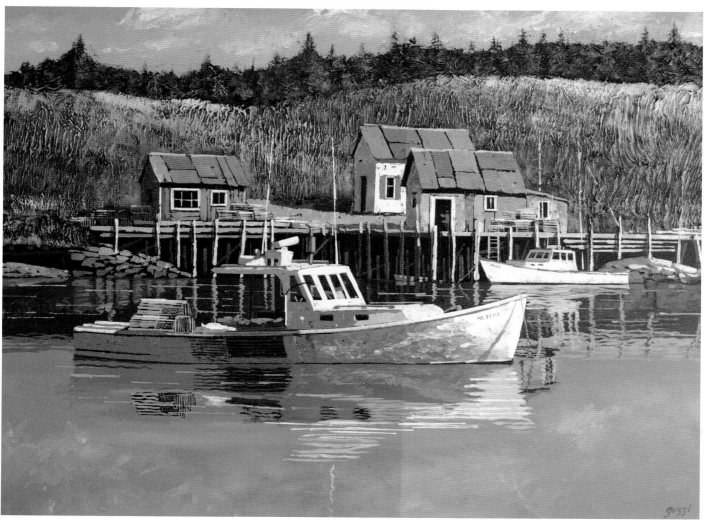

PORT CLYDE, MAINE
22"×28" (55.9cm×71.1cm)
George Guzzi, Acrylic

STEP 14

Finish

To finish off the painting, add the reflection of the antenna, the numbers on the boats, a little rust (wet the side of the boat and run some Burnt Sienna in it) and the railings on top of the cabin. Add a few tall posts, cutting into the grassy area. Take a piece of cardboard and add some blue streaks, reflecting the sky.

Add Colorful Texture to Coastal Scenes

GEORGE GUZZI, ACRYLIC

As a child, Guzzi observed the Maine coast where he lived and was also introduced to the colors and textures of the Italian coast through vistas of Venice painted by an artist named Canaletto. He saw a photo of Positano Beach and decided it would be his first stop in Europe, which indeed it was. He has since painted upward of seventy-five paintings of this coastal Italian village. It's a village built on a cliff with wonderful Moorish architecture contrasting with the jagged edges of the rocks above the town. On the beach, elaborately colored fishing boats are always seen.

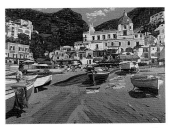

The whole composition—*Positano Beach.*

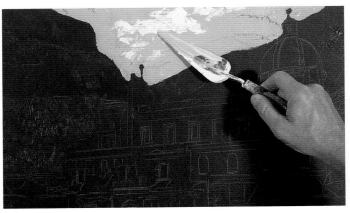

STEP 1

Underpainting and Sky

Paint a canvas brown-black then draw the scene using white pencil. Mix two parts Utrecht modeling paste and one part gloss acrylic gel medium to make a textured paste, then add Phthalo Green, Hooker's Green and Ultramarine Blue. Apply to the canvas in areas where foliage and trees will be. Apply texture with a bottle brush while the mixture is wet. Apply the sky color with a painting knife. Apply pure white for the clouds, then scrape some sky color into the bottom of the clouds.

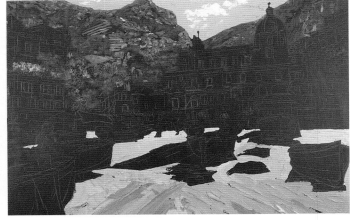

STEP 2

Laying in Beach Color

The beach has grayish blue pebbles, but I choose to warm it up with mixtures of Raw Umber, Ultramarine Blue, a little of the sky color, Indo Orange Red, Burnt Sienna plus white. Spread the color with a painting knife. Make a large amount of the paste-gel mixture and add the colors as you go, giving the beach a thick texture.

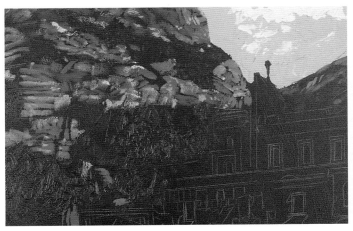

STEP 3

Rocks

For the mountain rocks, use cooler mixtures and spread these with a regular brush.

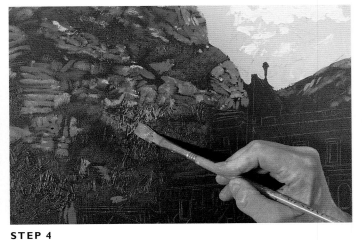

STEP 4

Trees

Use a bristle brush to apply a green mixture over the paste-gel texture, indicating trees.

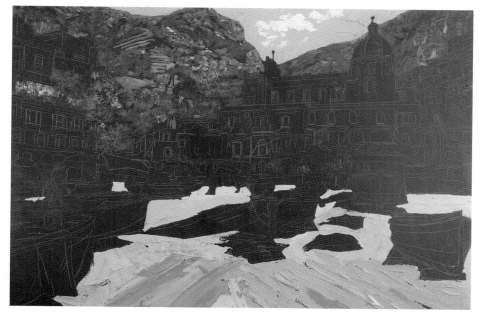

Here's the whole painting to this point.

STEP 5

The Net

Apply the dark side of the net with a knife using a mixture of Burnt Sienna and Dioxazine Purple. The light part of the net (already painted) is a mixture of Burnt Sienna, Cadmium Orange and Cadmium Yellow Medium.

STEP 6

Church

Paint the church with a knife using a mixture of Cadmium Yellow Medium, white, Dioxazine Purple and Raw Umber. Add more purple to the mixture for shadows under the eaves and for shadow sides.

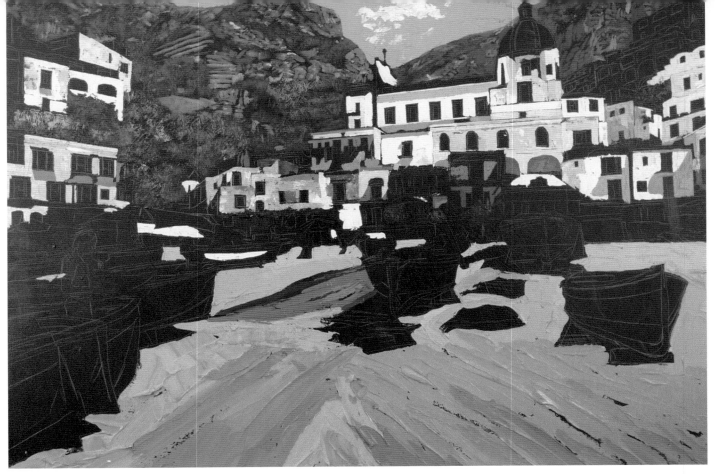

STEP 7

Buildings

Add the buildings on the left using Indo Orange Red and Cadmium Yellow Light and white—applied with a knife. Dioxazine Purple is added to the mixture for shadows under the windows.

detail
STEP 8

Cardboard for Straight Lines

Lay in highlights with cardboard on some buildings, giving a pretty straight edge. Use this technique throughout the painting. On other buildings (such as the gray one), drag a knife across the canvas to give the texture of flaking stucco.

detail
STEP 9

Boat Under the Arch

There are three boats forming a triangle in the right foreground of the painting. This boat is the farthest back and is painted in midtones. The boat on the left point of the triangle is closest and is painted with the brightest colors and most contrast.

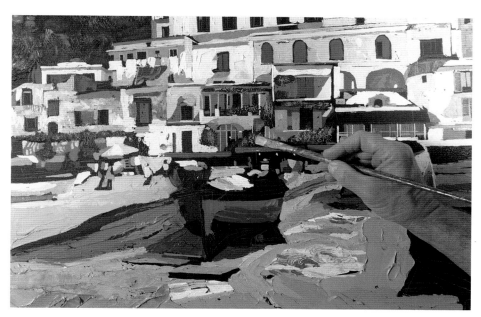

detail

STEP 10

Adding Notes of Interest

As you approach the finish, fill in the front boat with bright and dark mixtures based on Turquoise Deep. Then work on the small details that add interest to busy scenes like this. For these details, use a no. 4 sable brush, knives and cardboard. For the pink building on the left, brush in the shades, then use cardboard for the areas above the windows and the sides of windows. Indicate hanging laundry with a knife and use a no. 6 bright brush (sable) to put in foliage.

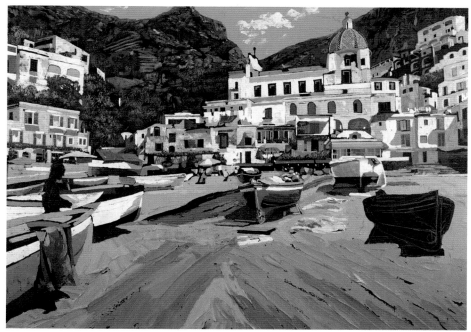

STEP 11

Big Picture

Use Cadmium Red Medium with a knife to finish the bottom of the boat. Add Dioxazine Purple and Ultramarine Blue for shadows.

Roof Lines

Use a piece of mat board to paint the awnings and roof lines.

More Details Added to Finish

Apply a light tone in the window frames with cardboard to show the light coming from the right side.

This boat was redrawn and cardboard used to lay in the seat with Venetian Red, Cadmium Orange and white.

Lay in the fisherman with a knife.

Use a sable brush to add detail to the little children. Apply white and yellow to the kids' shirts in sunlight with a painting knife. All additional details in the boats are done with knives.

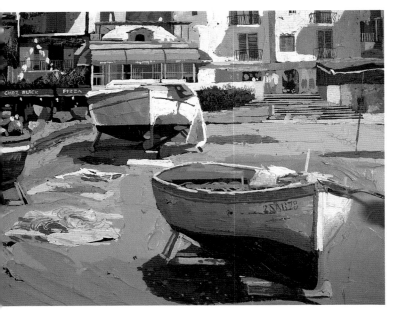

Add white canvas and yellow details to the right-hand boat with a knife. Add some rocks in shadow.

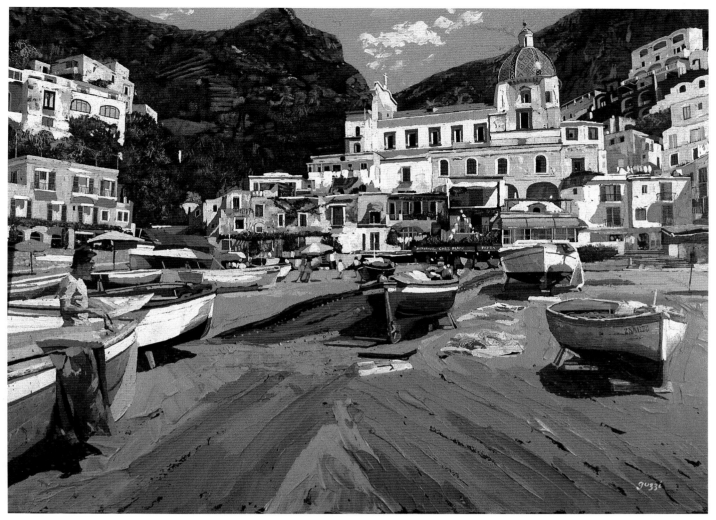

POSITANO BEACH
30″×40″ (76.2cm×101.6cm), George Guzzi, Acrylic

TIP FROM A PRO

OBJECTIVITY

To determine if a painting is really finished, it helps
to place the painting where you will see it frequently
over a period of several days. Another technique is to look at
it in a mirror. Remarkably, this simple reversal of the image
seems to create a new painting—one about which you can be
refreshingly objective.

—JAMES DRAKE IAMS

More Coastal Scenes

GEORGE GUZZI

These paintings of the Mediterranean coast are done with the same techniques shown in the previous demonstration.

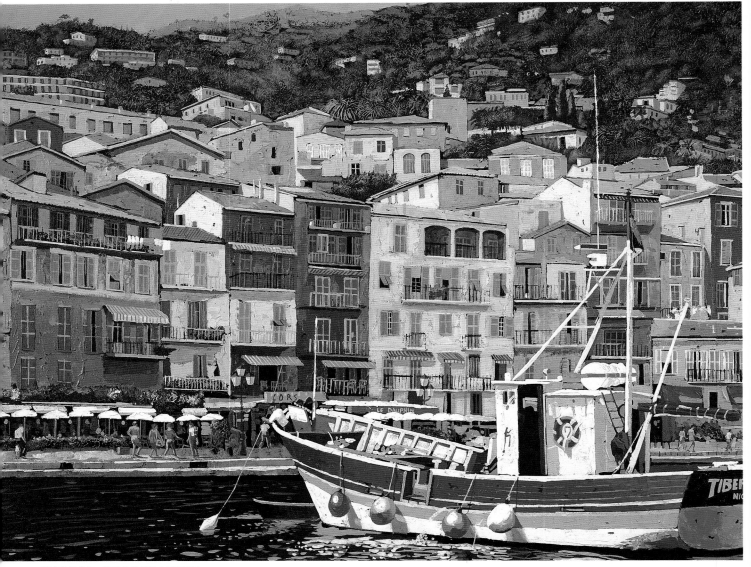

HARBOR, VILLE FRANCHE
30" × 40" (76.2cm × 101.6cm), George Guzzi, Acrylic.
Collection of Mr. and Mrs. Vahan Martirosian

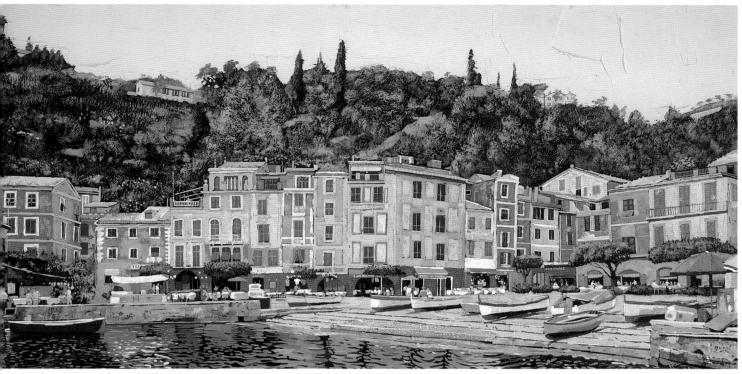

PRIMAVERA A PORTOFINO
24" × 48" (61cm × 121.9cm), George Guzzi, Acrylic. Courtesy of Shaw Gallery, Naples, Florida

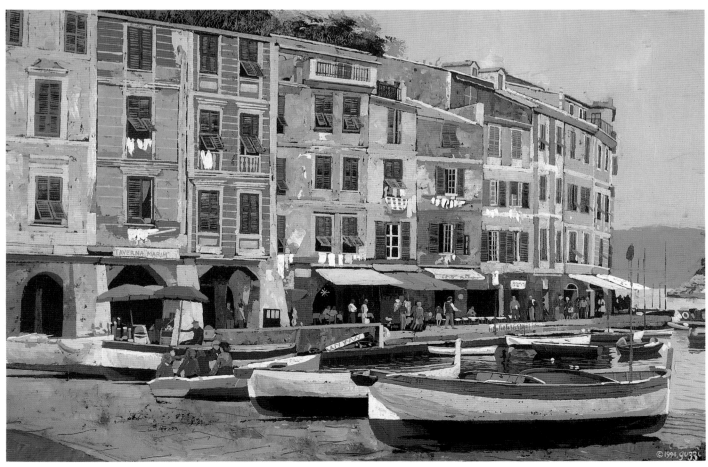

HARBOR VIEW, PORTOFINO
24" × 36" (61cm × 91.4cm), George Guzzi, Acrylic. Collection of Mr. and Mrs. Ron Carrighan

Painting a Rocky Coast

LEONARD MIZEREK, TRANSPARENT WATERCOLOR

This painting was done on location with several trips to the site. Mizerek usually begins a painting with the sky treatment, but it was so windy that the paint was drying too fast for the effect he wanted. He began by painting the rocks, to get the color notes down that would be used throughout the painting. He looked for a strong compositional theme and chose rock formations that directed the eye inward toward the crashing surf. He particularly liked the contrast between the still water in the foreground and the turbulence of crashing waves in the background. The wide-angle format adds drama and emphasizes the horizontal concept.

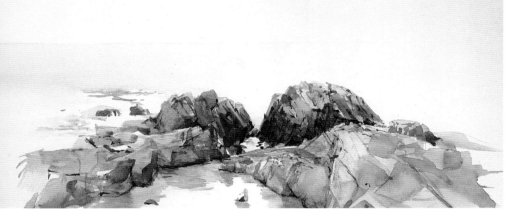

STEP 1

Basic Color Block In

After the initial drawing, block in basic colors using a ½-inch flat brush with angular strokes of diluted Alizarin Crimson and Raw Sienna, blended while wet. In addition, blend Ultramarine Blue with Alizarin and some Winsor Green Light to tone down the reddish color. Let some colors blend, and apply some dry to give biting edges to the rocks. Try to paint in the direction of the grain of the rocks and add dark cracks and dots to solidify them.

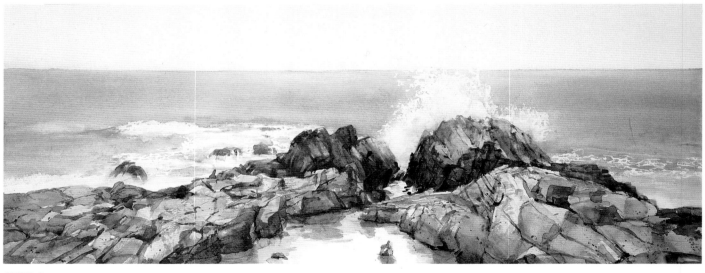

STEP 2

Adding the Water

Add more rocks to the left to fill out the painting. Mask the main cresting wave and the distant breakers, and then add a wash of Viridian and Ultramarine Blue for the body of water. I want the look of a freehand stroke versus a stiff ruled line for the horizon, so I use a large 1½-inch synthetic flat brush, being careful not to have it too ''bumpy.'' While still wet (but not shiny), blend light strokes of Alizarin Crimson mixed with Ultramarine Blue to give variation to the water, darkening the outer areas to help keep the focus on the wave. The breaker actually breaks the horizon and physically ties the water to the sky. Let the small distant rocks to the left blend with the white foam at their base to suggest runoff. Shoreline rocks have cooler colors to reflect the sky when wet.

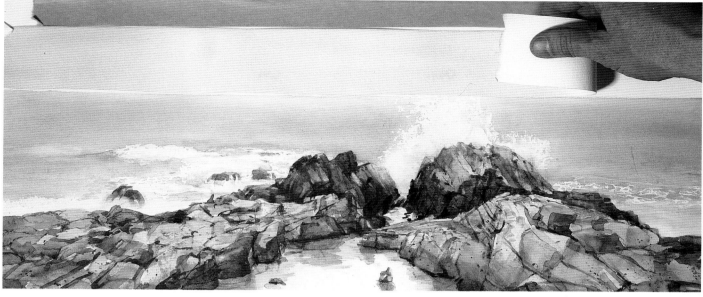

STEP 3

Getting the Sky Color Right

Here's a quick way to ensure you'll have the right sky. Cut strips of watercolor paper (Arches 140-lb. cold-press), and paint different sky treatments on them. Tape them right over your painting. Step back and see how several different skies look. Keep the sky low-key here so it won't compete with or draw attention away from the sea. Skies don't have the same value across the horizon. If you stand in one spot where you can see the horizon, and look left to right, you'll see changes in the intensity of the light. It's lighter when closer to the sun. Adding variety to your sky helps make your painting more interesting.

below
STEP 4

Darken the Water

Carefully remask the edges of the breaker and other water areas that you want to remain white, and then darken the water by adding another wash. Use dry-brush strokes for more detailing on the rocks. This gives a more accurate brushstroke and intensity to the painting. I use Winsor & Newton tube watercolors, which remain moist and workable yet have full value when applied to the paper. Continue to add wave strokes using a no. 6 round. Wipe out some color in the rocks at the point of contact on the large wave to suggest mist and overlapping of the wave.

TIP FROM A PRO

Rocks

When you look at rocky coast you can't help but wonder "Where do I begin?" It's best to break up an area and concentrate only on one or two large rocks, studying their mass, their color and how they protrude above the surface. Then work on the areas around that starting point and let it build. Study the contrasts. It's easier if you isolate smaller areas with a complicated subject like rocks.

—LEONARD MIZEREK

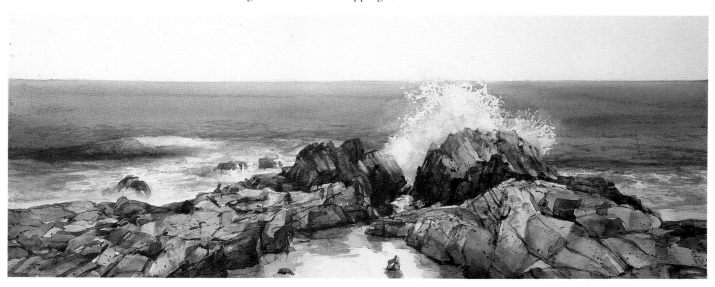

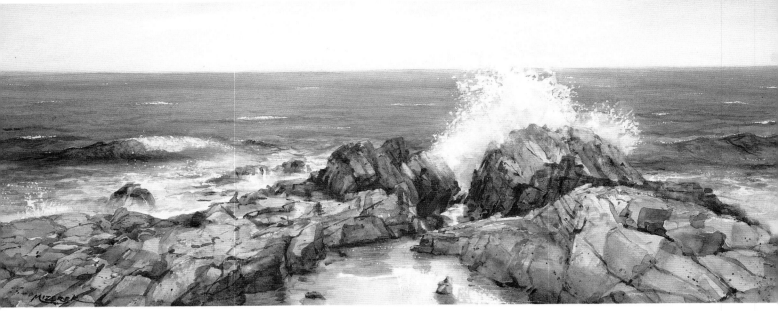

EARLY BREAKERS
8½" × 21" (21.6cm × 53.3cm)
Leonard Mizerek, Transparent Watercolor

STEP 5

Corrections and Finish

Even out areas that are too light with another wash of Raw Sienna and Alizarin Crimson on the rocks. The sky should be in harmony with the sea, so use some of the same colors as in the water and keep the sky subtle. Put a touch of Alizarin Crimson along the horizon.

Define the wave patterns closer to shore and apply a wash to the sky to increase the contrast between the top of the breaker and the sky.

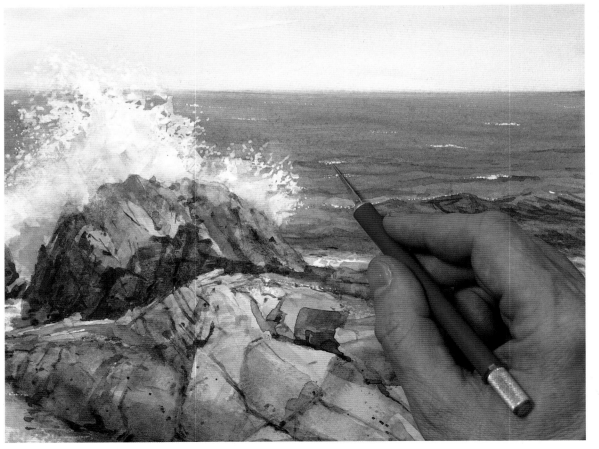

detail
Scratching Whites

Using a no. 11 X-acto Knife, go into the painting where you want to heighten the contrast and scratch areas with the edge of the knife to bring back the white of the paper. In this case, create the whitecaps in the distance with this technique.

A Rocky New England Shoreline

LEONARD MIZEREK, WATERCOLOR

Certain elements are common to New England coastal scenes. These include New England-style architecture, hills, small boats and rocks. All of these elements contain lots of planes, lines and angles that can be used to the artist's best advantage in designing a painting.

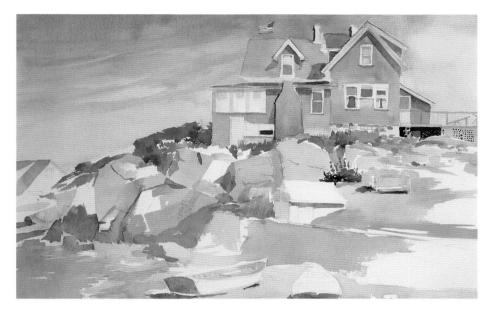

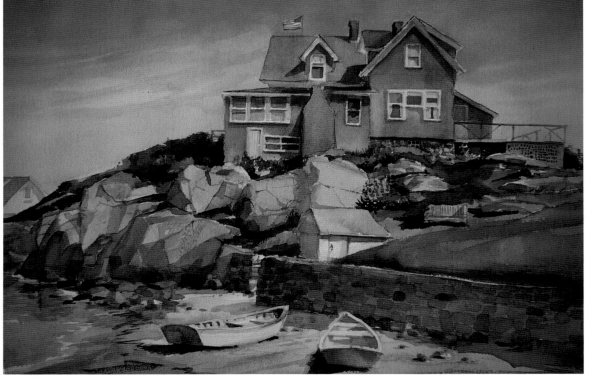

STEP 1

On-Site Start

With the wind blowing, I applied the sky color quickly so not to leave unwanted edges. Blot cloud areas with a paper towel to suggest that wind and flag blow the same way as the clouds. Lay in the land mass and shrubs keeping the grassy sunlit area lighter. Leave some paper areas untouched. This "painting skeleton" was done in about two hours. The goal is to place all the elements with enough color to finish it later.

STEP 2

Studio Finish

Use a flat brush to paint the rock surfaces warmer or cooler, depending on the direction of the light. Later, drybrush some individual rocks for surface textures. Keep the water's edge white, and use some sky and rock colors for the shallow water. Vary the windows, some with half-drawn shades and slightly opened curtains. For the boats in the foreground, make one light and one dark, pointing into the frame.

FISH BEACH
14" × 17"
(35.6cm × 43.2cm)
Leonard Mizerek
Watercolor

127

Combining Boat and Beach

LOIS SALMON TOOLE, WATERCOLOR

Sandy Hook is a narrow sandy peninsula, an extension of the coast of New Jersey south of New York, about 5 miles (8.1km) long, with the bay on one side and the Atlantic Ocean on the other. For centuries, its location at the entrance to New York Harbor made it strategic to shipping and defense until late twentieth-century technology made its installations obsolete. Over time, strong currents, tides and battering storms have changed its configuration. Near the end of the Hook, its historic lighthouse, the oldest original working lighthouse in the United States, now stands 1½ miles (2.4km) from the sea.

Once accessible only to the military, in 1972 Sandy Hook became part of the Gateway National Recreation Area. Its development for recreational purposes in recent years has made its fragile ecology even more vulnerable. On this strip are dense holly stands and flora and fauna indigenous to only that area. There are protected shorebird nesting sites, nature walks and seas of poison ivy!

Materials:
300-lb. Arches cold-press rag paper
3-inch and 1½-inch hake brushes
½-inch and 1-inch flats
no. 4, no. 6 and no. 10 rounds
a small rigger
Winsor & Newton transparent watercolors

STEP 1

Composition and Afternoon Glow

Soak 300-lb. Arches rag cold-press paper and staple it to a board. After drawing in the composition, mask a few whites to save. We're facing west so create an afternoon skyglow with Yellow Ochre. With a 3-inch hake brush, wet the paper from the top to the beach and grade a Yellow Ochre wash from the top, fading down to the beach, tipping the paper vertically. As the paper dries, brush a Light Yellow Ochre base wash into the foreground sand area with a little more color at the sides and bottom.

STEP 2

Base Coats for Sea, Sky and Background

Wetting the paper to the shoreline, grade Antwerp Blue down into the water. With the tip of a 1-inch brush, stroke in some mauve waves as you approach the shore. These can be augmented later. While the paper is still damp, slightly darken the distant horizon waterline. When the paper is dry, re-wet the background area, and, adding Cobalt Blue to the Antwerp, brush in the Highlands, lifting some paint here and there to suggest buildings.

STEP 3

Form Dunes and Boulders

Using "sand" colors (Yellow Ochre, Burnt Sienna, Van Dyke Brown, Mauve and Alizarin Crimson/Cobalt Blue mix charged into one of my blues), form dune and boulder patterns in broad strokes, alternating a 1½-inch hake brush and a 1-inch flat. The gentle sloping leads to the "path," which in turn directs the eye toward the schooner. Painting sand is in some ways like painting snow, with lost and found edges.

STEP 4

Define Hull and Masts

Before you get much further, define the boat hull and masts with a Cobalt Blue/Sienna Gray mix using a no. 10 round. Check on the values and when comfortable with them, continue the dunes and start introducing grasses.

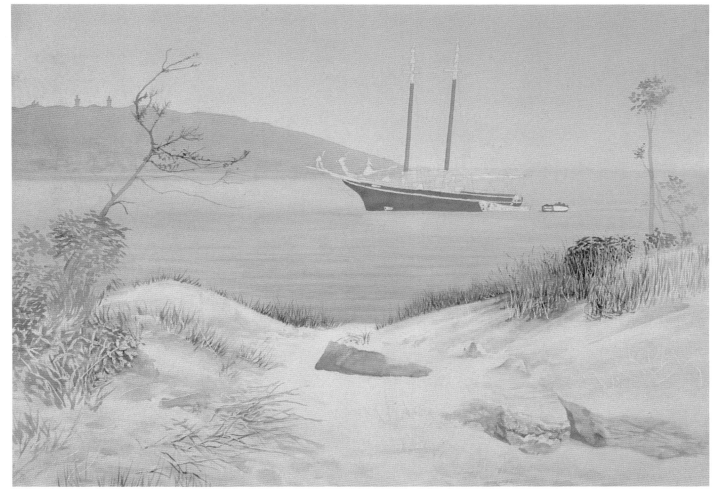

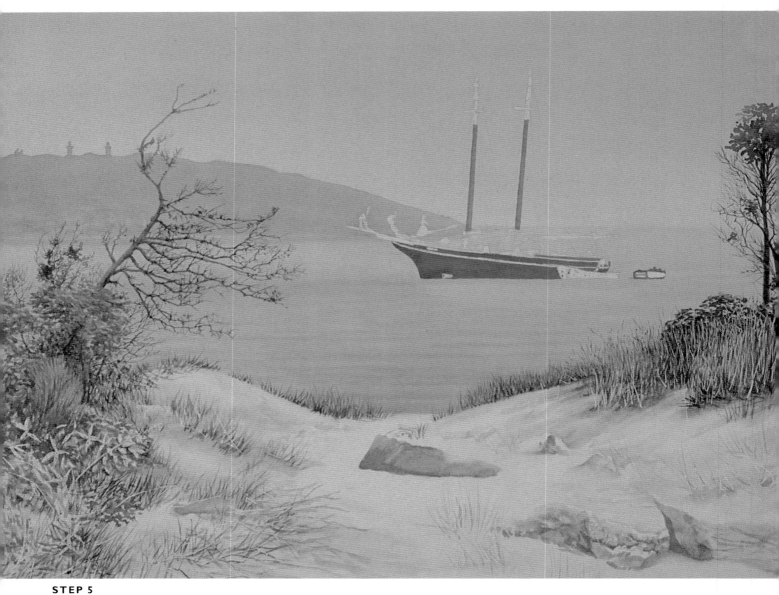

STEP 5

Grasses

For the grasses, start with Yellow Ochre and Cadmium Yellow and introduce Viridian,
Burnt Sienna and cobalt in various brush pickup mixes. For narrow leaves, use a no. 4
round in quick upward and curving strokes. Use a no. 10 round for trees and broad-
leafed plants dabbed on with the tip or side of the brush. Suggest most leaves in masses,
and model just a few. Use a small rigger for the fine twigs. Gradually build the color
intensity and value of the tree clumps on both sides to frame the schooner, and contour
the grassy dunes with stroke and value to lead the eye toward the schooner.

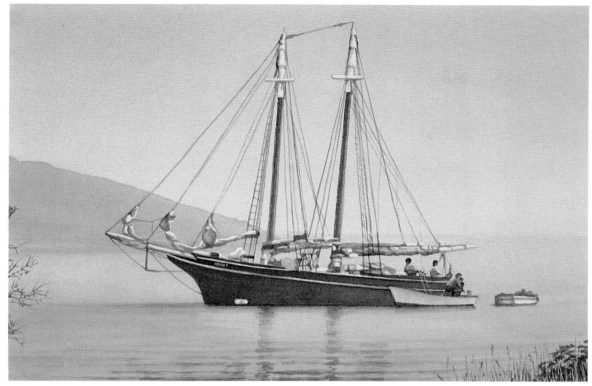

detail

STEP 6

The Schooner

Before removing the masking, put a piece of paper towel down beside the ropes and with a sharp pointed no. 4 or no. 6 round, run a brushload of Cobalt Blue-Sienna Gray down each rope freehand. Sketch in the figures and glaze another layer of Cobalt Blue-Sienna Dark Gray over the masts and haul. At the waterline, run a narrow line of Burnt Sienna. After removing the mask, model the sails with cobalt, sienna, mauve and the gray. Use the same colors in the boulders and dunes.

detail

STEP 7

Dunes and Grasses at Left

Even the trees reach out toward the schooner. Paint up the trunk of the tree, and keeping it wet, extend the main branches in a continuous flow, charging the same colors, mostly Antwerp Blue and Burnt Sienna, to both trunk and branches. Shade the darker tones to suggest the direction from which limbs emerge. Darken broad leaves at the base, then remove the masking, wet the white areas and daub Viridian to shape leaves or form outline keeping white highlights. Pick up a brown mix and follow the fallen twigs and branch masked shapes. Then add some shadow lines with Cobalt Blue before removing the masking. You can dull the fresh white with a little yellow, Cobalt Blue or Cadmium Orange.

Grasses and Dunes on Right

I use a lot of mixes for grasses—Viridian with Cadmium Yellow, Viridian with Burnt Sienna, Cadmium Yellow with Cobalt Blue; pick up Antwerp Blue with any of these or each other—whatever works. Shade with Cobalt Blue and continue shaping the dunes with Burnt Sienna, mauve, Cobalt Blue and Yellow Ochre. Paint the blades in one long quick stroke from the bottom up to the tip. Remove masking.

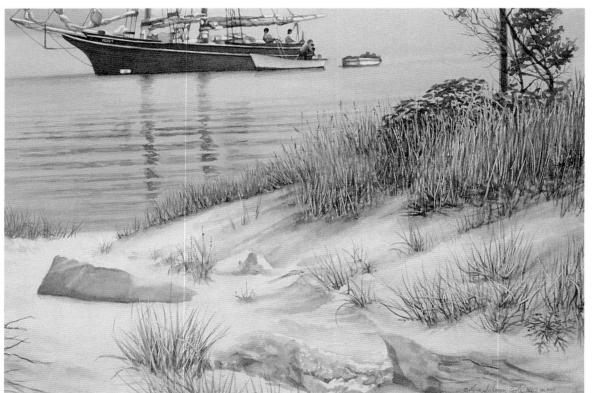

Fill in the Grasses

Fill in the once-masked blades with Yellow Ochre, Cadmium Yellow and aureolin in the foreground, shaping with greens and Burnt Sienna. Now add more shading to grass areas and finish the ship reflections.

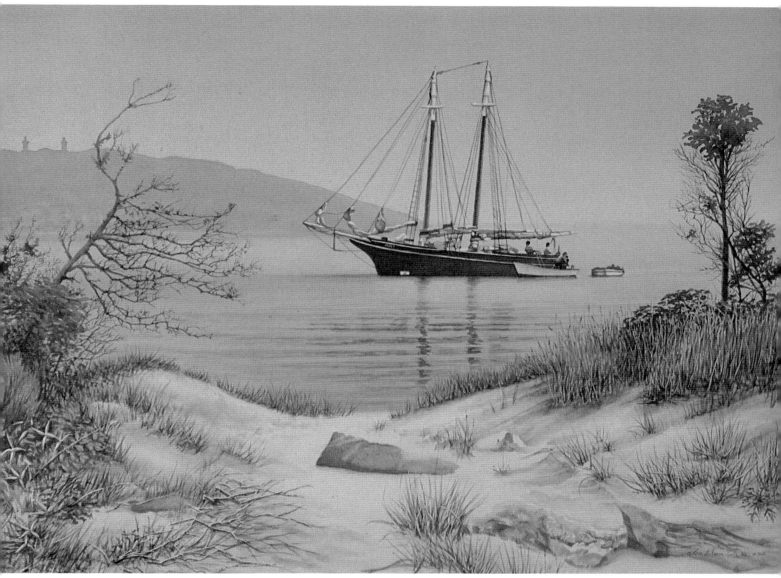

SAIL ON THE TIDE
21" × 28" (53.3cm × 71.1cm)
Lois Salmon Toole, Watercolor

STEP 10

Finishing Touches

In the total scheme of things, these are minor adjustments, subtle but important nonetheless. Fill in a touch more green to left foliage, more crags to boulders, lifted depressions on far boulder. Darken some left sand areas; put Light Antwerp Blue on the base of once-masked grass blades, preserving highlights to suggest curves. When painting depressions in the sand, keep in mind the source of light and put the shadow opposite, keeping edges soft (lost and found).

NOSTALGIA

Sandy Hook has been an important anchor in my family's life. Now that we are geographically dispersed, it has become a tradition that every New Year's Day when the family reunites at my mother's house, we trek over to Sandy Hook. We hike the dunes, climb over the crumbling bunkers and gun emplacements and walk the beaches. We top it off by heading up to the Hofbrau Haus on the top of the Highlands to share some libation and watch the sun set on the Twin Trade Towers and lower Manhattan across the bay.

Painting a Historic Scene

ROBERT C. SEMLER, OIL

The oil painting, *Twilight on the Delaware*, depicts a scene circa 1912. The viewpoint is just above the Pennsylvania Reading Railroad (PRR) Ferry Terminal in Philadelphia looking toward Camden, New Jersey, across the Delaware River with the PRR Ferry slips visible. The Wilson Line steamer, *Twilight*, passes the ferry slips heading north on a moonlit night. The battleship, *South Carolina*, is docked on the Camden side of the river for the upcoming July Fourth celebration on the Delaware.

Semler's sources of reference material for this project included books and early photographs of the area and the vessels. The scene is based on a contrasty photograph of the era. He opted for a moonlight scene just after twilight to tie it in with the vessel of the same name. Painting historical subjects is a challenge and requires hours of research to get the view as accurate as possible. Visits to the Philadelphia Independence Seaport Museum's library aided in the task.

Semler used a color scheme of Cerulean Blue, Payne's Gray and white throughout the painting. The moonlight casts a greenish light, and the Payne's Gray helps neutralize the color. On a night like this, there's a lot of gray in the colors. He's carried these colors throughout, even using some of the mixture in the redbrick buildings in the foreground. This helps tie everything together in the color scheme.

Reference Material
Here's some of the reference material used in the initial ideas for the painting: books, photographs, etc. Finding the right material for a historic subject can sometimes be more challenging than executing the finished painting. Special-interest museums and libraries are good sources. Look for information in the area the event you're painting took place.

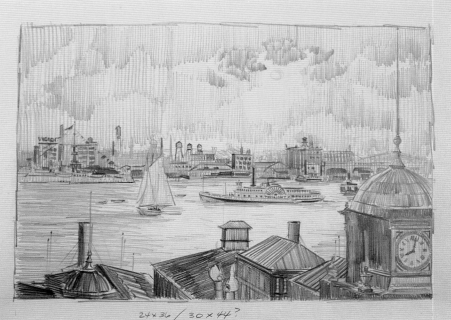

Finished Sketch
After doing several thumbnail sketches, I complete a detailed pencil drawing. I place this in an opaque projector and enlarge it directly onto the stretched linen canvas. I also used it as a basis for the watercolor study on the next page.

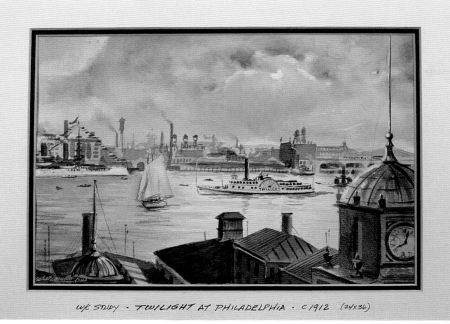

w/c STUDY · *TWILIGHT AT PHILADELPHIA* · C 1912 (24X36)

Watercolor Study

I paint a small watercolor study before applying any color to my canvas. I work out the basic color scheme as well as the values in this sketch. If you do intense work up front, it saves time and makes the final painting much easier to complete.

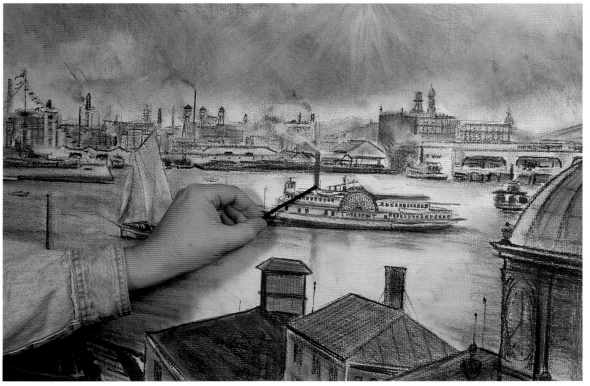

STEP 1

Using thin vine charcoal sticks, I execute a detailed drawing from the projection of my drawing. Although I use the opaque projector for most of the work, there's still a lot to do at this drawing stage. I prefer the vine charcoal over pencil because it's easy to correct. When satisfied with the drawing, I spray it lightly with two or three coats of fixative to hold it in place.

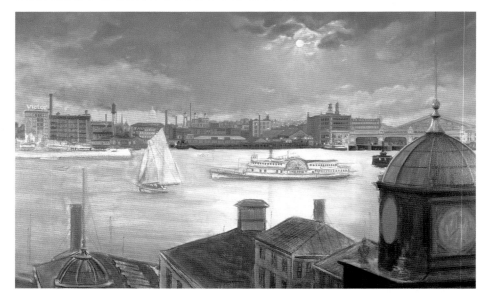

STEP 2

The colors are now all blocked in lightly using mineral spirits or Turpenoid. I paint in most of the sky, applying large areas of color with a no. 10 or no. 12 filbert bristle brush and then blending the colors with a large fan blender. At this stage I complete the skyline buildings, almost entirely painting with Cerulean Blue, Payne's Gray and white with a touch of Burnt Umber. The blacks (which I mix with Payne's Gray, Cerulean Blue and a touch of Burnt Umber) in the skyline are rather muted. Pure black would look like holes in the canvas at that distance.

detail
STEP 3

Not much work is completed on the steamship yet, but I paint the stack and smoke since the background is finished and the color still tacky. For the smoke, I load up the brush with some Payne's Gray for the shadow side, get rid of any excess paint on a paper towel and drybrush the smoke into the tacky background paint. Then I use my finger to push it in and smooth it out. It blends into the background just as smoke would. A little lighter gray on top would be where the moonlight strikes it.

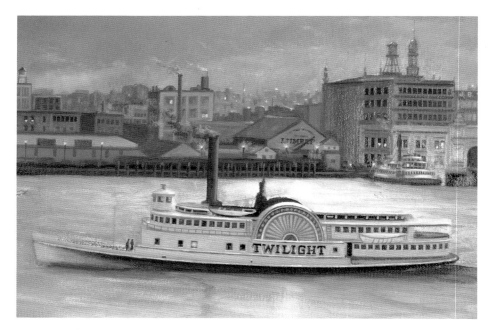

detail
STEP 4

I now add a great deal more detail to the steamboat. This vessel's name is painted in red with a drop shadow underneath. I paint the shadow first, allowing it to dry thoroughly and then mix some Winsor Red and Payne's Gray to paint the actual name of the vessel. I like to use a magnifying lens and a very small sable watercolor brush while painting this type of detail; it eliminates some shaky strokes and the need for a muscle relaxant after the session!

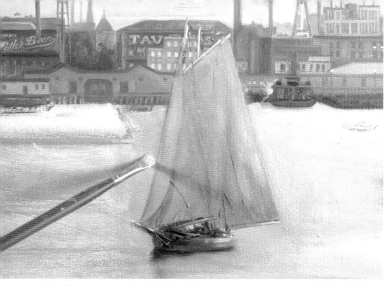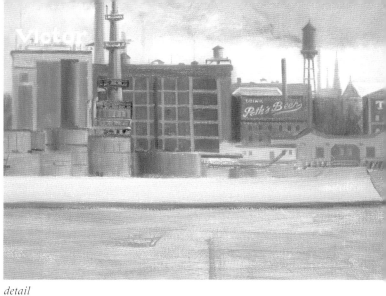

detail

STEP 5

I paint the small schooner in one session, concentrating on the light and dark shapes rather than specific details. You can't see details at this distance anyway. Here I'm shaping the curve of the sail with a "white sable flat," which in reality is not pure sable, but a combination of hairs. It handles like a bristle, but tends to spread a more even layer of paint, instead of streaking.

detail

STEP 6

The battleship *Oregon* is docked on the New Jersey side of the river. It's blocked in with the basic color scheme with no attempt at detail. This vessel adds "flavor" to the overall scene. It will be darkened and some detail added later, but not much. You don't want to lead your viewer away from the main focal point; just give him places to browse.

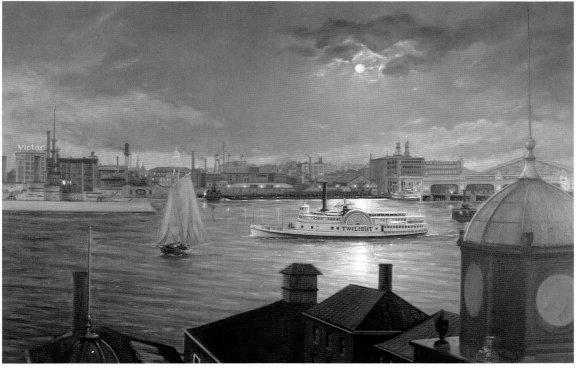

STEP 7

I paint the steamship, sailing schooner and battleship before I work on the water so I can paint the water "over the hulls," making the vessels appear to sit *in* the water. I do several things at this stage. I bring the water up close to the value and colors that I want, further emphasizing the bright moonlight area over and above the main subject of the steamship. Cerulean Blue, Payne's Gray, Raw Sienna (nearer the moonlight), Burnt Umber and some Ultramarine Blue are used to help show the dirtier effects of the Delaware's water at this time in its history. The foreground roofs and buildings are painted in their basic flat color prior to adding the bricks and roofing materials.

detail

STEP 8

Finally, I paint in the details, such as the clockfaces, and the bricks in the foreground buildings. Bricks in particular can be as fun as they can be tedious. Using Winsor Red and Viridian Green (these are complementary colors, and the green will darken the red without changing the hue), I first paint in the flat color of the building, light and shadow sides. Allowing it to set up but not dry completely, I then use a very fine sable watercolor brush to stripe in the lines of the bricks (the same red-green mixture with a little Payne's Gray added). Right below this line, I use Payne's Gray and white to stripe in the mortar, doing the horizontal as well as the vertical separations. When this paint sets up slightly, I use a fan brush and ever so lightly soften the harsh lines. Remember your perspective and vanishing points. In this painting, the vanishing point is on the horizon at a position near the first stack of the battleship. Keep all your lines converging on that point, or the buildings won't appear as they should.

detail

STEP 9

I paint in the clockfaces and decide to reposition and resize the decorative finials at the tower's corners. Don't hesitate to redo an object if you don't feel it's right. In this case, I correct for perspective. Continuing the way I originally sketched it in would have ruined the look of this area of the painting.

RESEARCH THE WATER

Research the water as carefully as the rest of the painting. In Philadelphia at the turn of the century, there was a lot of oil, coal dust and grime in the Delaware. I painted this water using Cerulean Blue, Payne's Gray and Raw Sienna (closer to the moonlight) and even Burnt Umber and some Ultramarine Blue, making certain that the ripples and movement of the water remain in one direction.

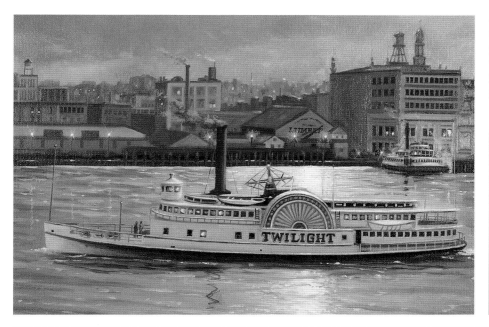

A detail showing the steamship *Twilight* finished and with all the interior lighting, paddle wheel equipment, etc., painted in. You can also see the star lines in the street-lamps and pier lighting to help make the illusion appear real.

TIP FROM A PRO

SMALL DETAILS ARE IMPORTANT

Make certain that small details, such as flags and smoke from the factories and ships, are all flowing in the same wind direction. It's these small details that make the subtle difference in a professional piece of art.

—ROBERT C. SEMLER

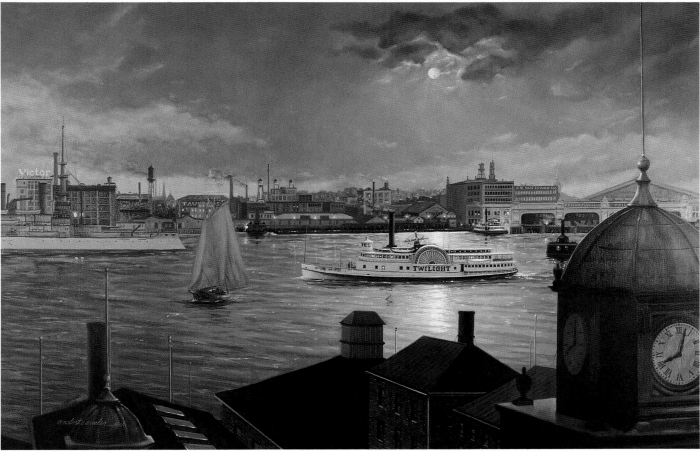

TWILIGHT ON THE DELAWARE
24" × 36" (61cm × 91.4cm)
Robert C. Semler, Oil on Canvas

FINISH

Always keep the lighting in mind. I paint *Twilight*, which is a white vessel, a light to medium blue-gray because it's out of the direct moonlight. This makes the all important direct lights and reflections appear as bright as they would be if you were standing there. The center of interest is the steamship, so I place that at a position just to the right and below center, in an area known as the "golden section." With the moon placed directly above, it draws your attention immediately to the central theme.

About the Artists

To get in touch with any of these artists, please contact the American Society of Marine Artists. (See page 142.)

WILLARD BOND is a fellow of the American Society of Marine Artists. He began his training at the Art Institute of Chicago, going to school at night while in the navy. Bond continued his education in New York at Pratt Institute, graduating in 1949, and then spent two years at the Art Students League of New York.

As night pier master at New York's South Street Seaport, in 1976 Bond found himself occupying a ringside seat at the Bicentennial "Operation Sail." "I had always loved ships, but watching the ships from all over the world . . . turned me around. Ships and the sea had always been in my repertoire . . . but not like this!" There is something about the movement, the power and speed in his work that captures the action familiar to all sailors.

MARC A. CASTELLI has focused his painting and drawing on the environment of water, wind, light and their effects on boats for the last twenty-two years. His work has appeared in *Sailing Magazine*, American Society of Marine Artists publications, *Splash 3*, *Splash 4*, *Nautical Quarterly* and *Scow Slants*. He is a racing sailor, and his views of racing sailboats appeal to the experience of sailors. Taking this intimacy with his subject to the Eastern Shore of the Chesapeake Bay has given him a unique approach to the genre of workboats, watermen and the seasons as they exert their influence on his subjects. His wife, Phyllis, and their three children make their home on the Eastern Shore, close to the activities, subjects and life they all enjoy there.

PETER E. EGELI was born in 1934 to a family of artists and has always lived on or near the waters of the Chesapeake Bay. He works in all mediums and is willing to approach any subject. Though best known as a portrait painter whose works hang in federal and state offices, court- and boardrooms, as well as in many private homes, he has a special interest in marine art and is a charter member, fellow and past president of the American Society of Marine Artists. Egeli feels that achieving precision by paying close attention to details of all kinds necessary to do a good portrait is a great asset for successful marine painting as well.

GEORGE GUZZI attended Tufts University, graduating premed in 1956. Instead of continuing his medical education, he listened to a little voice that told him art was his true calling. He went on to the Art Institute of Boston, graduating in 1959.

Guzzi has been awarded commissions for many different types of paintings including extensive work as an aviation artist for NASA and the air force, for whom he's painted historic and state-of-the-art aircraft, Desert Storm images, shuttle launches and landings, astronauts and pilots. Using mostly acrylics, Guzzi also paints marine scenes, especially the coast of Maine and small towns in Italy and France.

JAMES DRAKE IAMS has painted the Chesapeake Bay and sailing craft since the mid-1950s. Having sailed the rivers and tributaries of the Eastern Shore, he combines his observations, sailor's knowledge and the eye of an artist. The result is paintings and sketches authentic in detail, appealing both to those familiar with the scenes and to waterscape lovers outside the Chesapeake Bay area. A graduate of Indiana University, Iams holds graduate degrees from Pennsylvania State University and the Maryland Institute College of Art. Iams is a member of the American Watercolor Society, the American Society of Marine Artists and the Baltimore Watercolor Society.

His work receives national and international recognition and is represented in galleries and private collections.

DEE KNOTT's paintings are widely exhibited in museums and galleries throughout the country, and she's received numerous national awards.

Lee A. Iacocca, Chairman of Chrysler Corporation, presented Knott's paintings as gifts to high-ranking government leaders in China and Japan. Chairman Iacocca also presented a series of her paintings to various government officials of Venezuela.

She has been honored as an elected member of the American Watercolor Society, the National Watercolor Society and the American Society of Marine Artists among others. Her watercolors are included in several permanent collections, including those at General Motors Corporation, Walt Disney Corporation, and Marriott Corporation.

GEORGE F. MCWILLIAMS is fascinated by the water and the people who live and work on it; it is the driving force behind his work. The connection between artist and subject is rooted in his family history. In the early 1800s, George's family became involved in the Potomac River's maritime history and maintained a constant presence on the river throughout the 1900s. In the early part of the century, they sailed everything from schooners to dories.

McWilliams completed his first mural at a local marina at the age of seventeen. He attended the University of Maryland and in 1980 received a B.A. In 1981, George went to work at the U.S. Naval Air Test Center at Patuxent River, Maryland, as a graphic artist/illustrator. In 1987, George left his job to pursue his art full-time.

His work is well received and is in private collections all over the country. He's twice placed in the top

twenty for the Maryland Duck Stamp Competition and has won awards that include the President's Choice Award at the Chesapeake Bay Foundation Art Show and the Mystic Seaport Museum Purchase Award. He is an artist member of the American Society of Marine Artists.

LEONARD MIZEREK, born in Philadelphia, Pennsylvania, presently lives in Westport, Connecticut. He graduated with a B.F.A. from Virginia Commonwealth University and studied at the New York Art Students League under Nelson Shanks. Mizerek is an officer and Signature Artist Member of the American Society of Marine Artists. He's also Signature Artist Member of the Northeast Watercolor Society and the International Society of Marine Painters.

His primary interest is maritime subjects. For years, he has traveled along the eastern coastline of the United States, as well as around the world, looking for places to paint.

Past exhibitions have included Operation Sail, Boston, First Place in the Sea Heritage Marine Exhibition, The American Society of Marine Artists Exhibition and numerous national exhibitions.

Mizerek's work is included in *Splash 3* and *Splash 4*, books showcasing America's top watercolorists. He was chosen as a finalist in *The Artist Magazine's Competition 95*. He's also featured in the book *Make Your Watercolors Look Professional*, published by North Light Books, and *Colored Pencil 3*, by Rockport Publishers.

YVES PARENT, born in Normandy, France, in 1941, has been painting watercolors since the age of fifteen. He's displayed his paintings in the most prominent galleries of France, England and the East Coast of the United States, including the prestigious Mystic Maritime Gallery. He's an artist member of the American Society Marine Artists.

Besides being a full-time artist, Parent is also an experienced sailor. Sketches from the deck of his own sloop are the basic materials he uses to paint his watercolors in his studio in Old Saybrook, Connecticut. He's made several Atlantic crossings, two that were single-handed, and has been involved in extensive cruising and racing. In 1982, Parent was part of the crew with the Whitbread Round the World Race. His knowledge permits him to paint yachts and the sea with the eye of an experienced sailor.

Recently, Parent decided to combine his experience in watercolors with the challenge and pleasure of painting yacht portraits. These unique portraits, set in the owner's favorite locale, constitute an affordable and personal treasure.

CHARLES RASKOB ROBINSON was raised in the Brandywine Valley of landlocked Pennsylvania, where he was exposed to the art and influence of Howard Pyle, the Wyeths and others of the Brandywine School. His bent for marine subjects can be traced to the summers he spent on the Eastern Shore of the Chesapeake Bay and in the waters off the Maine coast.

He obtained a B.A. from Haverford College and an M.A. at the Johns Hopkins University. He moved to New York City in 1965 and attended the Arts Students League for a number of years and is now a life member of the league.

During college, he founded the Colonial Arms Foundry, a company that manufactured model operational reproductions of U.S. Naval cannon of the 1812 vintage.

His works are in a number of collections, including the renowned collection of Malcolm B. Forbes, Sr. He's been featured in several publications, including *Nautical Quarterly*, *Sea History*, *Yankee Magazine* and *Architectural Digest*. His work is also featured in the large-format book *Yacht Portraits: The Best of Contemporary Marine Art* (Sheridan House).

The artist has been active in the National Maritime Historical Society and the South Street Seaport Museum and is an officer and director of the American Society of Marine Artists. Robinson is one of the few fellows in the ASMA. In 1994, the Society gave him the "Iron Man" Award, representing only the third time the award was given in the nearly twenty-year history of the society. His most recent museum exhibitions were at the Maryland Historical Society in Baltimore, Maryland, and the Schaeffer Museum in Mystic, Connecticut.

ROBERT C. SEMLER studied at the Pennsylvania Academy of the Fine Arts in Philadelphia, Pennsylvania, majoring in figure and portrait work. Since 1987, he has been conducting classes in portrait painting at Gloucester County College.

He's an artist member and vice-president of the American Society of Marine Artists and is active with the U.S. Coast Guard art program. Through this program, he travels extensively throughout the country painting coast guard activities. He has won the coveted "George Gray" coast guard award twice for his contributions and support of the Coast Guard's art program, having a total of eight paintings in the guard's permanent collection.

His maritime paintings and prints are represented by several galleries, including Mystic Seaport Gallery, Mystic, Connecticut; Deck the Walls, Deptford, New Jersey; The Pilothouse, Philadelphia, Pennsylvania; and Limited Art Associates, Chantilly, Virginia.

LOIS SALMON TOOLE received a B.A. in Fine Arts from Douglass College of Rutgers University. Born and raised on the coast of New Jersey, she draws inspiration from the fishing docks of her Bay Shore hometown and the moods of the nearby ocean. The picturesque falls of her adopted Ohio hometown and nearby Lake Erie waterways also provide plenty of marine subject material. She is an award-winning signature member of National Watercolor Society; Rocky Mountain National Watermedia Society; The Midwest, Ohio, Kentucky, New Jersey and Pittsburgh Watercolor Societies; Salmagundi Club; National Association of Women Artists; Miniature Artists of America; and Coast Guard Art Program. She has work featured in *Splash 3*, *Best of Watercolor* and is listed in *Who's Who in American Art*.

Glossary

AFT Near the stern (rear end of the boat).

BACKSTAY Standing rigging from the mast to the stern (rear) of a sailboat.

BALLAST Weight placed in or on the hull to improve stability.

BATEAU French for boat, used in some areas for a vessel like a skipjack.

BATTENS Long light narrow strips of wood or long narrow metal slats.

BEAM 1. Greatest width of a vessel. 2. Any of the main cross timbers that span the sides of a vessel horizontally and support the decks.

BOOT TOP 1. The portion of the exterior hull at the waterline. 2. A painted stripe at the waterline.

CENTERBOARD Thin boards that can be lowered through the keel, used to counteract the tendency of a sailboat to move sideways.

CHOP Confused water action found where tidal currents meet or due to windy conditions.

CLUB In a log canoe, a vertical piece of wood to which the horizontal spreet is fitted at one end. (See log canoe.)

CULLING BOARD The board where oysters are dumped to separate the "keepers" from the trash.

DINGHY Small open boat often carried on a larger boat.

FORESTAY Standing rigging from the mast to the bow of a sailboat.

FREEBOARD Distance between the waterline and the top of the deck.

GAFF-RIGGED A four-sided sail with a spar holding the upper side.

GUNWALES Upper edge of the side of a boat, pronounced *gun'l*.

HALYARD A line used to hoist a sail or spar aloft.

HARD-A-LEE An order to put the helm to the lee side.

JIB A single headsail, a triangular sail set on the headstay.

KEEL The main longitudinal member of the hull, the body of the vessel.

LEEWARD Toward the lee, the direction away from which the wind is blowing.

LOG CANOE Racing log canoes are small clipper-bowed sharp-sterned boats with little freeboard. They carry a sharply raked mast, stepped right forward and another nearly amidship. Instead of carrying the fore and main on booms, they have a vertical piece of wood called a club fitted to the trailing side of a quadrilateral sail with a spreet connecting the club to the mast and holding the sail out from the mast. With only a centerboard instead of a keel, there are springboards with crew for movable ballast.

MIZZEN Fore and aft sail set on the mizzenmast.

MIZZENMAST The aftermost mast, or third mast from forward.

PULPIT An extension forward of the bow, normally consisting of a small platform, sometimes with a rail.

RAKED Inclined at an angle to the waterline.

RUNNING RIGGING The adjustable lines used to control spars and sails.

SCHOONER Fore-and-aft rigged vessel, two to six masts, foremast shorter than main.

SHEETS Lines used to control a sail's lateral movement.

SHROUD Fixed rigging from the mast to the sides of a sailboat.

SKIPJACK Vertical-sided sailboat with a flat-V-shaped hull.

SPAR General term for masts, booms, gaffs and poles used in sailboat rigging.

SPREADERS Arms used to spread the shrouds and give better support to the mast.

SPREET A wooden horizontal piece that serves the function of a boom in a log canoe, holding the sail away from the mast. It is different from a boom in that instead of running along the foot of the sail it runs a few feet above the foot of the sail. It is fitted to the mast at one end and the club at the other end.

SPRINGBOARD Hollow board used on small racing craft like log canoes to support "human ballast," people sitting on the springboard over the water to balance the boat.

SPRIT Small boom or gaff used with sails in small boats.

SPRITSAIL Sail extended by a sprit.

STANDING RIGGING Permanent stays and shrouds used to hold up the mast.

STEM The upright post of the bow, the extreme leading edge of the hull; on wooden boats the main structural member.

SWELL Long large wave that does not crest.

TILLER A lever attached to the rudder post that is used to steer the vessel.

TONG BOAT Open boat used in harvesting oysters and clams, which are gathered with long-handled tongs.

TOPSIDES 1. On deck. 2. The side skin of a boat between the waterline and the deck.

TRANSOM Flat area across the stern.

WINCH Mechanical device used to increase the pull on a line or chain.

THE AMERICAN SOCIETY OF MARINE ARTISTS (ASMA)

With artist and nonartist members in forty states, the ASMA is dedicated to the advancement and appreciation of marine art in the United States. Since its founding in 1978, the society has welcomed the membership and participation of anyone interested in marine art, our rich marine heritage or the history of marine art. As a nonprofit organization, the ASMA fulfills an educational and informational role and introduces the society's artists and their work to the public through their national exhibitions. The society also publishes a quarterly newsletter written and edited by members. For more information about the ASMA or about the artists in this book, contact
Nancy Stiles, ASMA Managing Director
1461 Cathys Lane
North Wales, PA 19454

Index